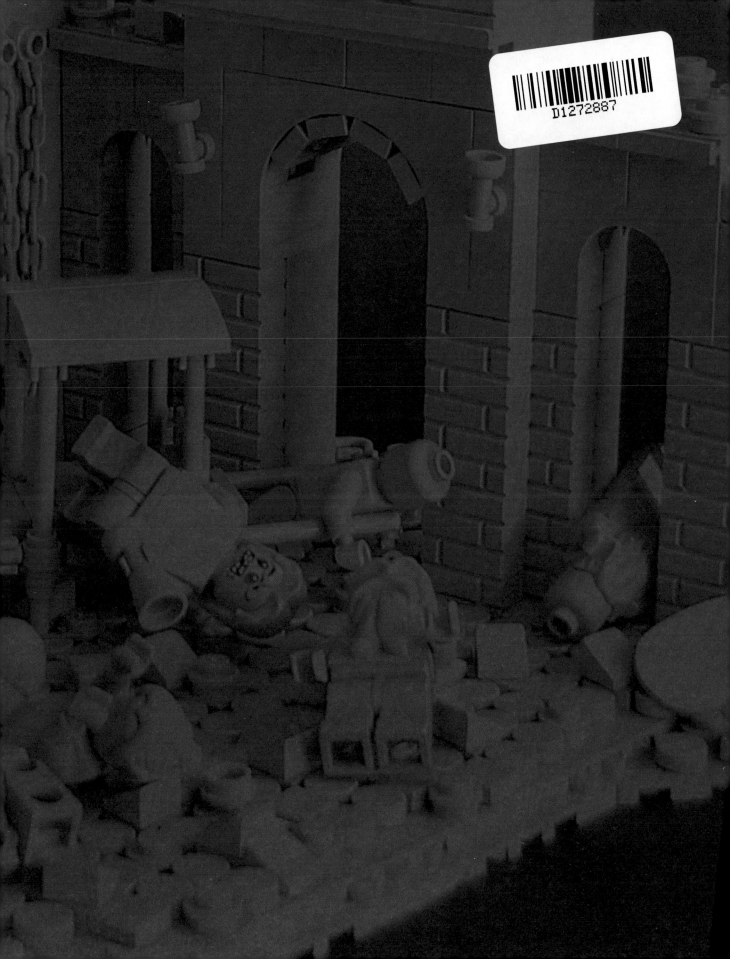

BEAUTIFUL LEGO® 2 DARK

MIKE DOYLE

San Francisco

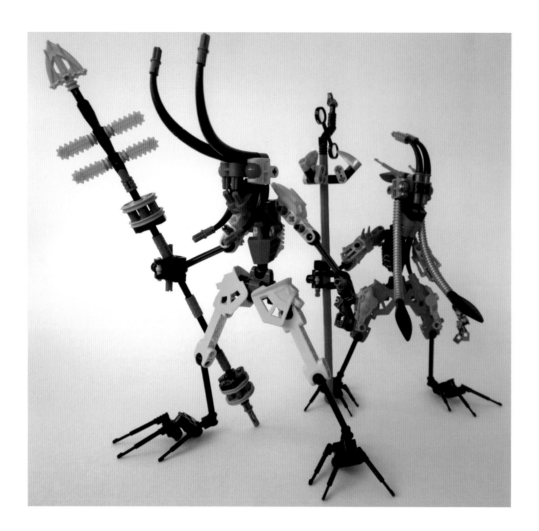

FEATURED ON THE COVER

FRONT
Sickening Sweet, Mike Doyle
FLAPS AND BACK
And the Band Played On..., Barney Main; *Marine Organisms*, Bidea;
Juvenile Draconis Diablos, Nathan DeCastro; *Abandoned Sea City*, Jason Allemann;
King Kong, Ken Ito; *Fiend's Eye,* Justin Vaughn; *Anubis and Ra,* David Alexander Smith

Limited edition fine art prints available for cover image (full image on pages 170–171),
and other works by Mike Doyle at *http://bumbleandbramble.blogspot.com.*

Andrew N. Swink
Queen and Seer 2009 (358 pieces)

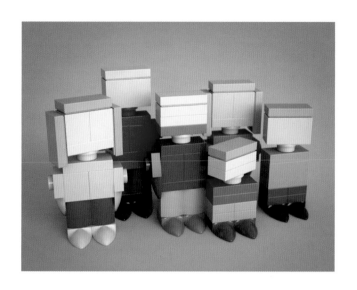

To Mina and Mike Doyle, my beautiful wife Stephanie, and our two boys, Caeden and Ian. You are all an inspiration to me—each in your own wonderful way!

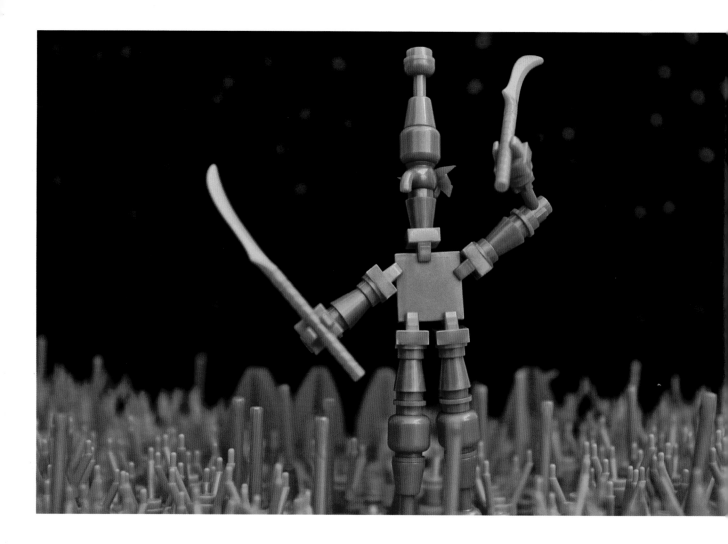

ACKNOWLEDGMENTS

This book is possible only through the amazing work created by the LEGO building community. Their work—shared online and at events—brings endless inspiration. Quite a few designers took extra effort to rephotograph and even rebuild their pieces for this book. I can't thank you enough—the work looks great!

Günther Möbius
The Golden Warrior Rises 2014 (~500 pieces)

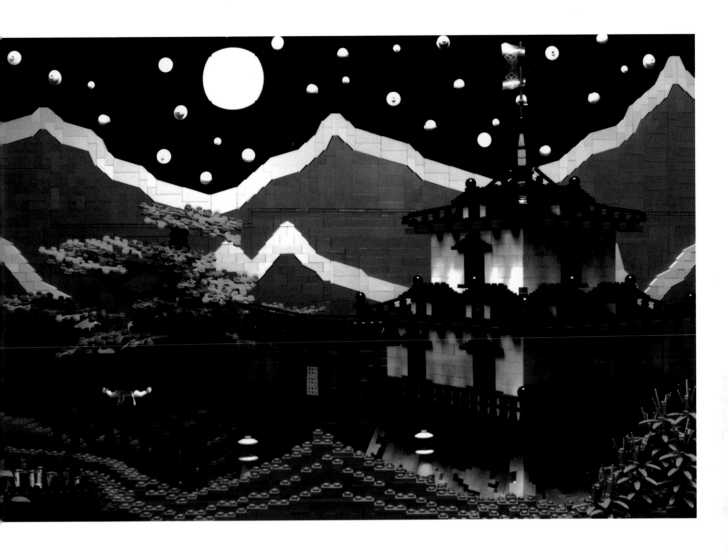

Lukasz Wiktorowicz
Midnight Training 2014

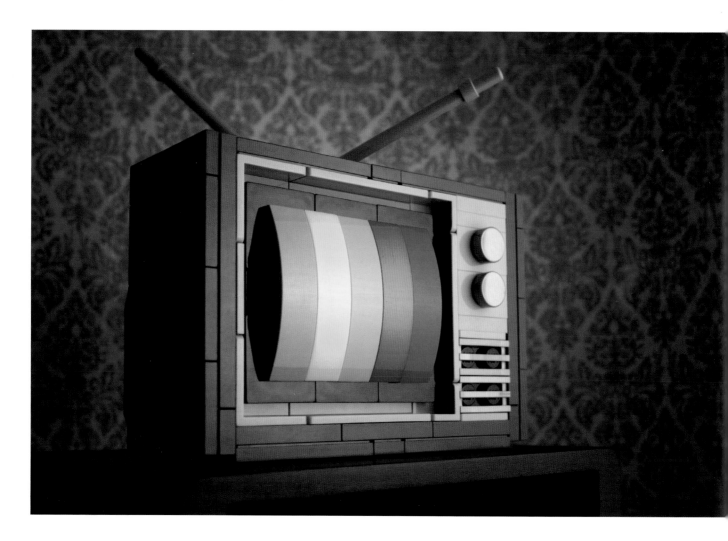

SPECIAL THANKS

Special thanks to those who participated in the online call-to-entry contest. This book grew that much more robust as a result of your creativity.

Winning participants are as follows:

Markus Aspacher, Eric Beitle, Tobias Buckdahn, Elliott Feldman, Tyler Halliwell, David Hensel, Maciej Kocot, Alexander Megerle, Mihai Marius Mihu, Günther Möbius, Matthew Oh, Dennis Qiu, Tom Remy, Brian Rinker, Kosmas Santosa, Timothy Schwalfenberg, David Alexander Smith, Ian Spacek, Michael Steindl, Lauchlan Toal, Aaron Van Cleave, and Lukasz Wiktorowicz

Chris McVeigh
My First TV 2013 (~150 pieces)

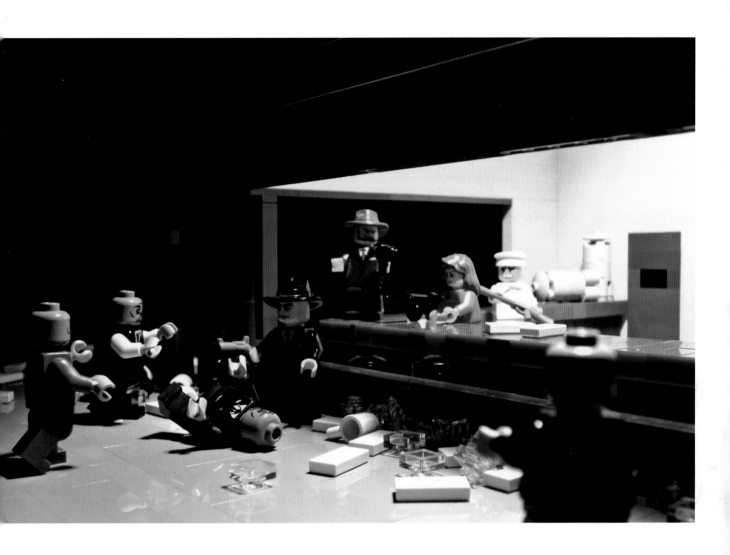

Alex Eylar
Nighthawks of the Living Dead 2010

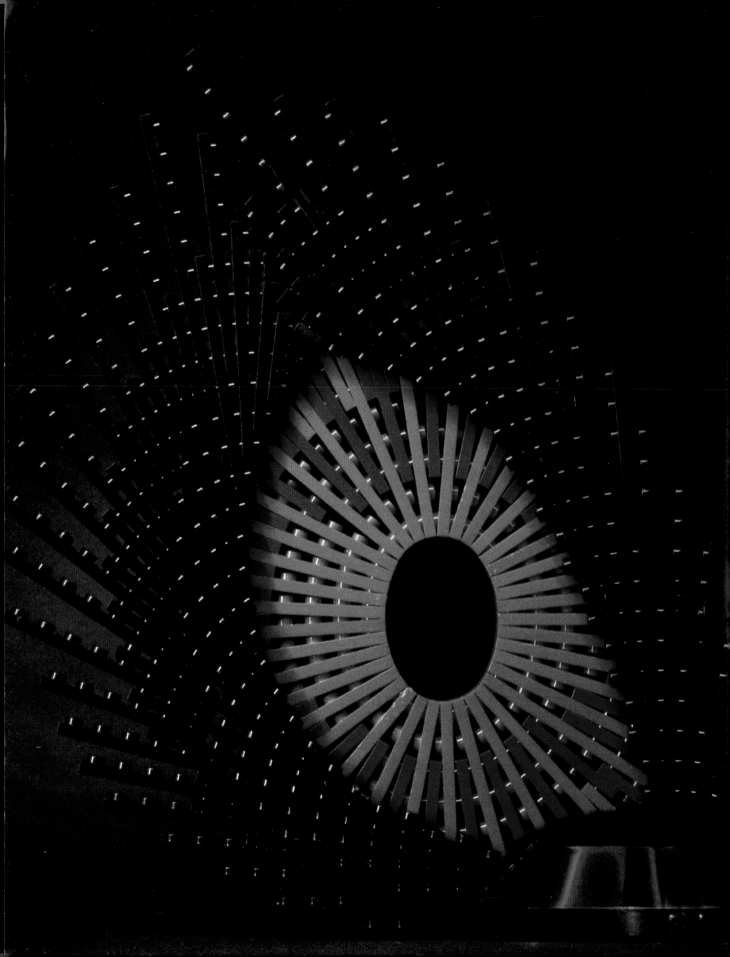

Contents

Tobias Buckdahn
Watch Out! 2013 (~250 pieces)

Contents

Thorsten Bonsch
The Hall of Prophecy (Harry Potter) 2013 (~5000 pieces)

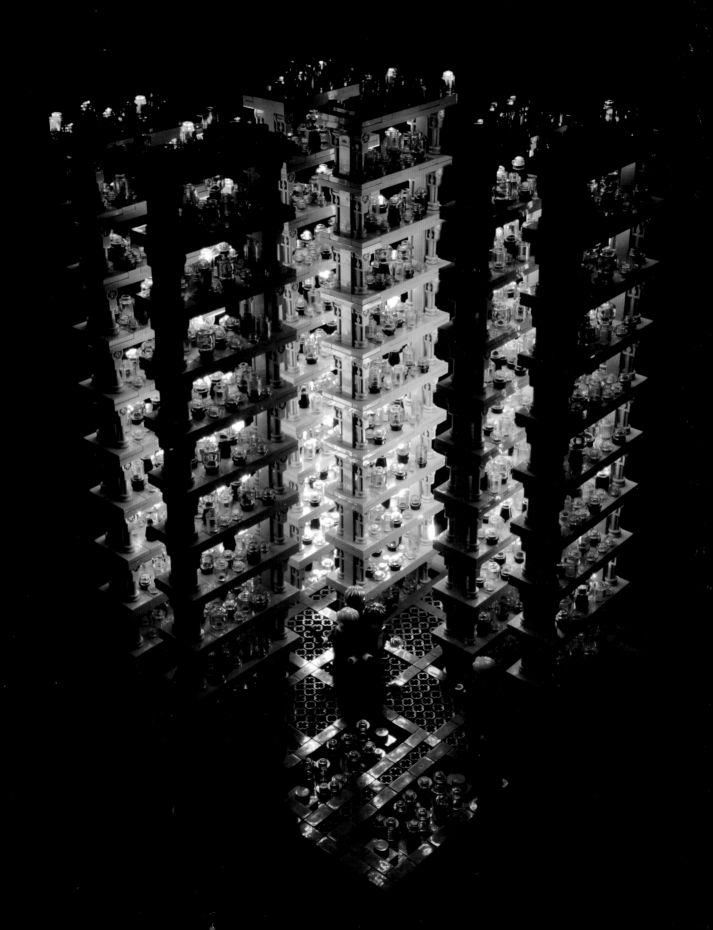

Preface

The second volume of *Beautiful LEGO* introduces a thematic filter to the curating process: Dark. I chose this theme because it seemed to represent a great number of works already coming out of the LEGO community. You'll see destructive objects, like warships and mecha, and dangerous and creepy animals; there is no shortage of material. The dark fantasies of dragons, zombies, and spooks have real-world counterparts: the unrestrained greed of bankers and financiers, the blind pollution of corporate zombies, and the fear and destruction spread by military spooks.

Dark has its light side, though. In the richness of chocolate and the thrill of the unknown, darkness can delight. And the interplay between darkness and light can have a powerful effect, as seen in David Alexander Smith's brightly backlit silhouettes.

I am pleased to show you even more models—from a larger and more diverse group of individuals—in this volume. With builders from the US, Canada, UK, France, Germany, Eastern Europe, China, Japan, Korea, Russia and more, we see just how global the LEGO community is.

In *Dark*, we also have a few representations of digitally rendered models. I have no doubt that this will be a controversial decision, but some of these works were simply too compelling not to include. Building digitally broadens the playing field of creativity, letting those without access to expensive LEGO pieces build impressive works. On the other hand, digital models do not have to contend with gravity, which is a serious consideration when building with real bricks. Ultimately, I found these digital pieces compelling enough to share with you.

The process of selection is a very subjective one. Clever parts usage, overall beauty, thematic appropriateness, and interesting color combinations are some of the things I look for. Unfortunately, many excellent works did not make it into this book, most often because of an inability to contact the builder.

I hope that this volume continues to inspire and delight you!

Riccardo Zangelmi
The Divine Comedy: Hell 2011

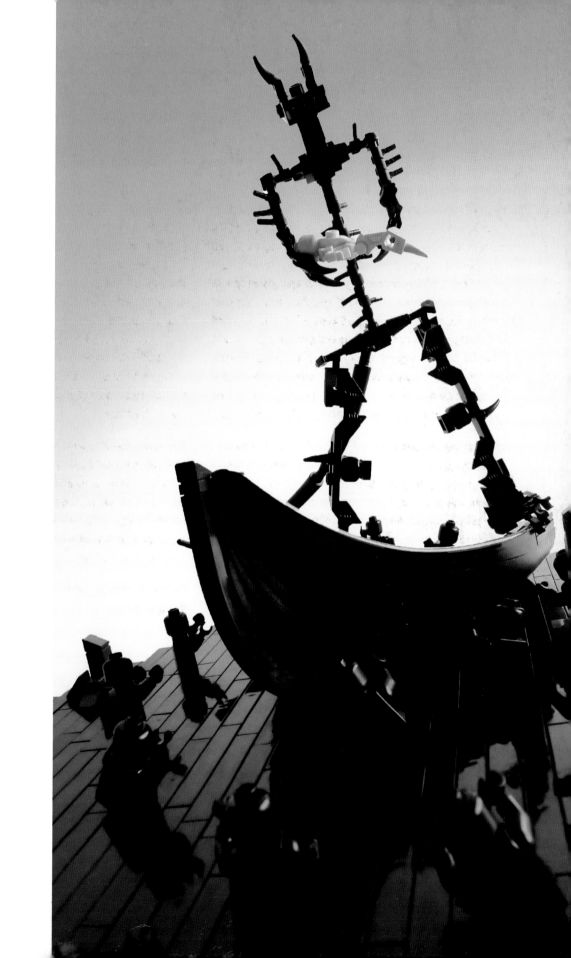

Bart De Dobbelaer

LEGO has been in my life since my early years. I was five when I got my first set (Space Digger #6822) and ever since, I've been hooked. As a young man, I gathered almost every Classic Space set, I dabbled a little in the Castle theme and ended with Technic. When the first computer hit our home, the LEGO got shelved in the attic. And so my Dark Ages began. Cue college, university, studying, meeting my wife, having kids, and even buying some LEGO for the little ones. Suddenly it's 2010 and the first Atlantis sets hit the shelves. I see the Gateway of the Squid set, and I find myself hooked again. Majorly hooked.

Why LEGO? Simple: it opens up a world of possibilities, with the only limitation being your own imagination. I often think I can never have enough bricks, but luckily I don't lack imagination or inspiration. I prefer to work directly from my mind and give my ideas free reign. I start with a broad idea of something I want to build and some colors to use, and the rest follows—not a stream of consciousness but a stream of building. More often than not, the original idea gets warped or even abandoned halfway through the construction process. I allow both the story and structure of each piece to unfold, change, jump, and surprise me—not because I planned every step, but because that's where where I allow it to take me.

Why LEGO? Bricks connect but people too. When I got out of my Dark Ages, I was simply amazed by the existing community. During my younger years, LEGO was a plaything, something to do on a rainy day. Occasionally I created something cool, and Mom would take a picture. Friends would come over to play and build, but that was all. Now, with a single click, thousands of people can see your creation and comment on it. There are forums to discuss techniques, groups to share themed creations, challenges and competitions, and even online shops with a never-ending supply of parts. There are so many ways to connect with fellow builders and make new friends.

For me, this is really a game changer: The creations I imagine can be shared all over the world, for everyone to see and to enjoy.

Why LEGO? Why not!

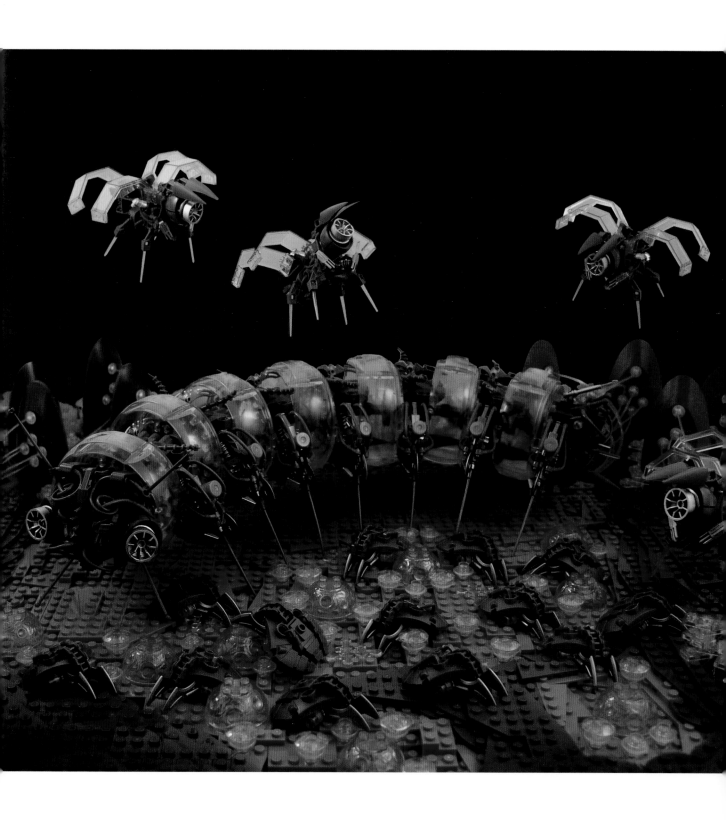

Hatchery 2013 (8000+ pieces)

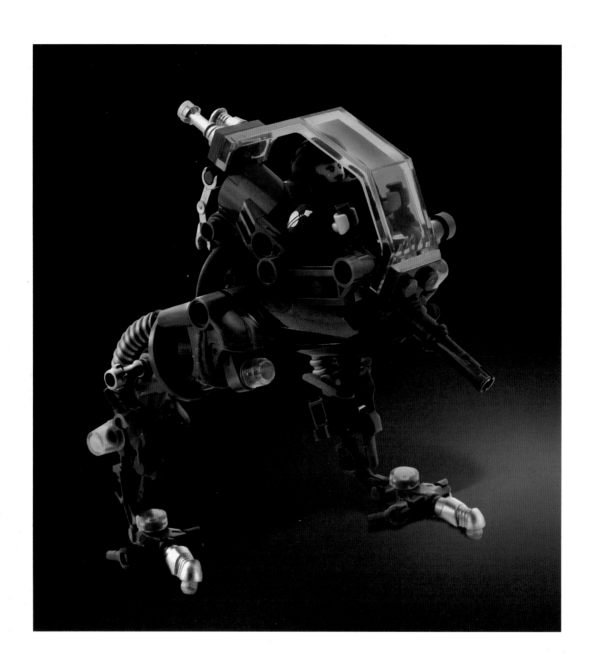

Chicken Walker 2013 (~70 pieces)

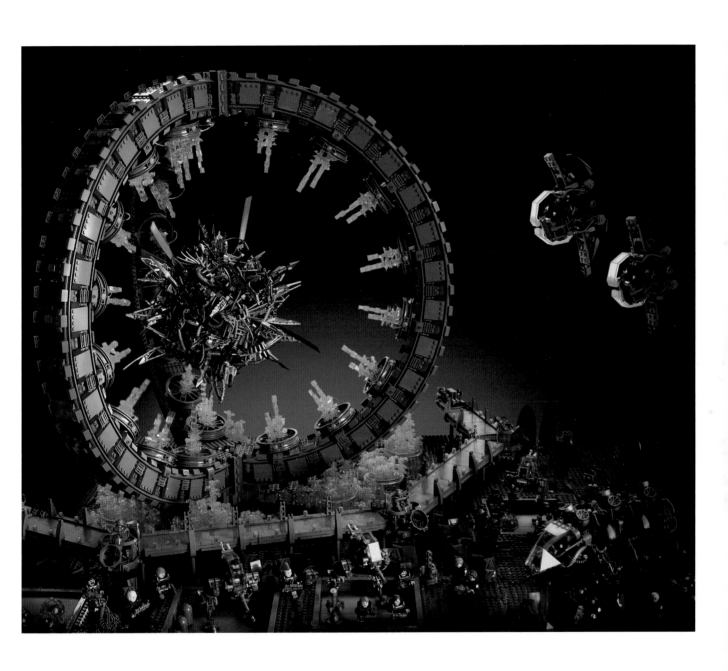

Deployment 2013 (40,000+ pieces)

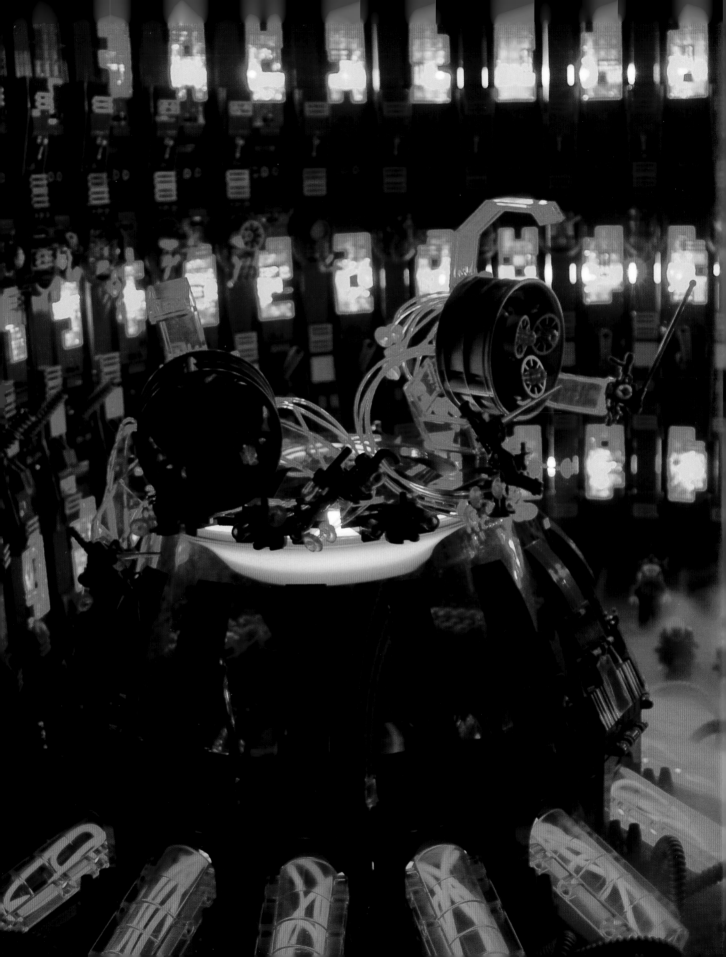

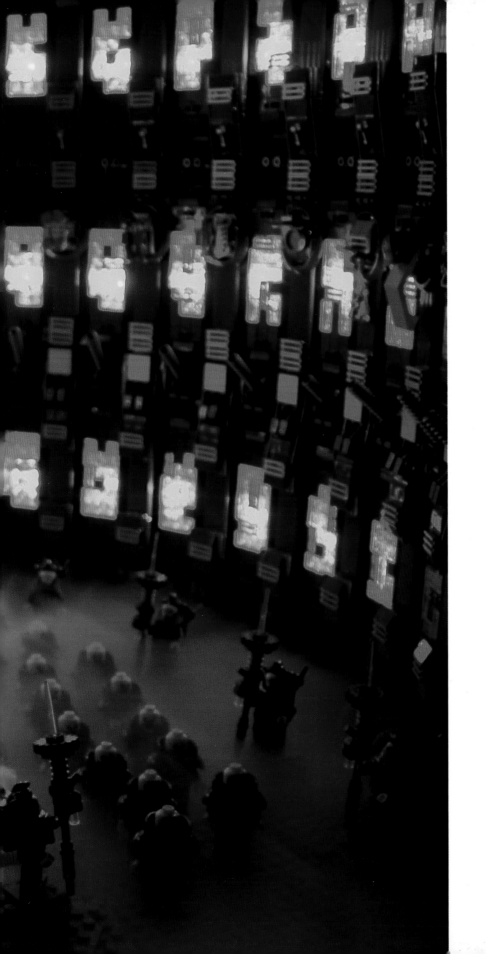

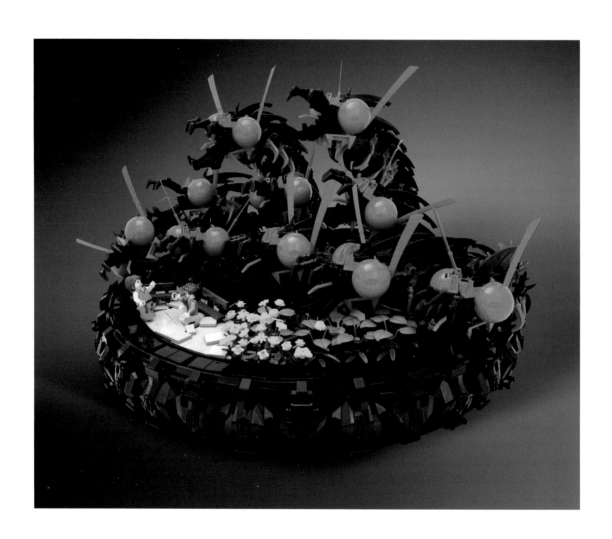

(previous spread) Control 2012 (20,000+ pieces)

(above) The Proposal 2013 (10,000+ pieces)

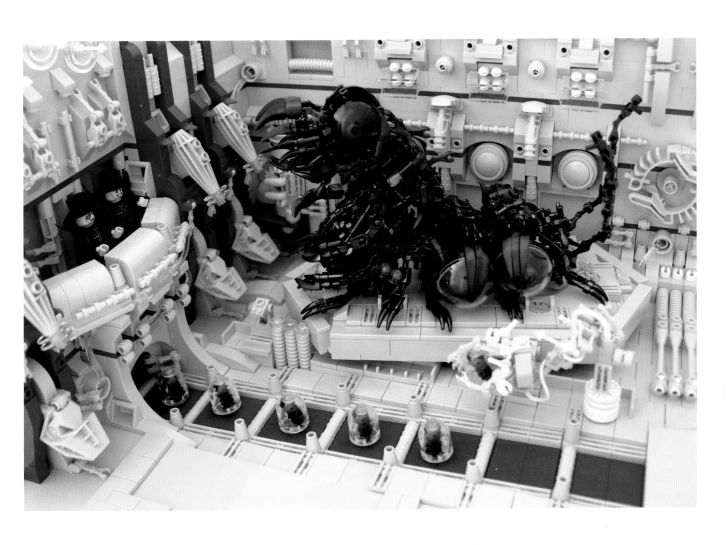

Alien Queen 2011 (6000 pieces)

Creepy Crawlers

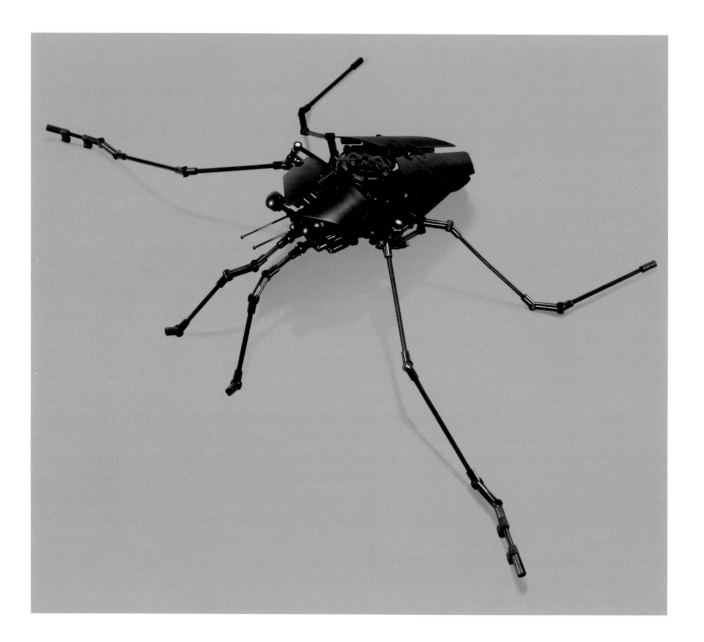

Stephan Froden
Technic Water Strider 2012 (277 pieces)

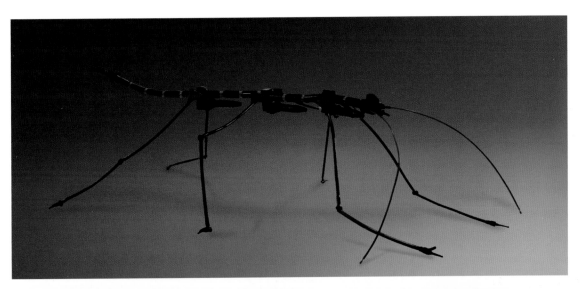

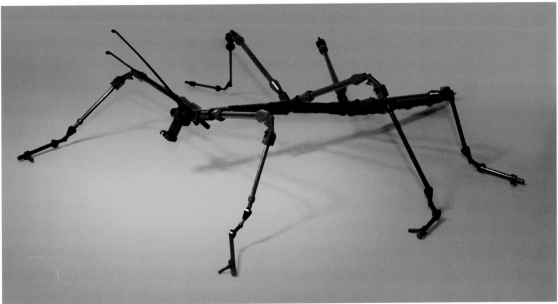

(top)
Jordan Robert Schwartz
Phasmatodea 2009 (150+ pieces)

(bottom)
Sean and Steph Mayo
Walking Stick 2013

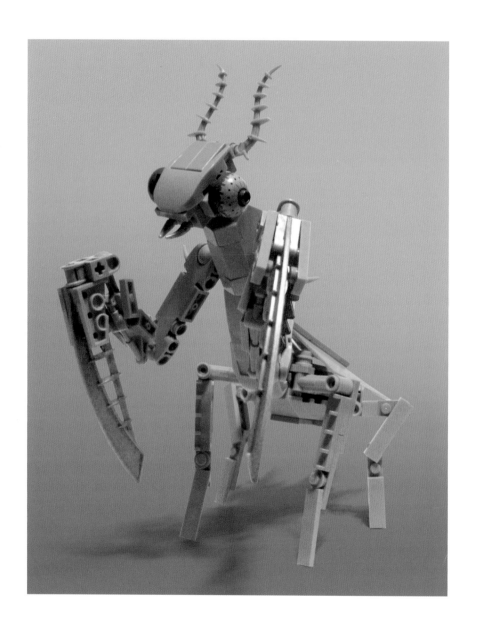

Andrew Lee
Mantis Style 2013

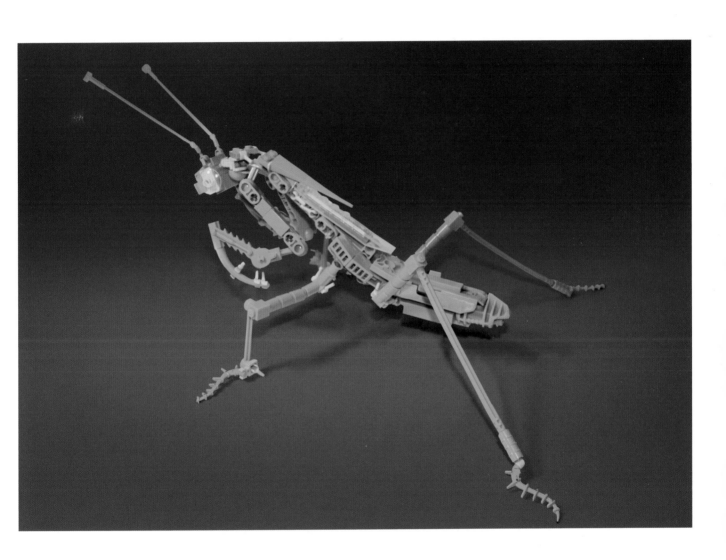

Sean and Steph Mayo
Praying Mantis 2013

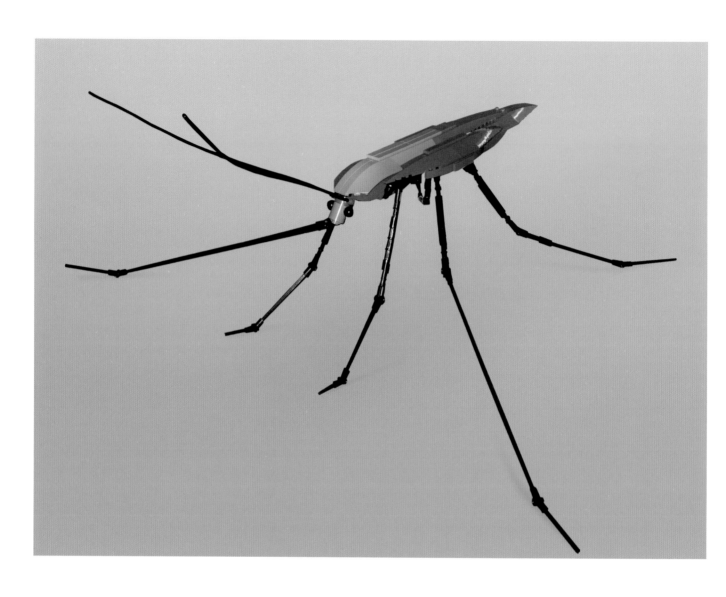

(above)
Jason Ruff
Gerridae – Water Strider 2010 (170 pieces)

(opposite top)
Bartosz Kacprzyk
House Fly – Musca Domestica 2012 (~50 pieces)

(opposite bottom)
Matthew Martin
Scum Sucker 2013 (74 pieces)

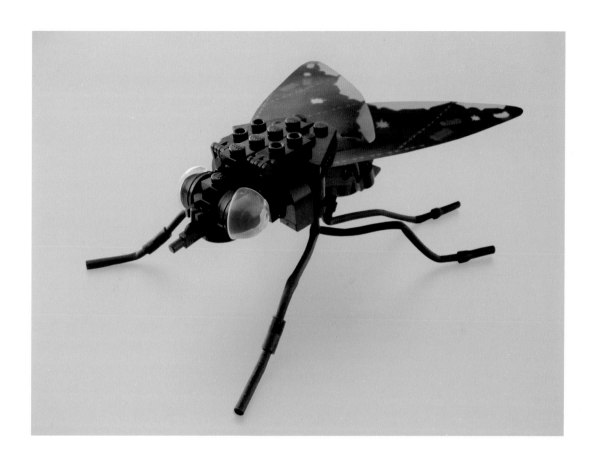

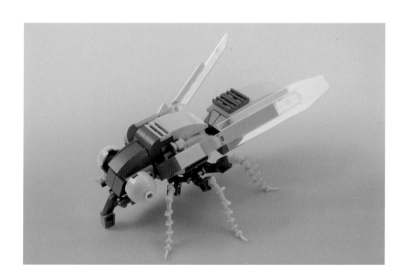

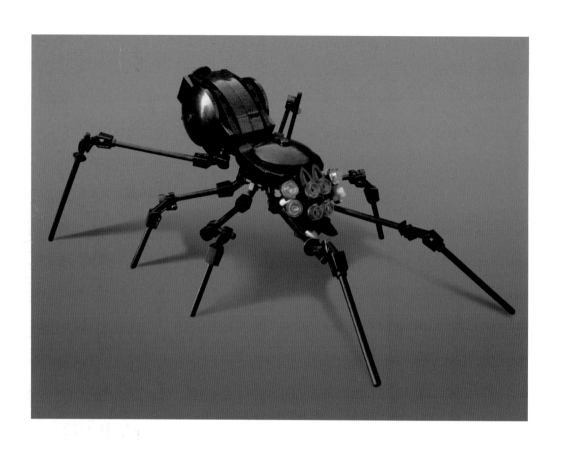

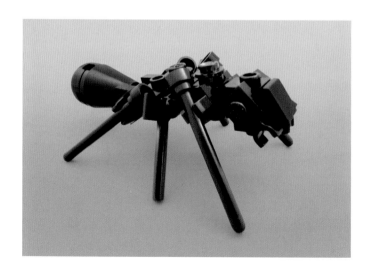

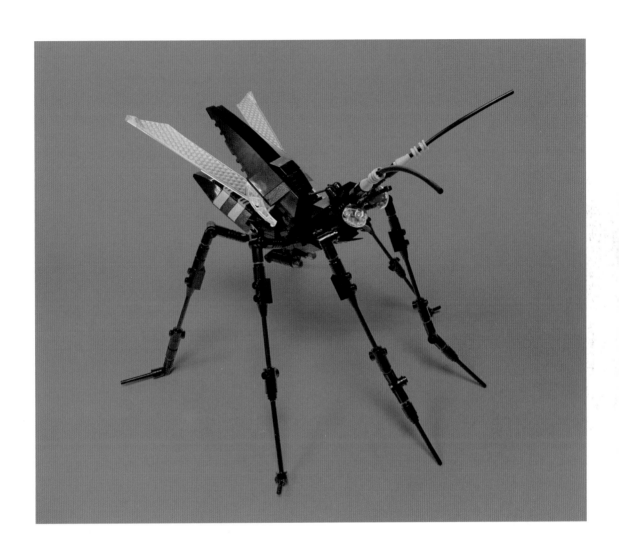

(opposite top)
Cole Blaq
Blaq Widow 2009

(opposite bottom)
Bartosz Kacprzyk
Ant 2009 (24 pieces)

(above)
Bidea
Cerambycidae 2012 (-160 pieces)

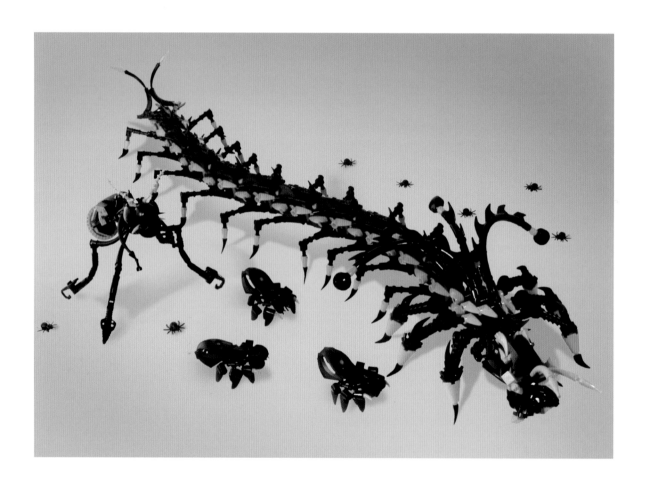

Nicolaas Vás
Entomophobics 2013

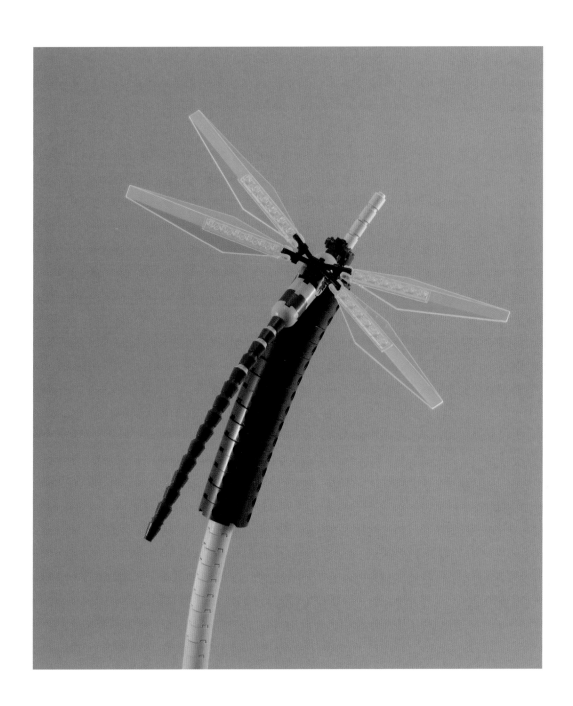

Chris Maddison
Dragonfly 2013 (90)

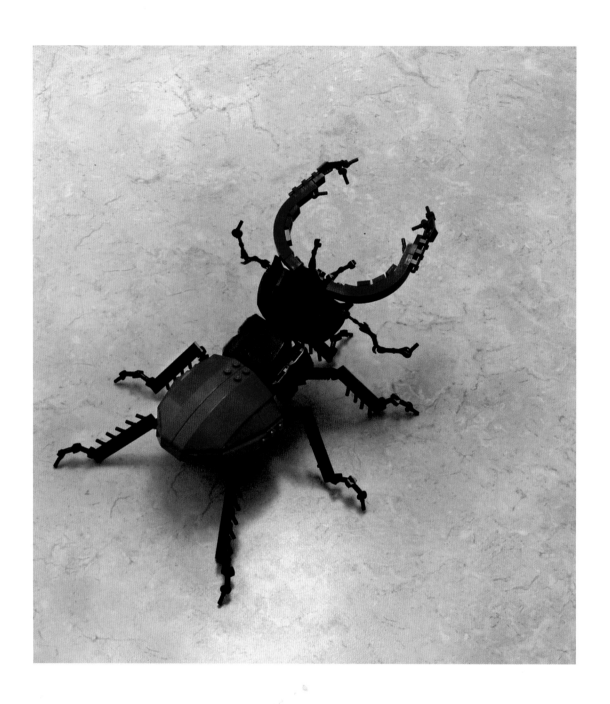

(above)
Tyler Clites
Stag Beetle – Albrecht Dürer 2011

(opposite top)
Paul Trach
Shelob 2013 (~300 pieces)

(opposite bottom)
Lino Martins
Dung Beetles 2009 (~600 pieces)

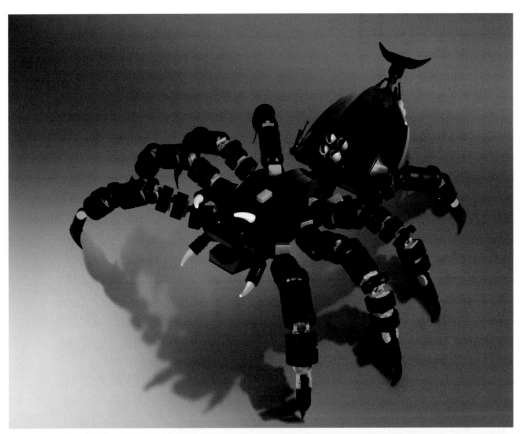

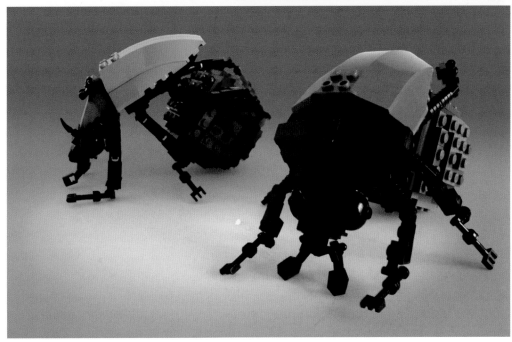

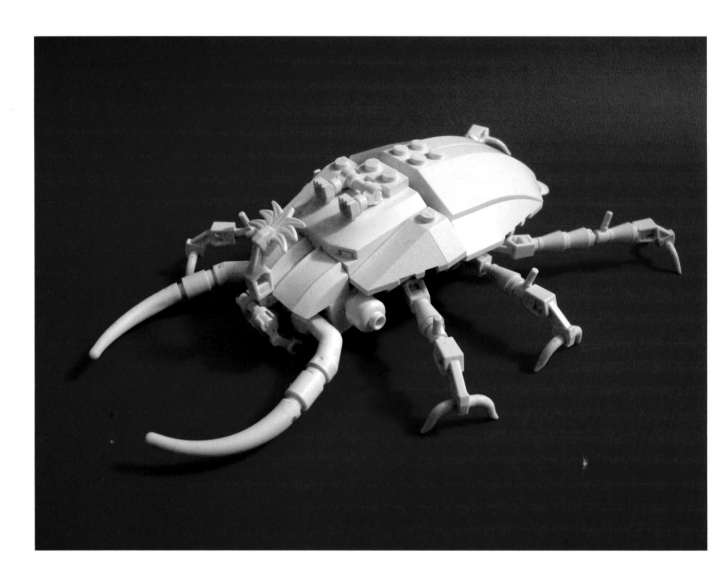

Lino Martins
White Beetle 2010 (~200 pieces)

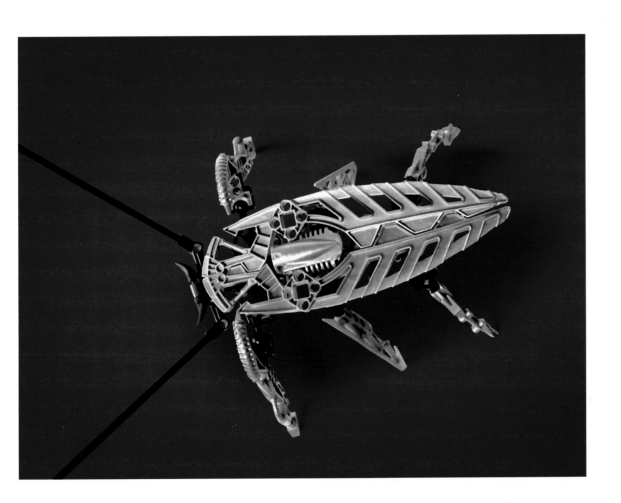

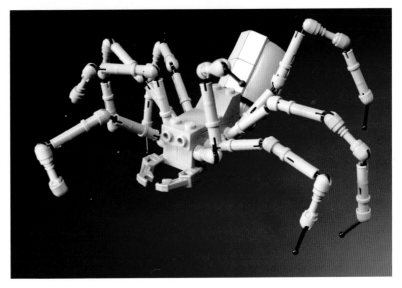

Matt Armstrong

(top) **Step on That!** 2013 (25–35 pieces)
(bottom) No... Lil Miss Muffet Lives Down the Street 2013 (~100 pieces)

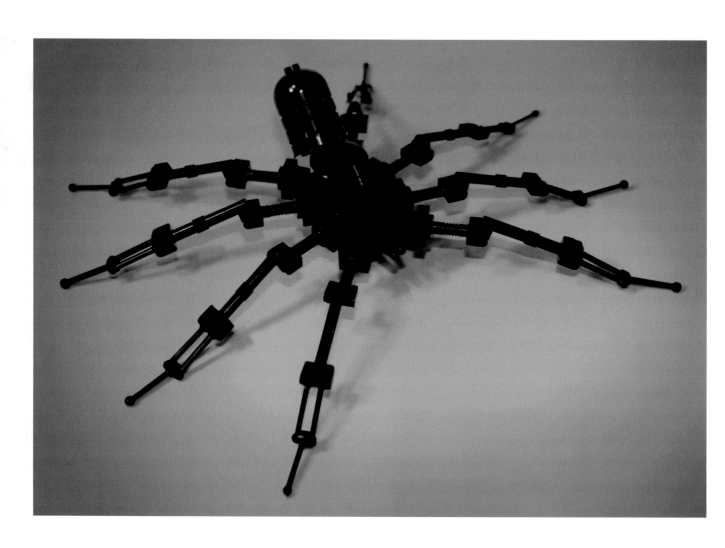

Sean and Steph Mayo
Black Wolf Spider 2013

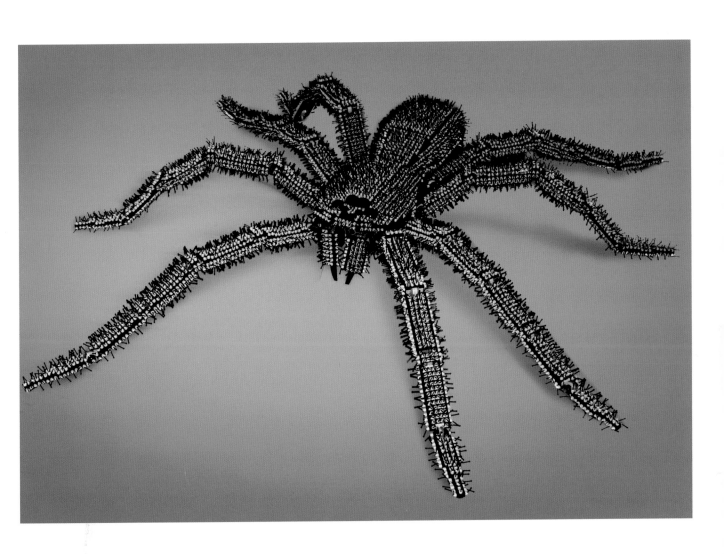

Jason Ruff
Big Hairy Spider 2010 (~9000 pieces / 7500 levers)

Biomimicry

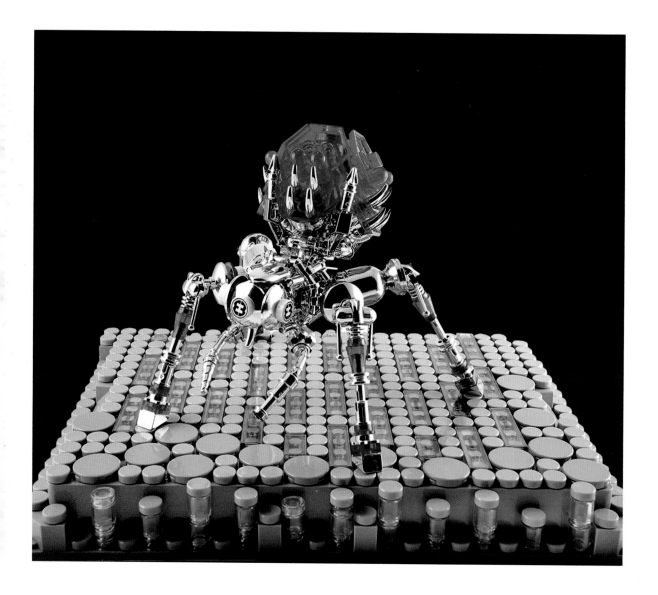

Vinny Paver
Kromikoma 2014 (~450 pieces)

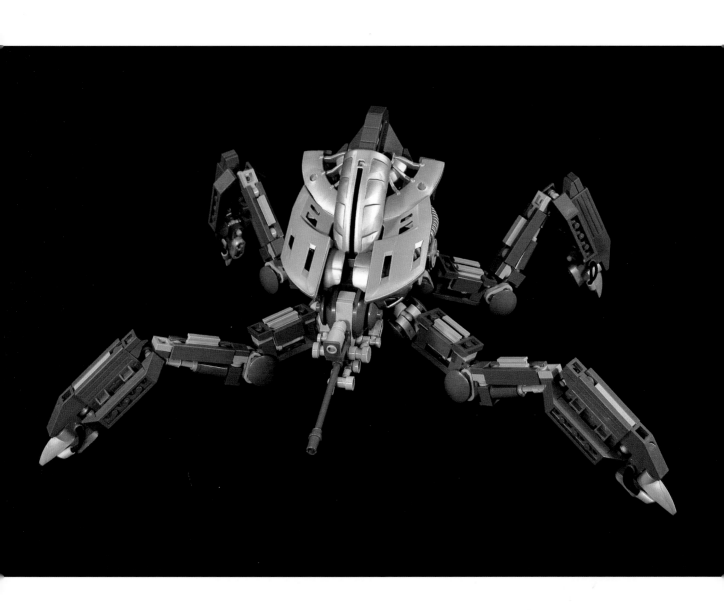

Brian Kescenovitz
UM-7 NAILHEAD Combat Frame 2012 (~400 pieces)

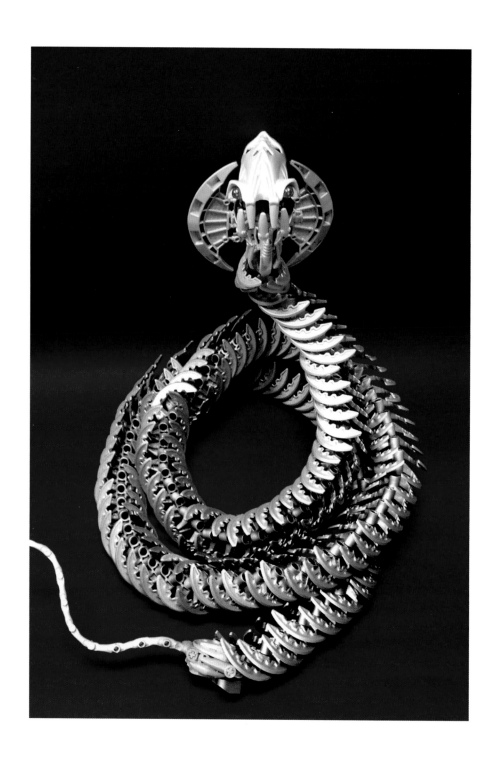

Matt Armstrong
Danger Danger! 2009 (~500 pieces)

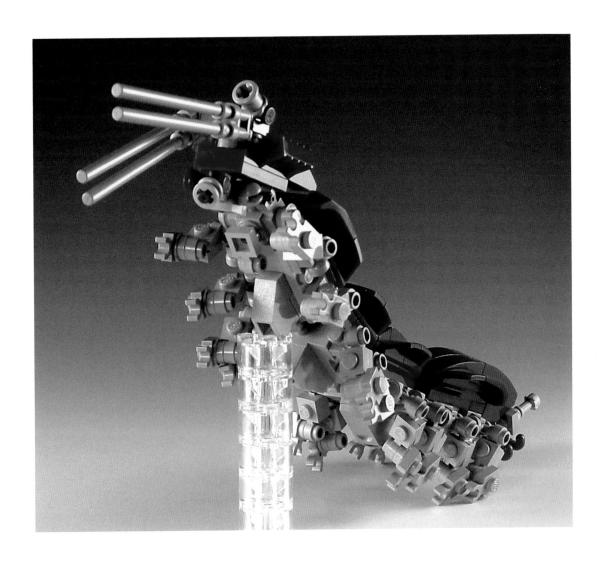

Izo Yoshimura
Tiny Multiped 2012

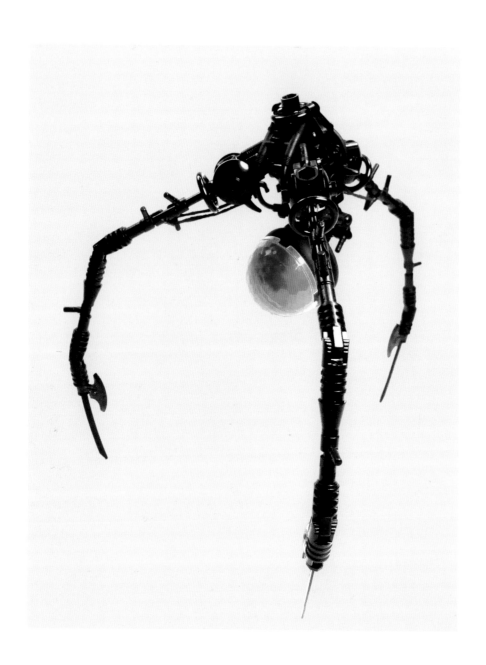

Kevin Fedde
Ethereal Wanderer 2009 (150 pieces)

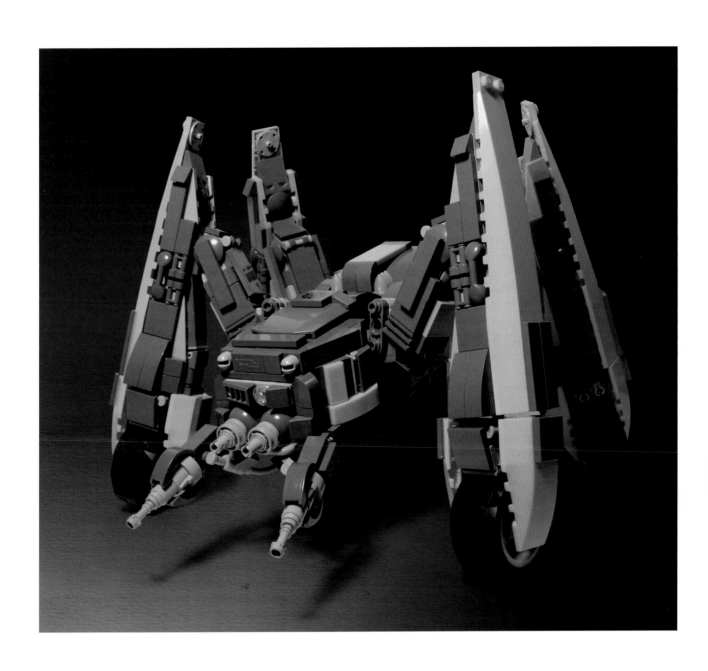

Vincent Gachod
Spider-Mecha 2010

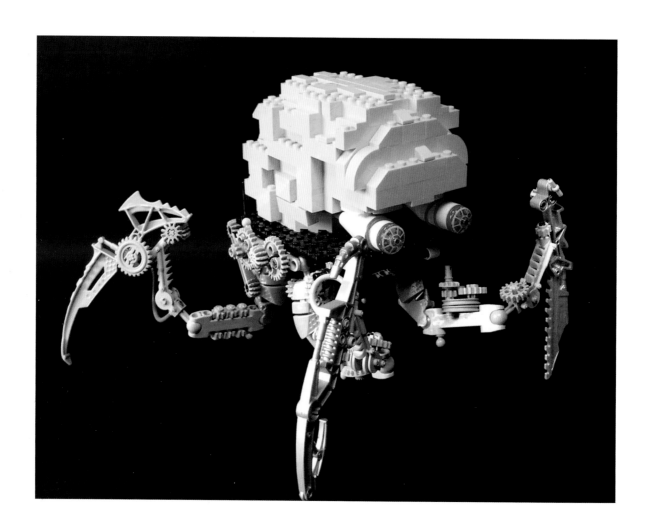

Matt Armstrong
This Is My Brain on LEGO 2013 (300–350 pieces)

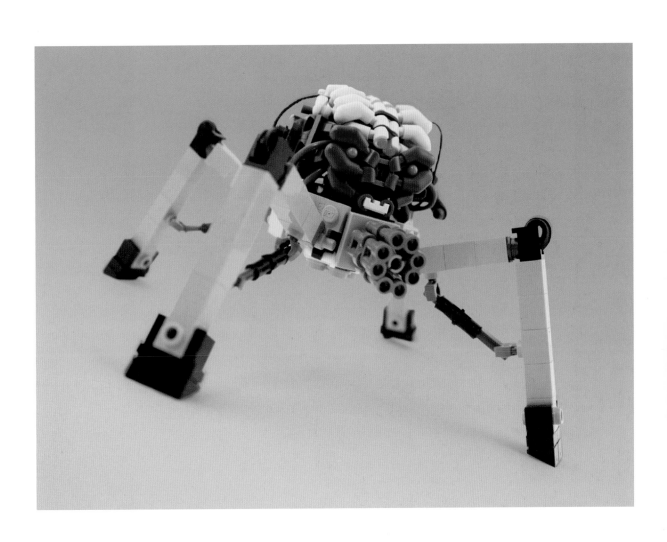

Jarek Książczyk
Doom Spiderdemon 2013 (~200 pieces)

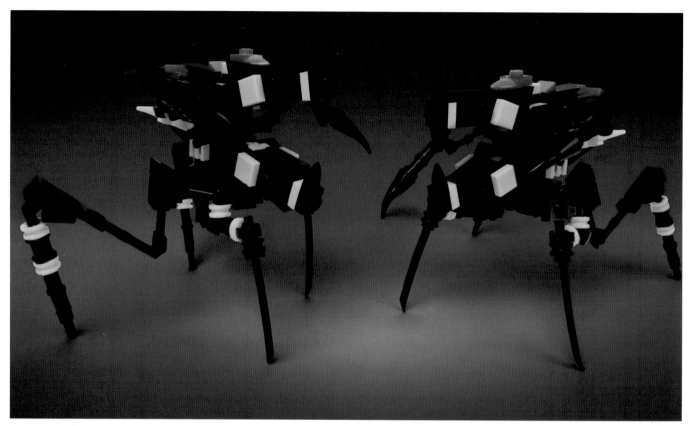

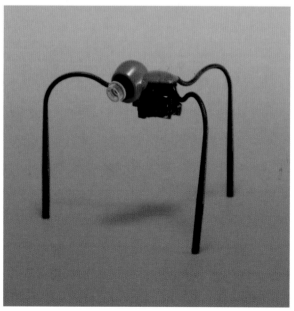

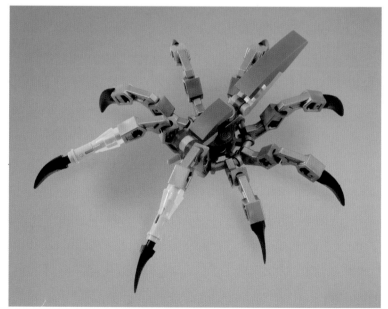

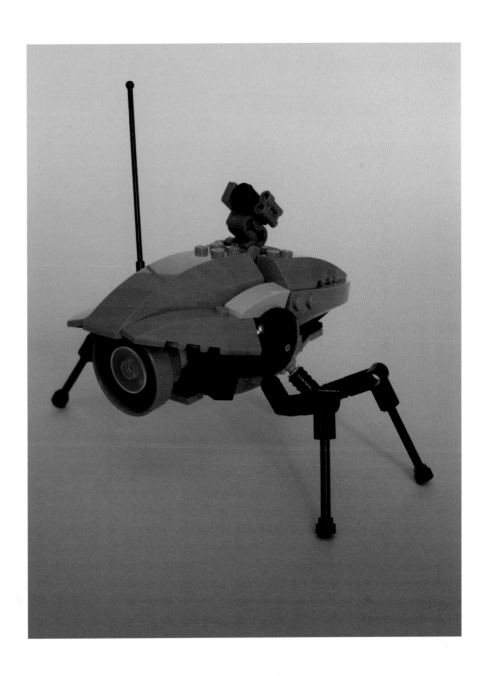

(opposite top)
Tim Goddard
Bug Warriors 2013

(opposite left)
Mike Nieves
ha-DES 2011 (12 pieces)

(opposite right)
Matthew Martin
Mechluse 2013 (~40 pieces)

(above)
Djordje Dobrosavljevic
Scuttle 2014 (~250 pieces)

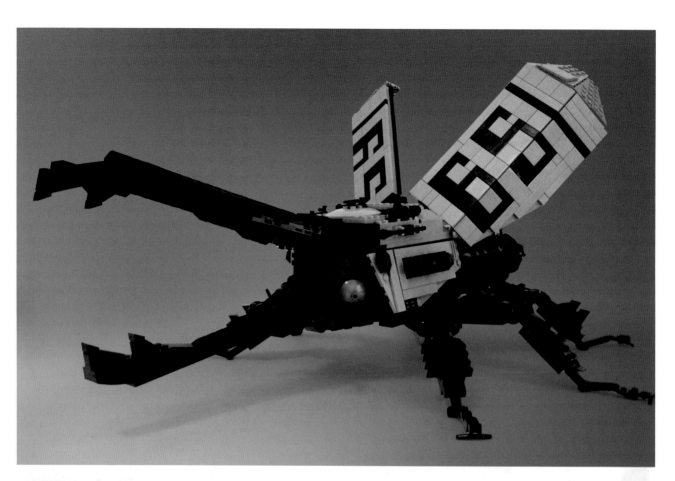
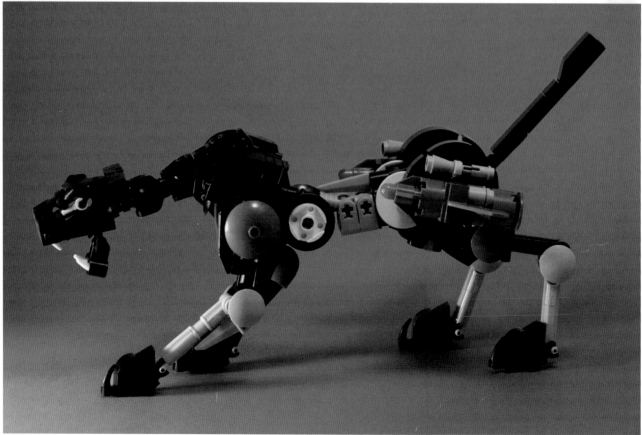

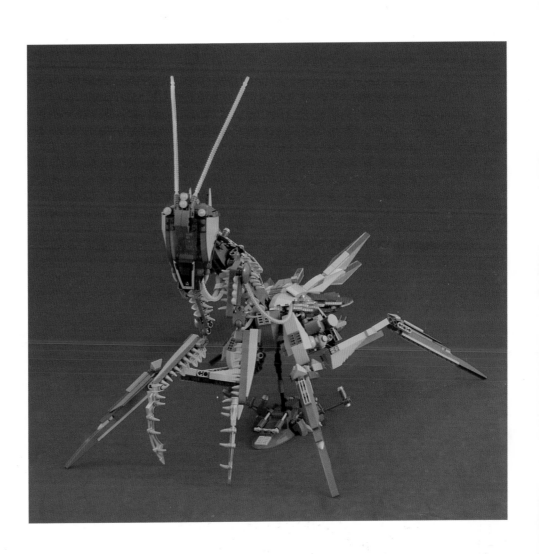

(opposite top)
Lino Martins
Juggernaut 2009 (~2200 pieces)

(opposite bottom)
Mike Nieves
Ravage 2011 (~200 pieces)

(above)
Matthew Martin
Mantis Mech 2013 (~1120 pieces)

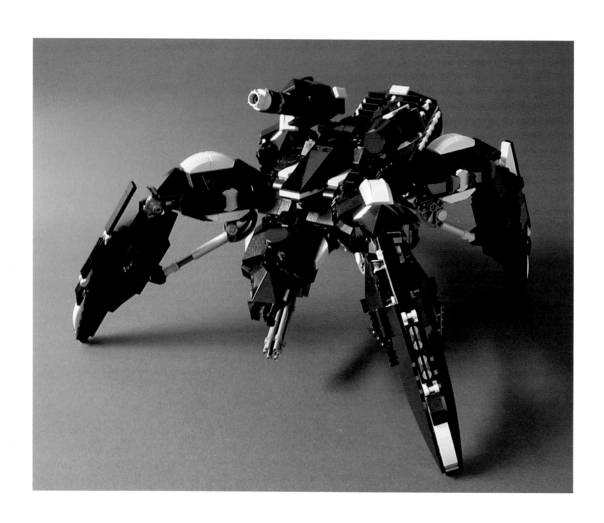

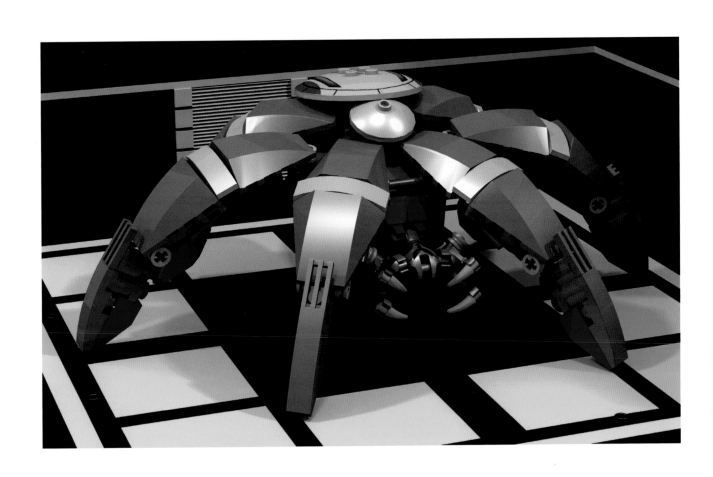

(opposite)
Ryuhei Kawai
LTW-006 GOTHICA 2009 (~1000 pieces)

(above)
Borisov Igor
Arachnicoma [digital render] 2013 (279 pieces)

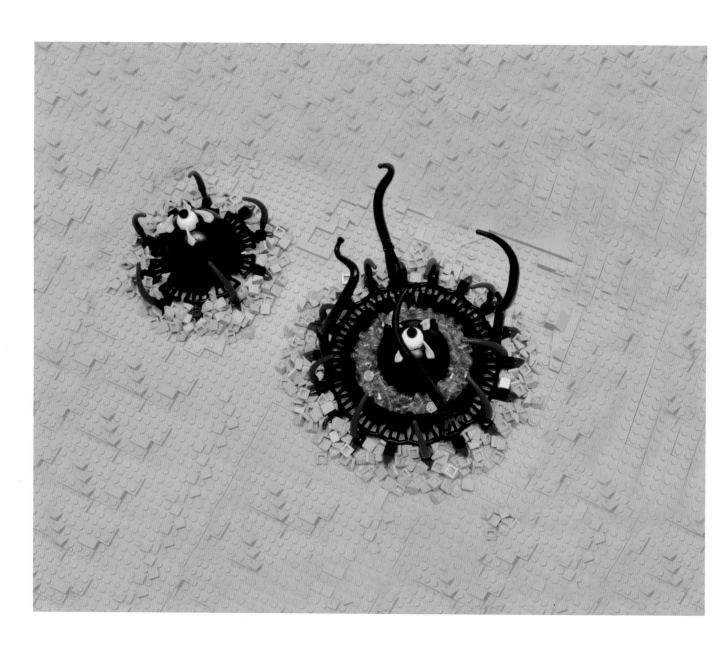

Gilcélio de Souza Chagas
Desert Kraken 2013 (~1200 pieces)

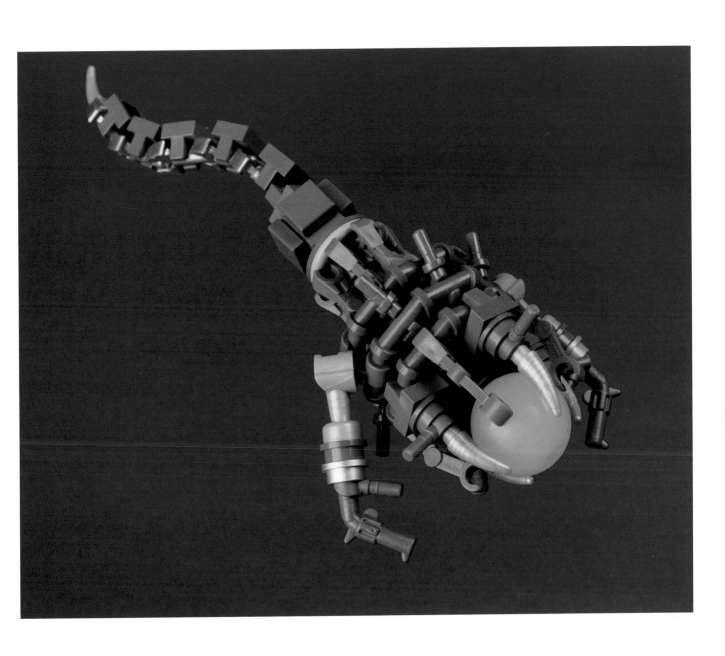

Peter Reid
Space Worm 2009 (42 pieces)

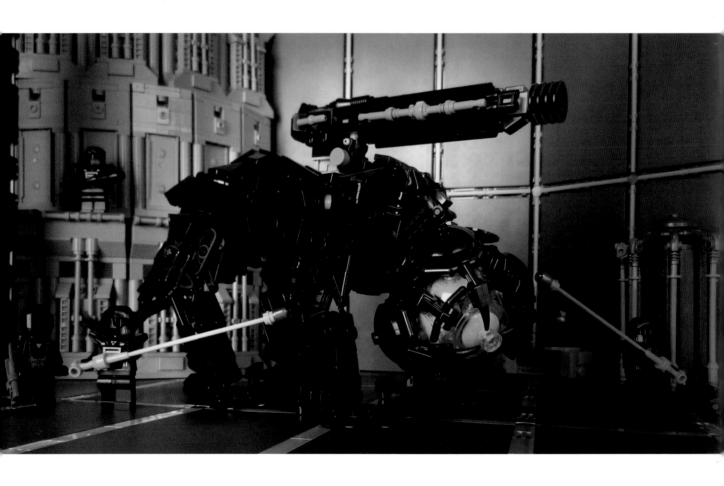

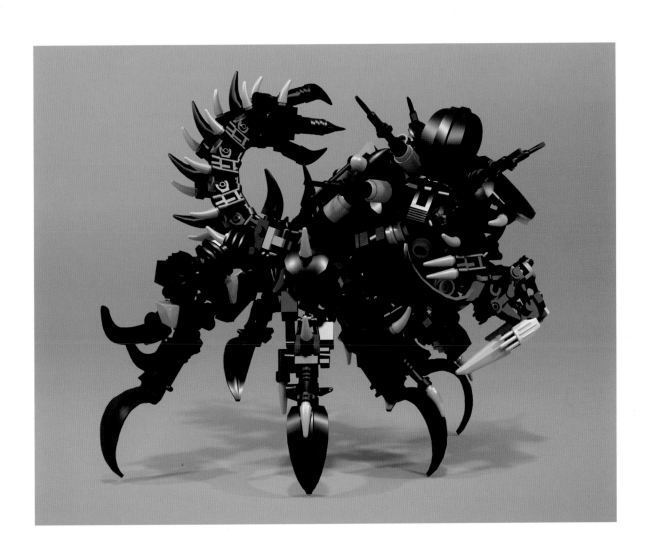

(opposite)
Tim Goddard
The Creature 2014

(above)
Borisov Igor
Crusader Carver [digital render] 2013 (458 pieces)

Warships

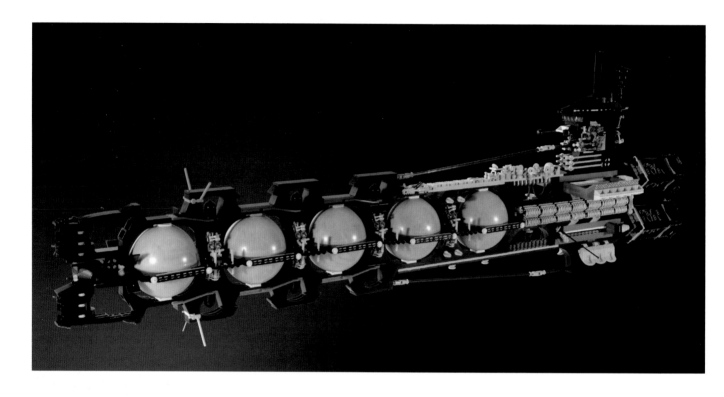

Fabien Minard

(above) Le Milan Noir 2013
(opposite top) Paaliaq 2013
(opposite middle) Unknown 2013

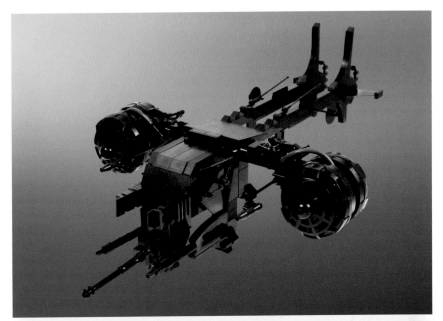

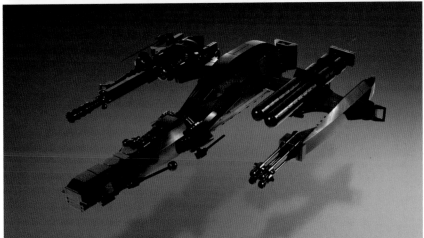

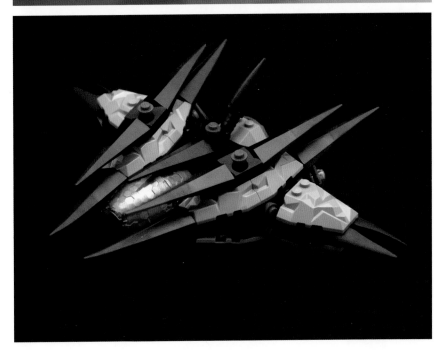

(bottom)
Tyler Clites
Thorn Viper 2013

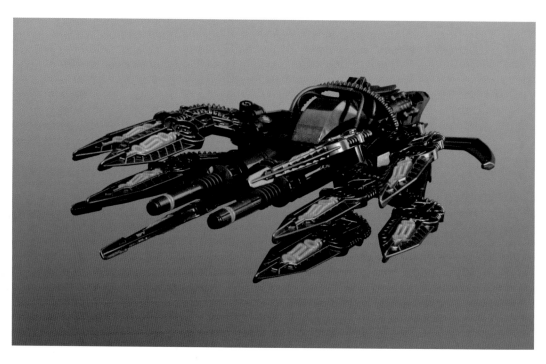

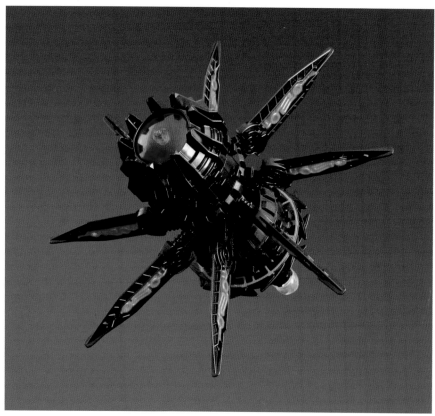

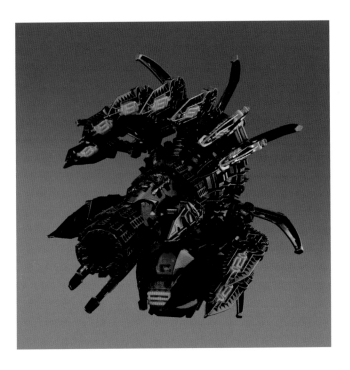

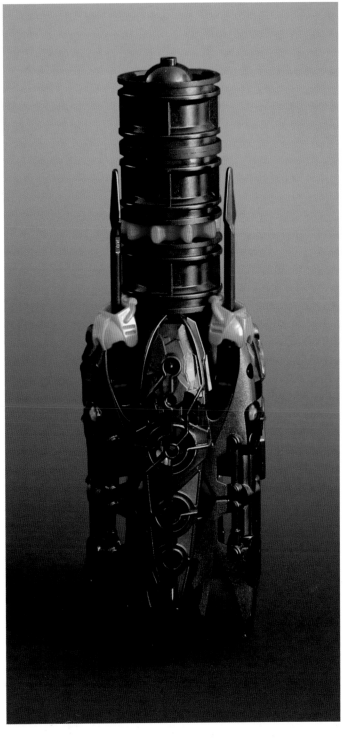

Justin Vaughn

(opposite top) Judas's Tongue 2009 (~200 pieces)
(opposite bottom) Fiend's Eye 2009 (30 pieces)
(left) Devil's Talon 2009 (~300 pieces)
(right) Chiron's Arrow 2009 (58 pieces)

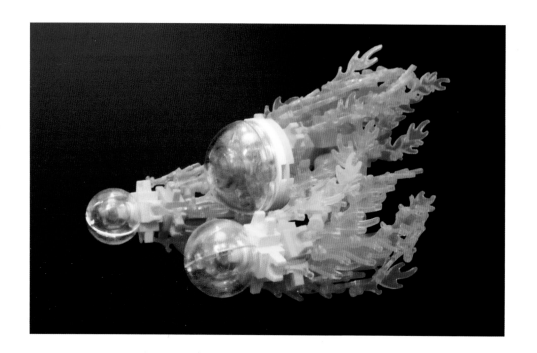

Cole Blaq
Phoenix 2010

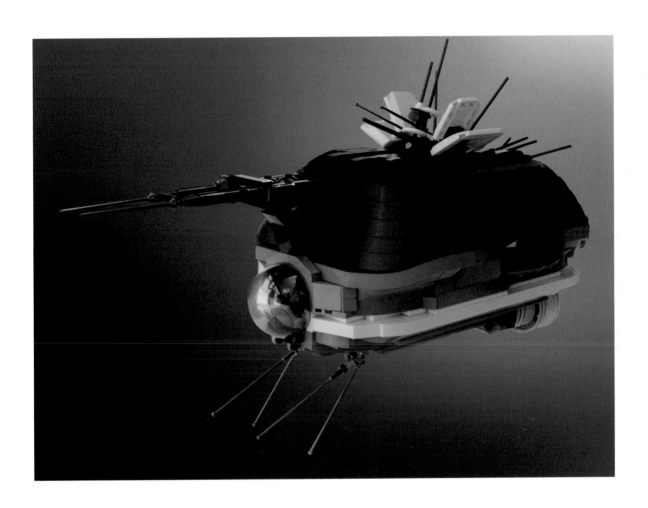

Vincent Gachod
BS-Transport 2011

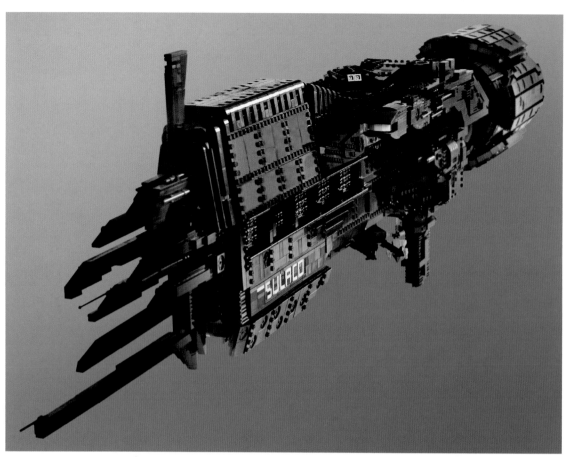

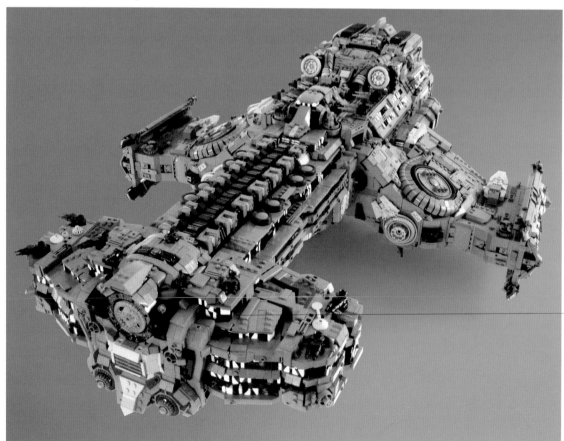

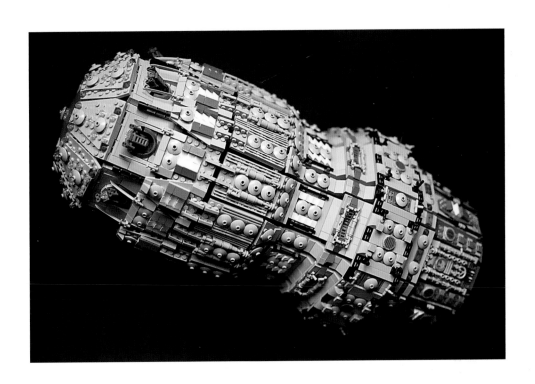

(opposite top)
Michael Steindl
USS Sulaco 2014 (9640 pieces)

(opposite bottom)
Sven Junga
Hyperion 2012 (~15,000 pieces)

(above)
Anton Fedin
Prometheus 2012 (~3000 pieces)

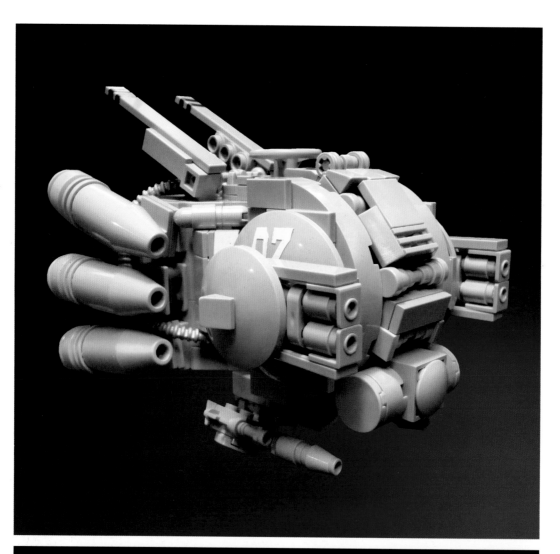

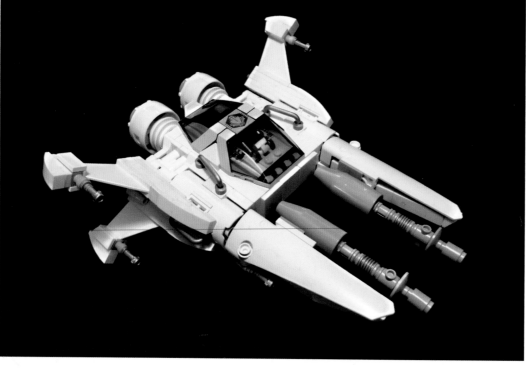

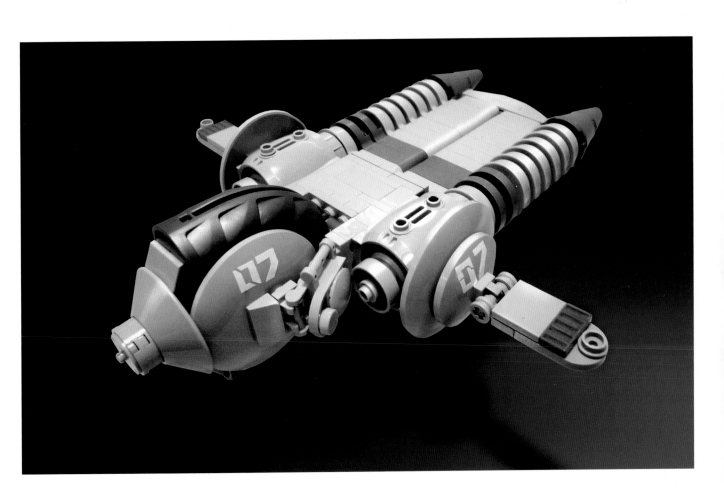

Nathan DeCastro

(opposite top) Flurry-class H-55 Charlie 2012 (~500 pieces)
(opposite bottom) X-S Kaishakunin 2012 (~270 pieces)
(above) NK-40 Lycan 2012 (~150 pieces)

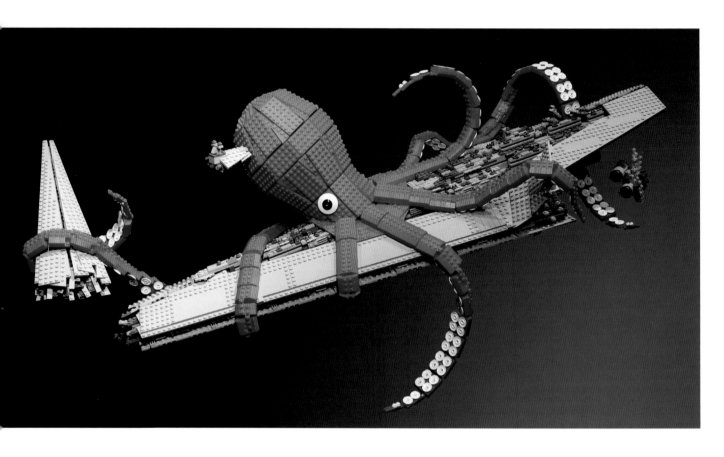

Iain Heath
Release the KR-KN! 2013

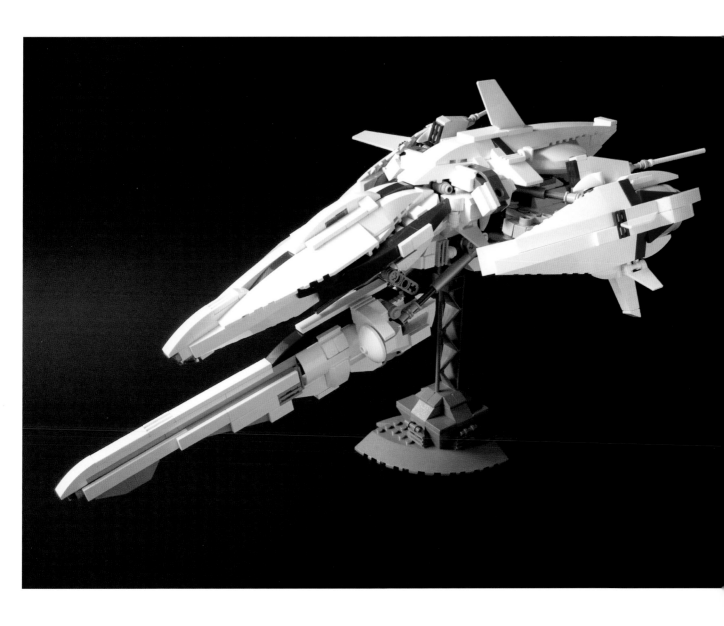

Ryuhei Kawai
LSF-006 Nalukami 2010

Transporterria

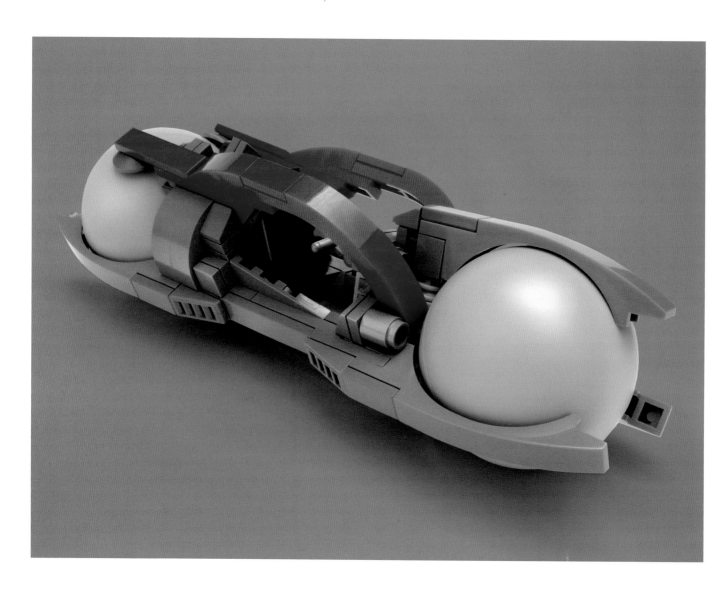

(above)
Vincent Gachod
SW-Bike 2011

(opposite top)
Sven Junga
R14 Bulldog 2009 (~500 pieces)

(opposite bottom)
Cole Blaq
Light Car 2012

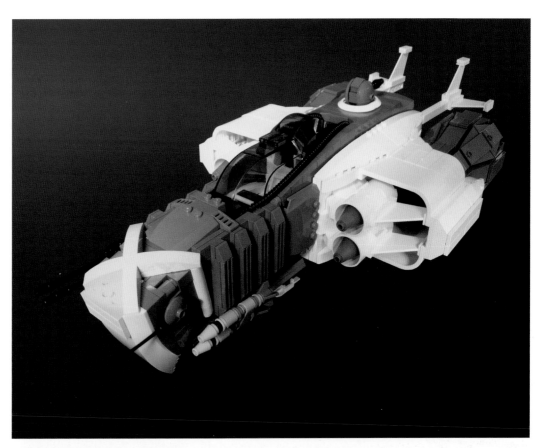

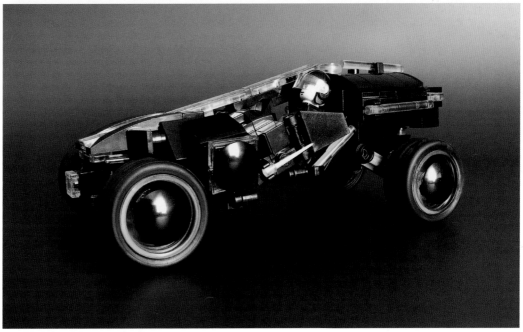

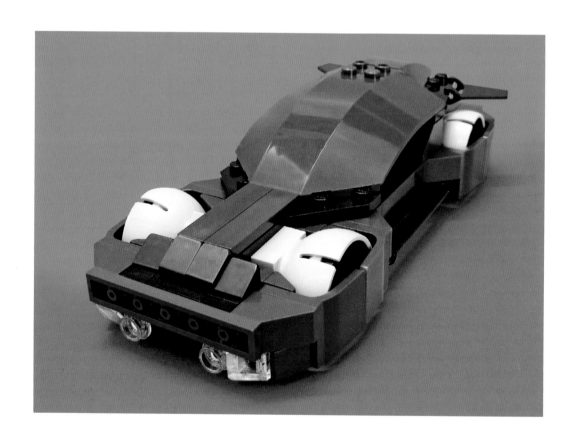

Cole Blaq
Hudson Cybird 2011

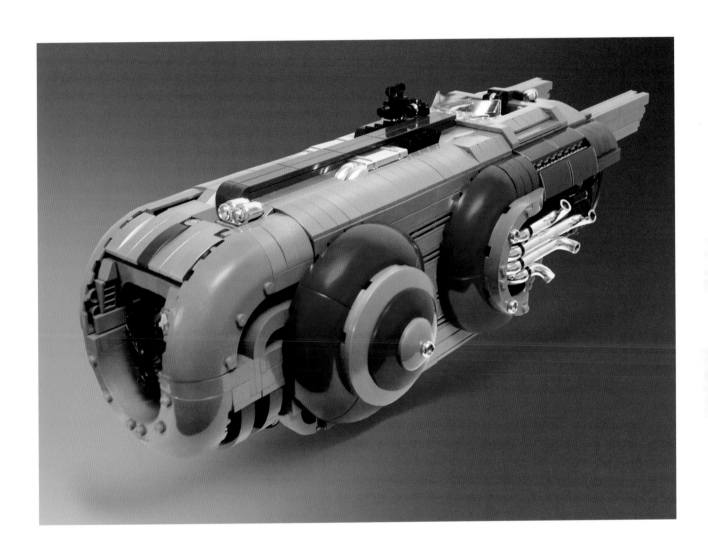

Vincent Gachod
Machine n°1 2013

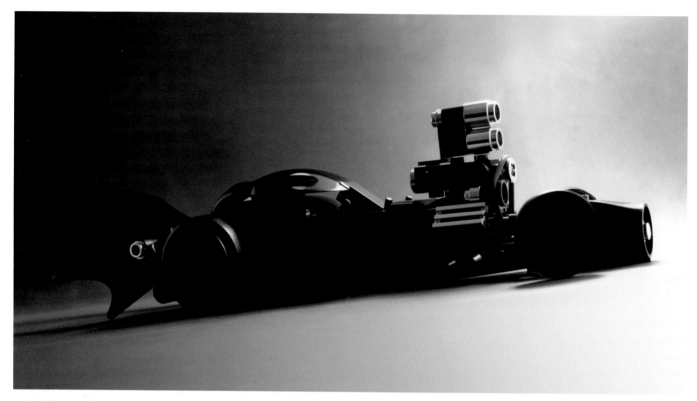

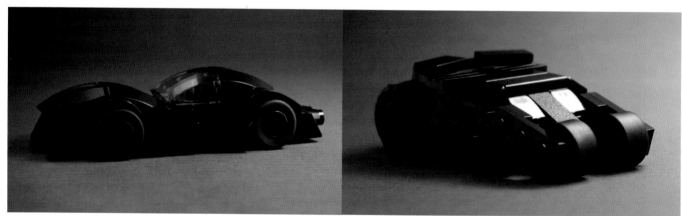

Călin Borş

(top) Batmobile – "The Rat" 2013
(left) Batmobile Noir 2012
(right) Batmobile – Mini Tumbler 2012

60

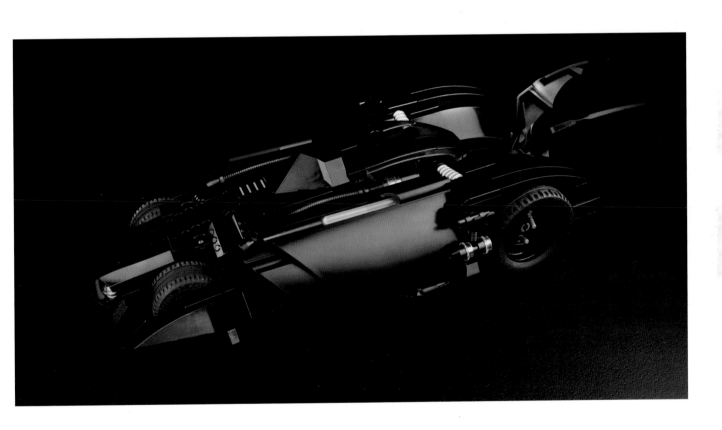

Lazlo Kissimon
Blk Shadow Batmobile 2012 (467 pieces)

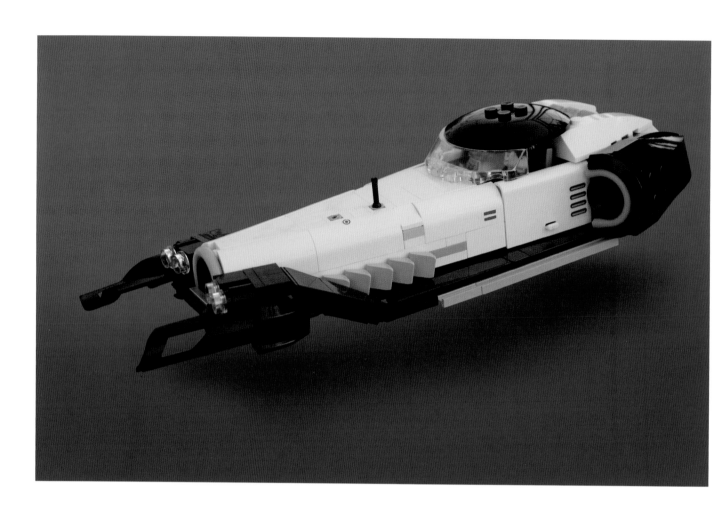

Jarek Książczyk
Antige-V Hovercar 2013 (~400 pieces)

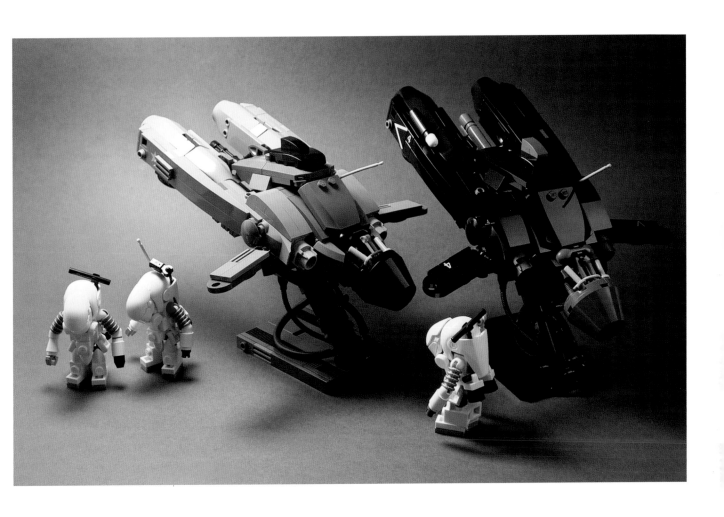

Călin Borș
(top) Maschinen Krieger – Pkf. 85 Falke 2013
(bottom) Trabant 6001 TurboJet 2013

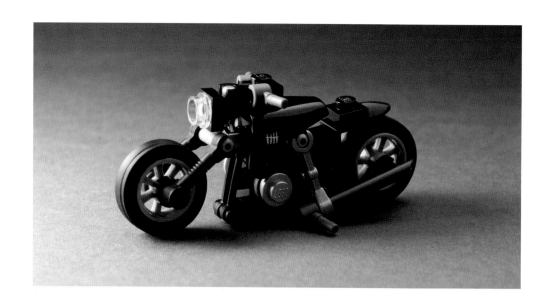

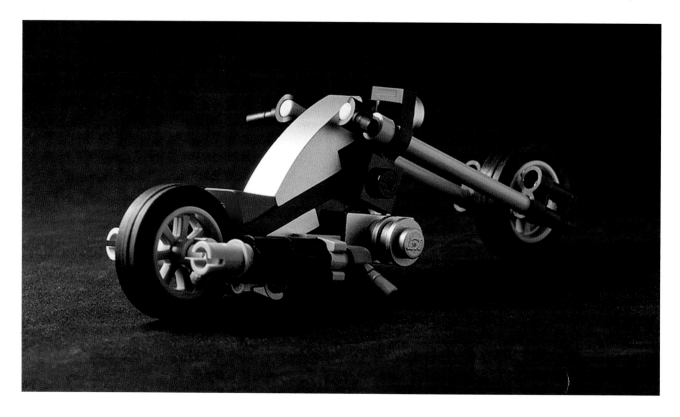

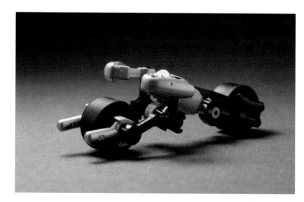

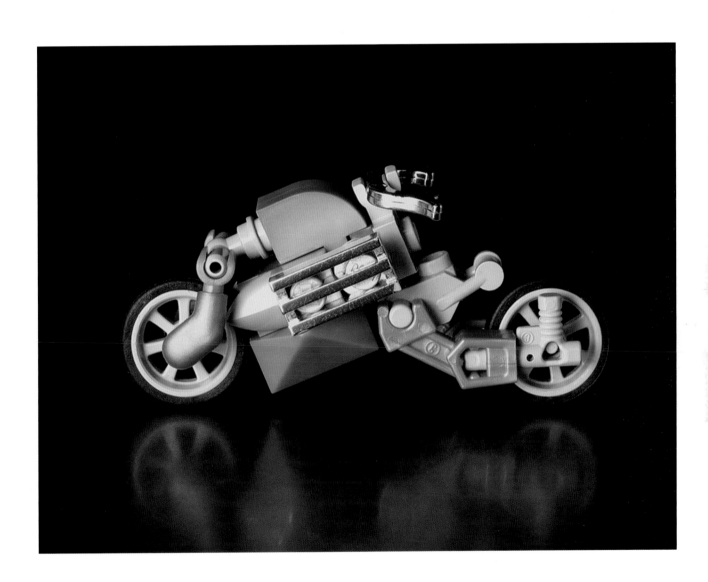

Călin Borş

(opposite top) The Punisher 2012
(opposite middle) Silver Fury 2012
(opposite bottom) Batmobile – Mini Batpod 2012

Brian Kescenovitz
(above) Baroom!!! 2013 (27 pieces)

Future Shock

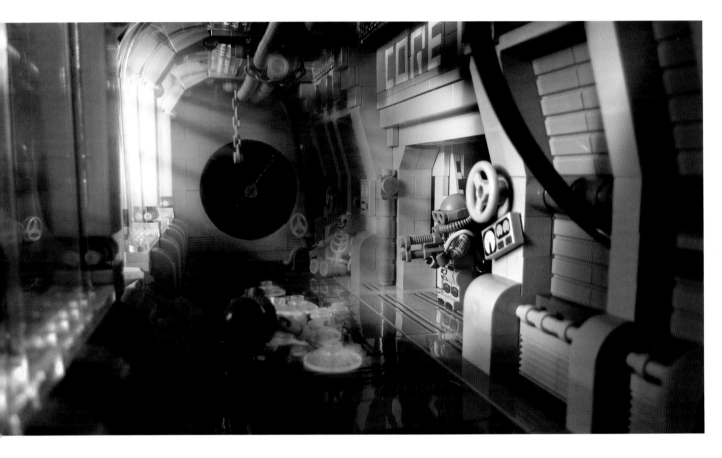

Clemens Kern
Section E2 2013–2014 (~2500 pieces)

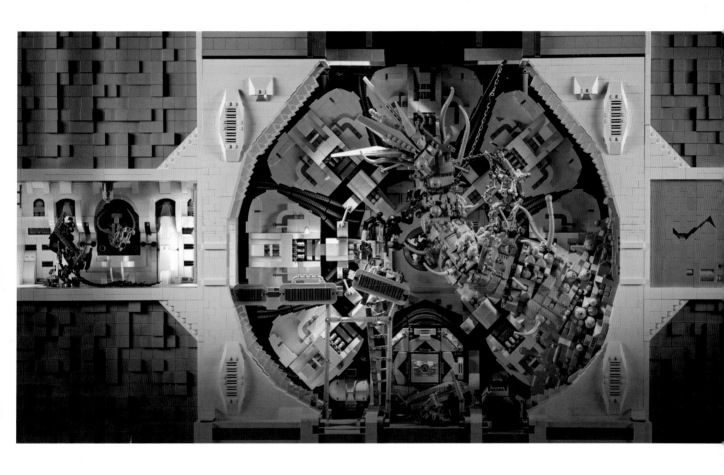

Chris Edwards
Fighting for Life 2008

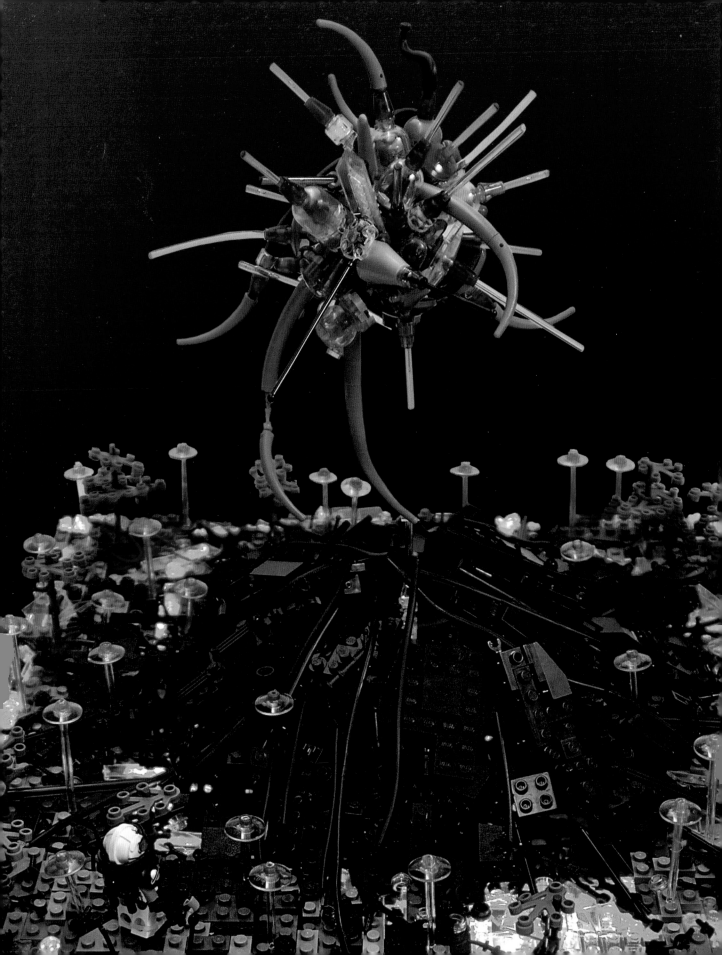

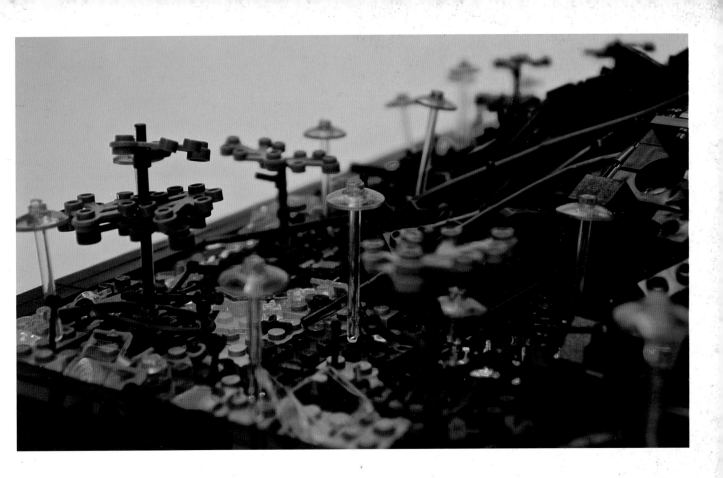

Günther Möbius
The Birth 2014 (~1000 pieces)

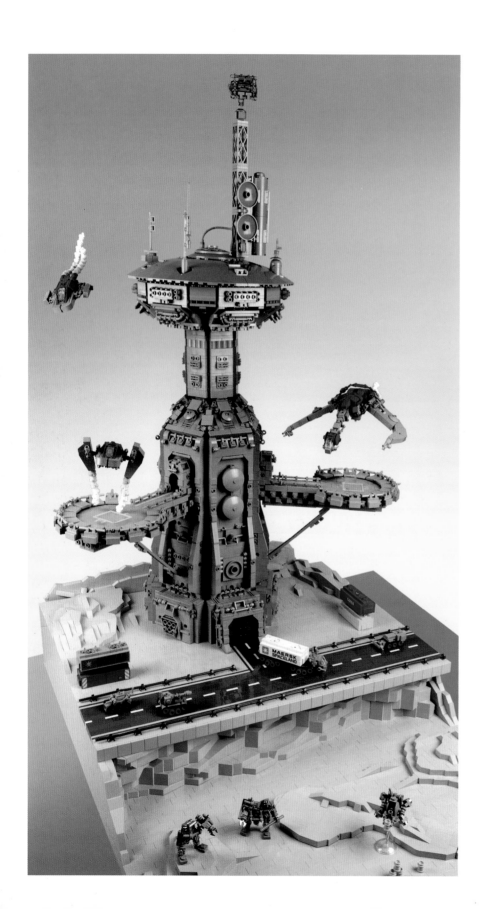

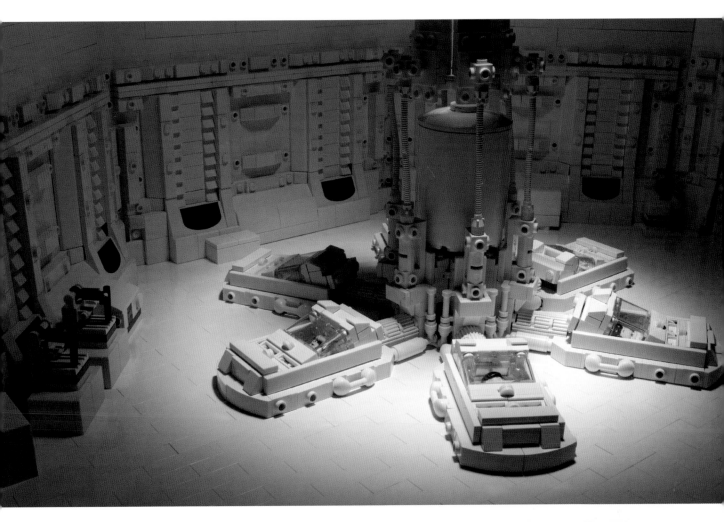

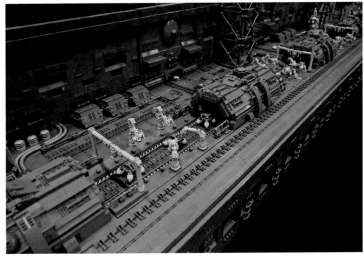

Peter Reid

(opposite) Onyasis Tower 2010 (3107 pieces)
(top) Cryo Chamber 2013 (1742 pieces)
(bottom) Turtle Factory 2010 (6296 pieces)

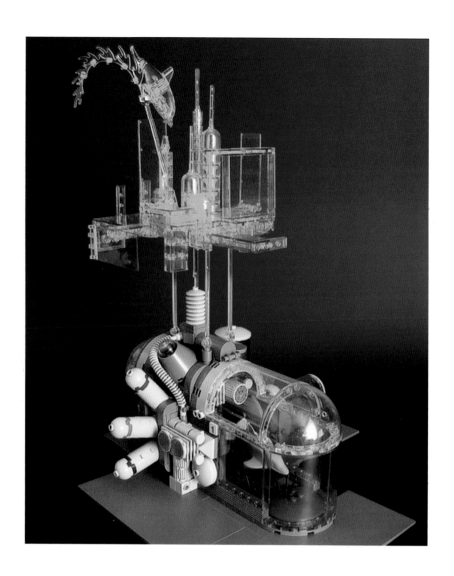

Cole Blaq
Jones's Addiction 2012

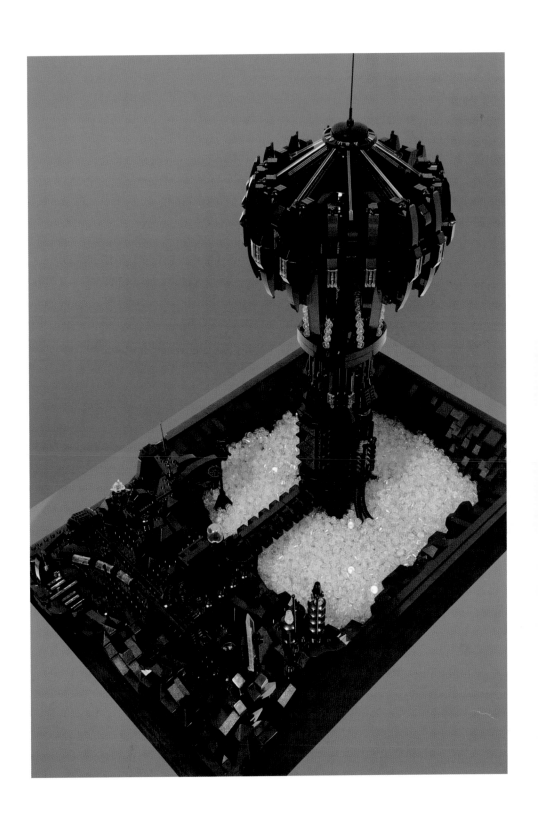

Jon Blackford
Draggone Mining Facility 2013

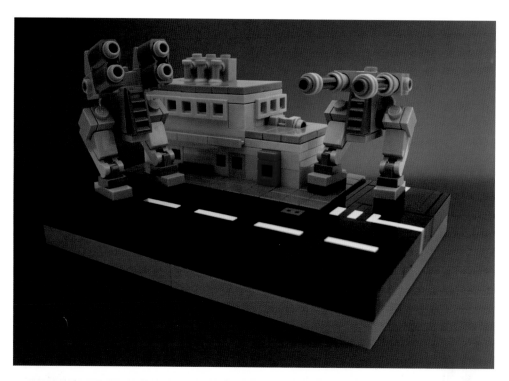

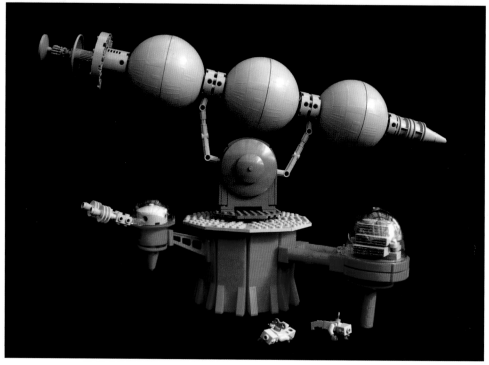

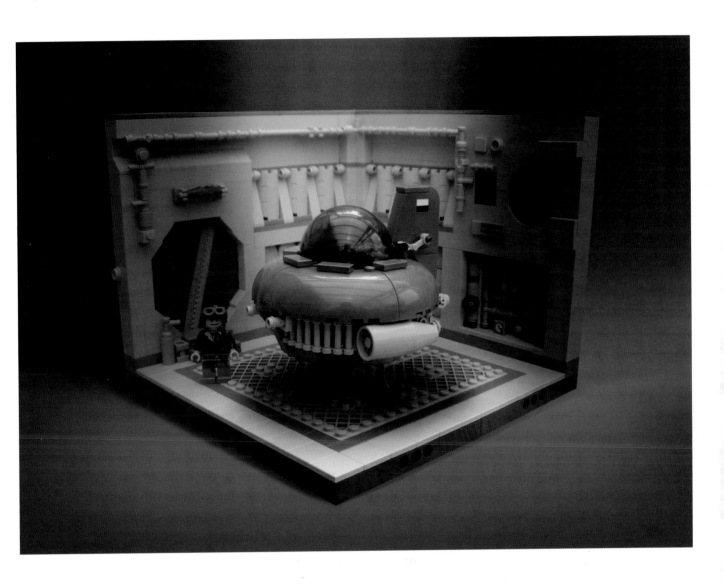

Rod Gillies

(opposite top) Hold the Line at Bleaker Street 2011 (~150 pieces)
(above) Focke-Wulfe "Meteor" 2011 (~1000 pieces)

(opposite bottom)
Shannon Sproule
Lunar A.T.L.A.S. Death Ray Complex 2012

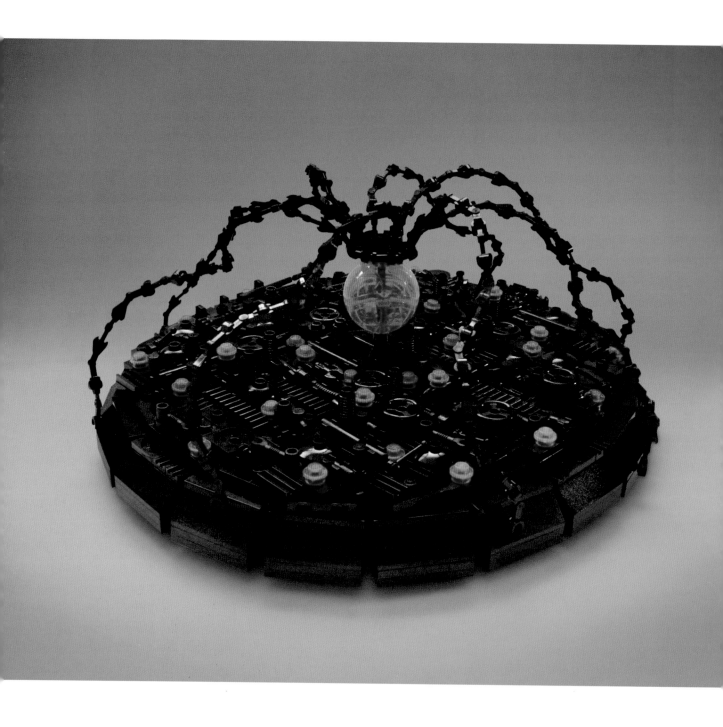

Alec Doede

(above) Black Fantasy Micro Colony 2011 (~400 pieces)
(opposite bottom) Micro Moon Outpost 2012 (~275 pieces)

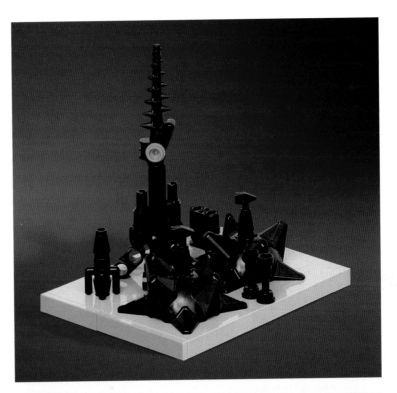

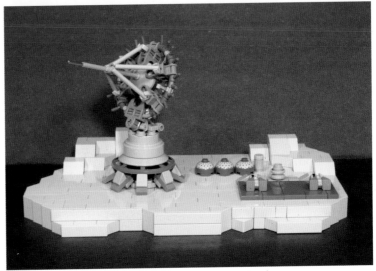

Tim Goddard

I feel like there is some kind of artist in me. But despite my best efforts, my drawing skills refuse to improve. LEGO is definitely my artistic outlet.

I started creating MOCs with Star Wars micro-scale models of my own design. As a child, I had created my own models—furniture-spanning bases linked by monorail—but I approached my first models as an adult like three-dimensional collages, trying different pieces together to create a line or shape and eventually a whole. My goal is to make something greater than the sum of its parts—something that looks real (whether truly real or imagined), not like a LEGO model. Building small, microscale models means every piece has to count and look right.

I now build in various space themes, as well as a fair few animals. I also dabble in other subjects, but whatever it is, I try to approach each one like a sculpture. The wonder of LEGO means I can sculpt in plastic easily and fairly quickly.

As I build, I am constantly replacing one part with another until I am happy with the appearance; I don't normally have much more than a rough idea of what I want the finished work to look like, but I know when I am happy.

I'm happiest building my own worlds. It's a kind of escapism from the stress of working life. You can have great schemes in your head—whole worlds where the model you're building is but a small part. These schemes may never be fully realized,

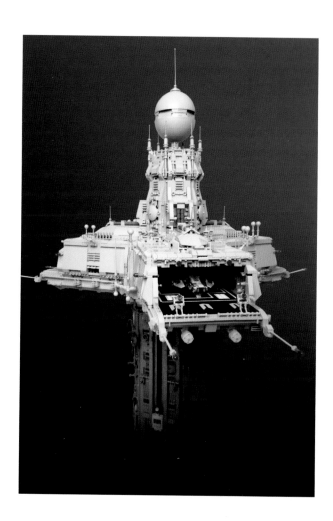

(above) The Triport Spire 2012
(opposite) Tunnel Vision 2011

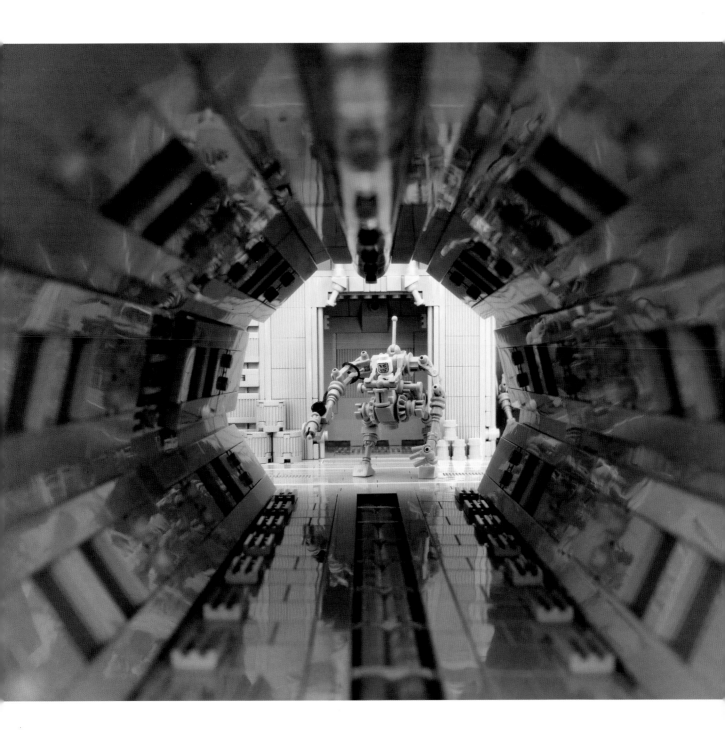

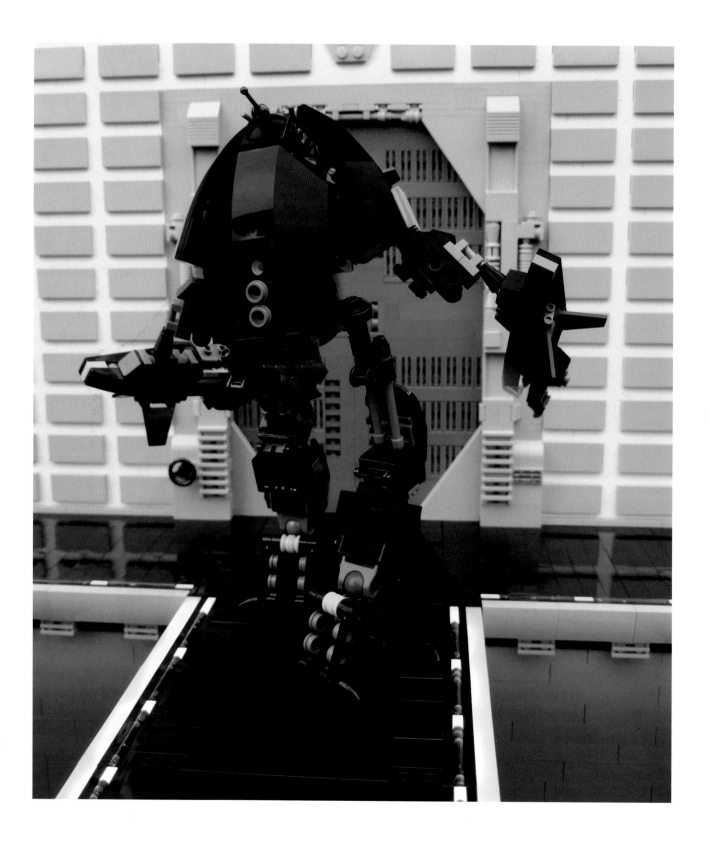

(above) The Inciser 2010
(opposite) Tranquility Base Hydroponics Bay 2013

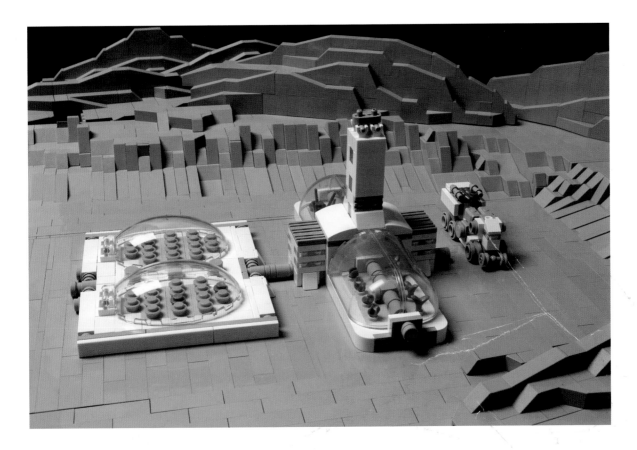

but that's part of the journey. The trick is to be satisfied with what you produce, not an easy feat. I'm probably my harshest critic.

The community of LEGO builders are at the core of what LEGO is about, and a constant source of inspiration.

I must admit to feeling a sense of competition. When I see an amazing model online, it pushes me to improve my game. There will always be someone better than you, with a bigger collection or more talent. You don't have to beat them, only draw inspiration. A tiny bit of jealousy can be constructive!

The community creates an interesting duality. I mainly view building as a solitary pursuit, and that's part of the reason I enjoy it. I am the shy and retiring type; building with LEGO is something I'm completely in control of. But building as part of a collaboration—for an online competition or a more direct project like a display for a public show—is one of the most rewarding parts of the hobby. It's a unique challenge, working together creatively to build something, and it means change and flexibility (which I'm not always great with), but it's always worth it in the end.

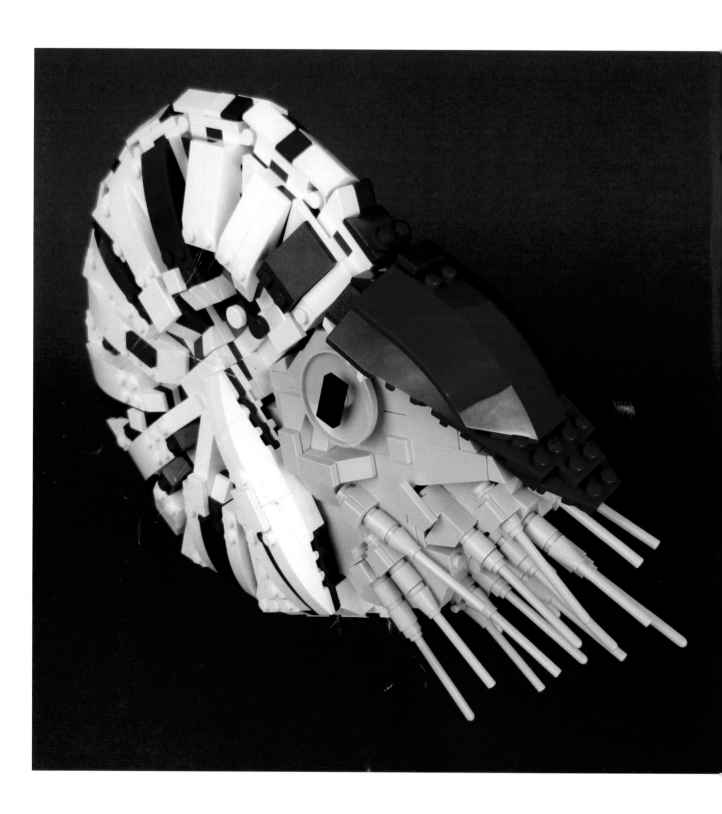

(above) Nautilus 2013
(opposite) Ammonite 2013

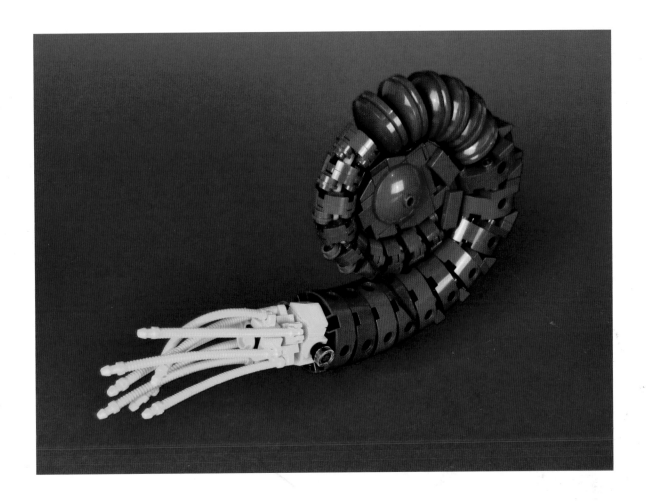

One of my biggest collaborations was on a book with my friend Pete. Our book, *LEGO Space: Building the Future*, pushed me to build more, faster, and to a higher standard than ever before. It wasn't just a building collaboration, either. Photography, writing, IT, driving, support from family (thanks, Sharon) and lots of tea were involved. The finished product is something I'll be proud of forever. Going through two years of torture to produce it has made me a better builder.

There is a nice little community of spacers growing in the UK right now who are great to work with. This gives me a good reason to keep building and pushing myself.

Ocean Depths

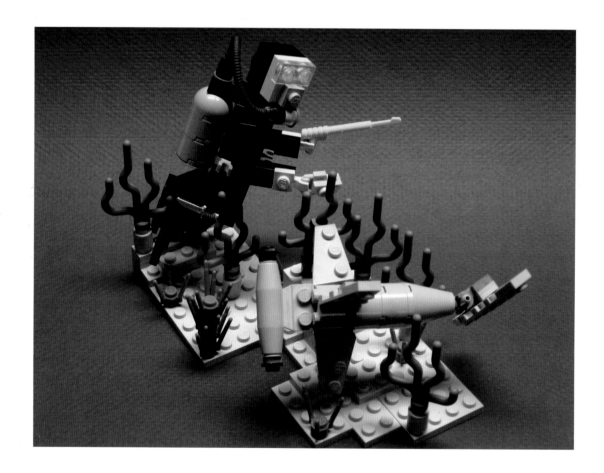

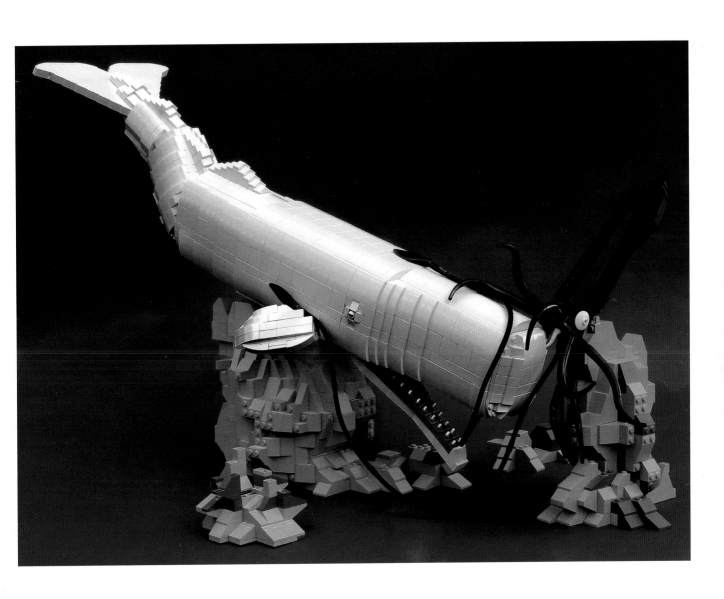

Ryan Rubino

(opposite) Scuba 2010 (135 pieces)
(above) Leviathans 2013 (~3500 pieces)

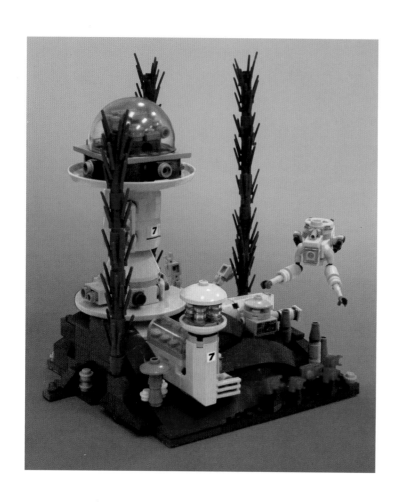

(top)
Andrew Lee
Sealab 7 2009

(opposite)
Mark Erickson
Kelp Forest 2013

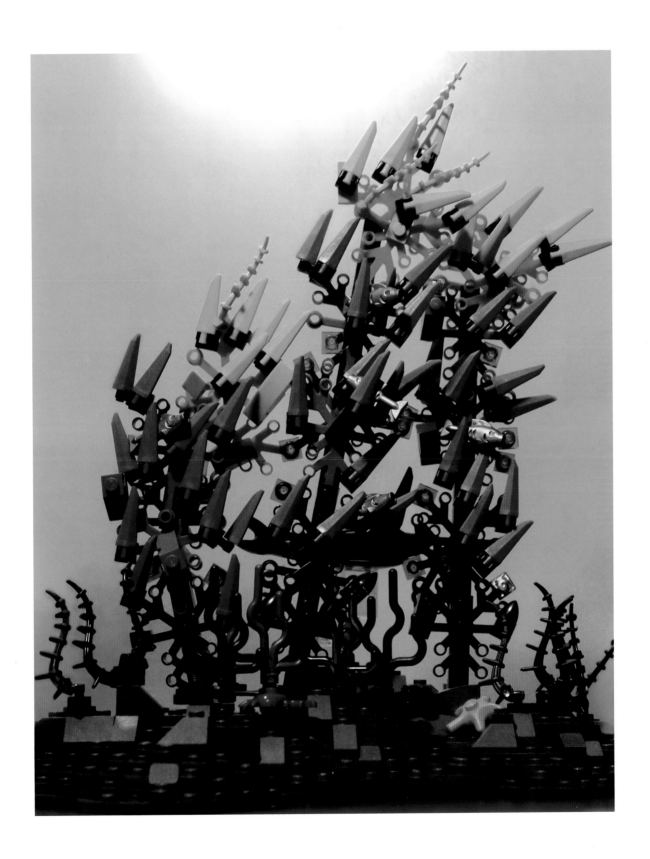

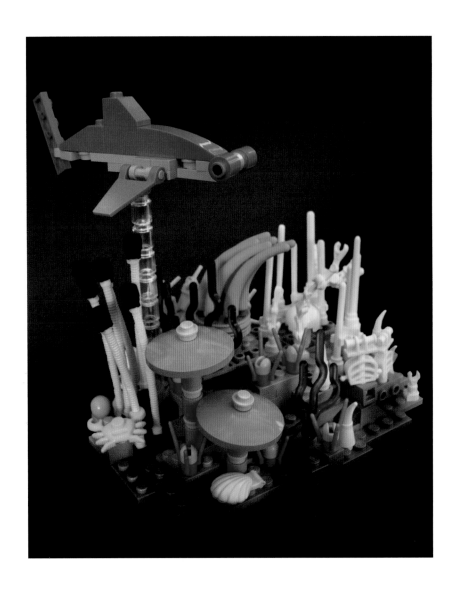

Shannon Sproule
Coral Reef Bleaching 2008 (~150 pieces)

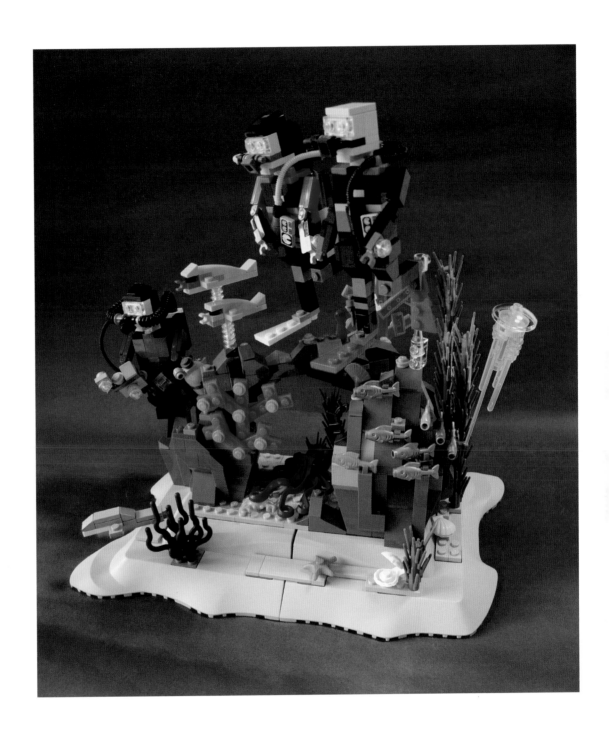

Bidea
Scuba Diving 2013 (~300 pieces)

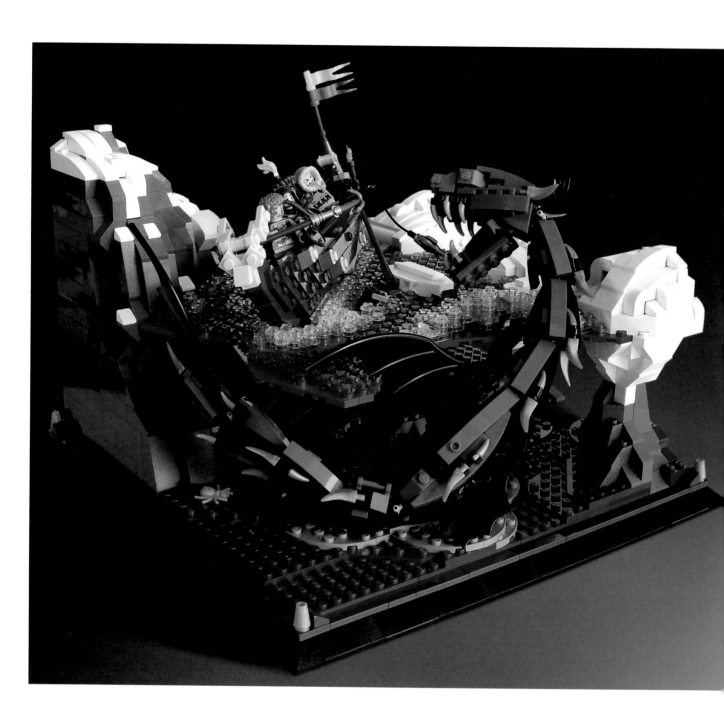

Mike Crance
Mitgardian Fishing Trip 2013 (~1100 pieces)

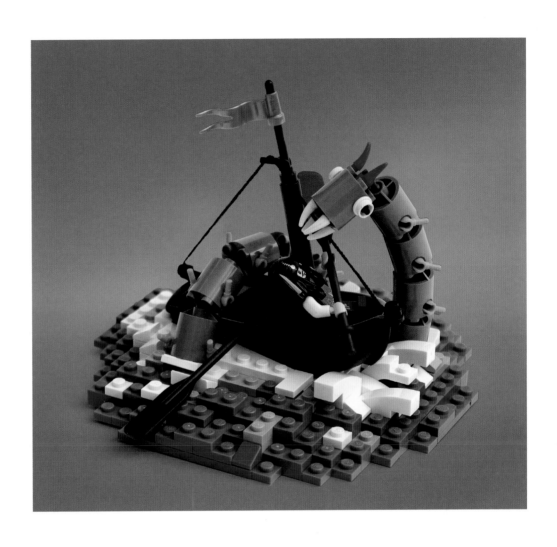

Barney Main
You're Off the Edge of the Map, Jack... 2011 (310 pieces)

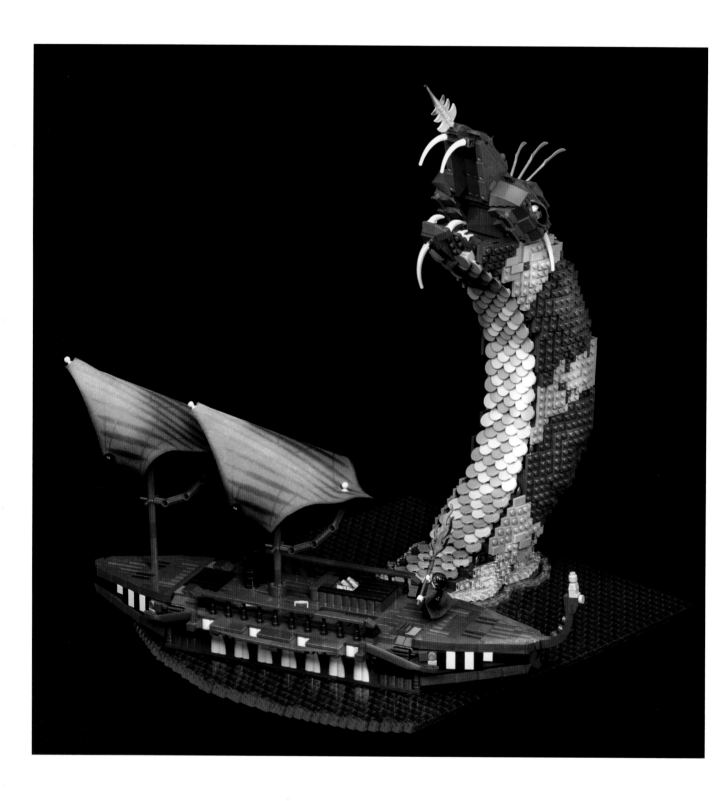

Lauchlan Toal
Guardian of the Emerald 2013 (4559 pieces)

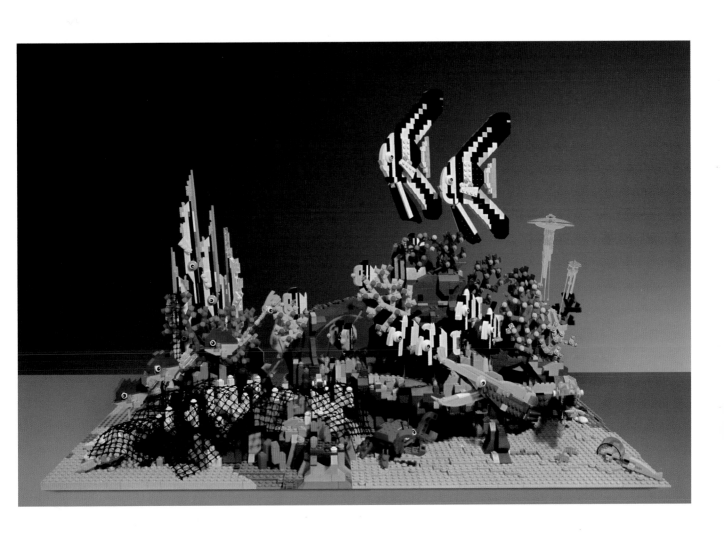

Bidea
Marine Organisms 2012 (~2300 pieces)

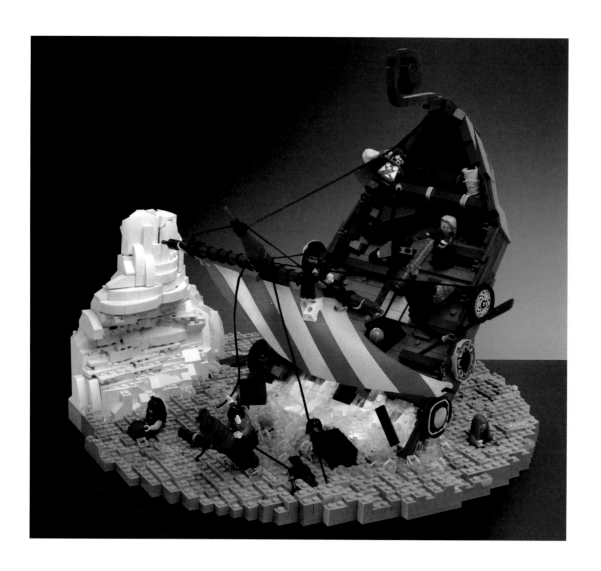

Barney Main
And the Band Played On... 2012

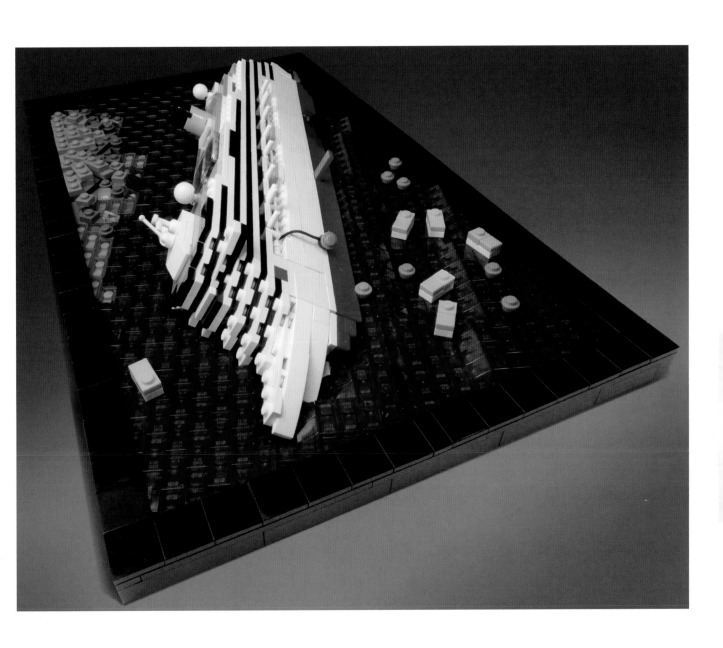

Gary Davis
The Costa Concordia Tragedy 2012 (~2500 pieces)

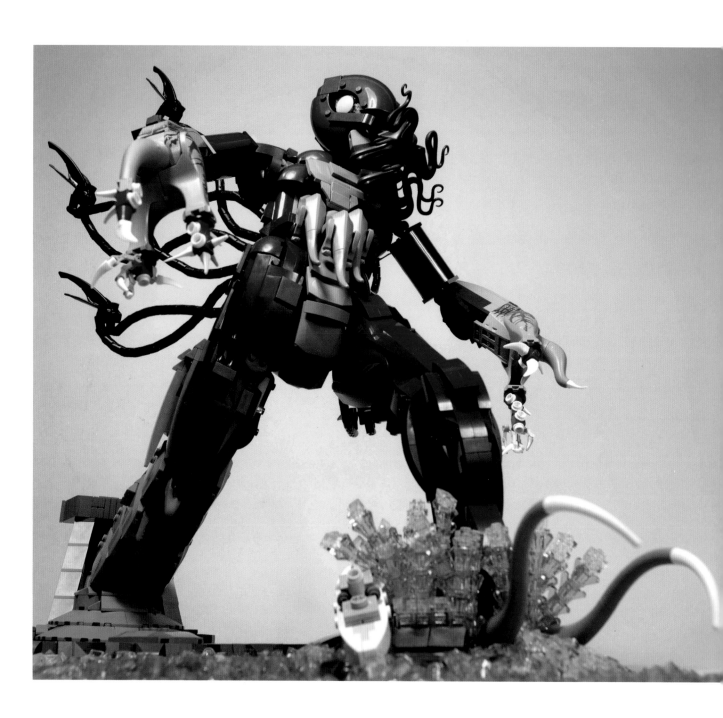

Carl Merriam
The Madness from the Sea 2013 (2500+ pieces)

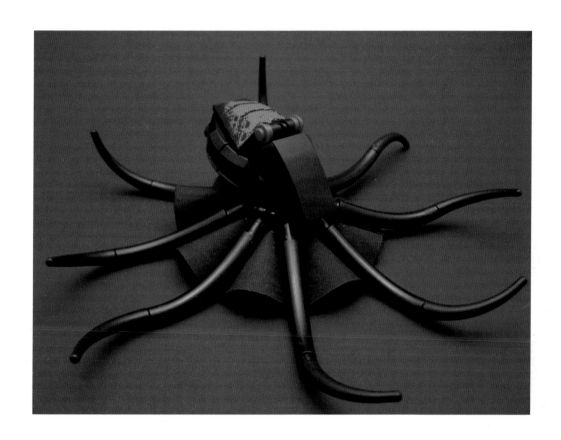

Tyler Clites
Giant Octopus 2009

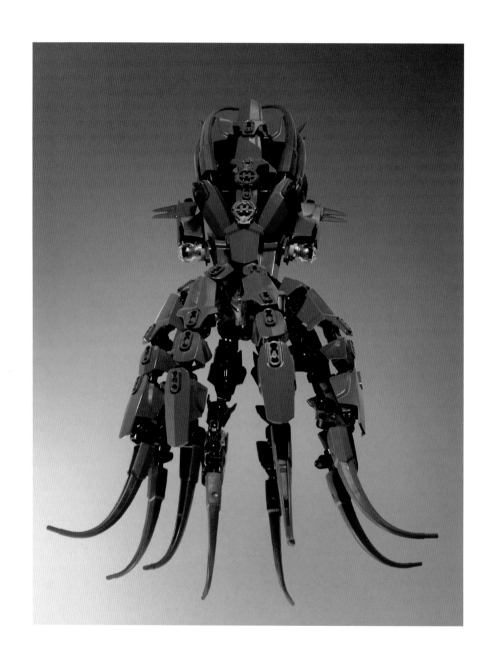

Norbert Labuguen
Midnight Octopus 2012 (~250 pieces)

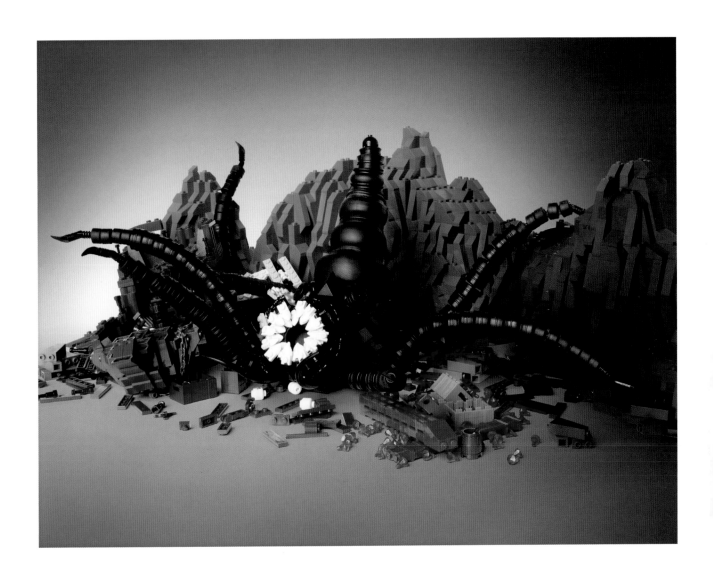

Timothy Schwalfenberg
The Kraken 2014 (~1500 pieces)

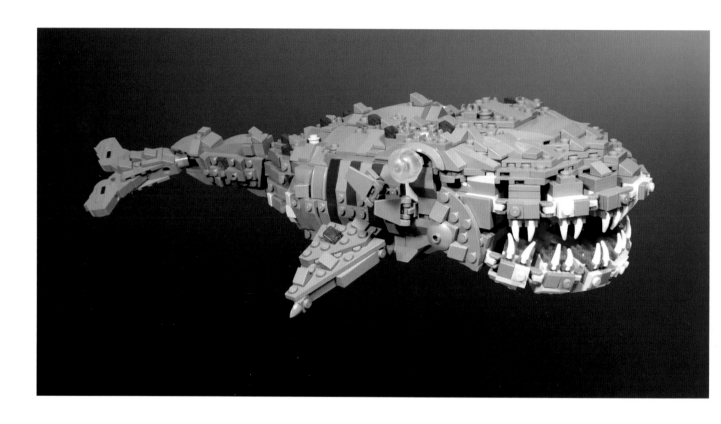

Taylor Baggs
Monstrous Whale 2013

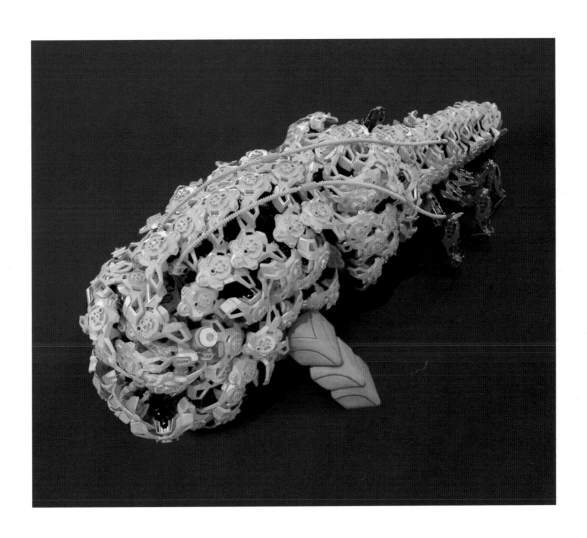

Norbert Labuguen
Opee See Killer (Star Wars Episode I: The Phantom Menace) 2011 (1200 pieces)

Dragon Lore

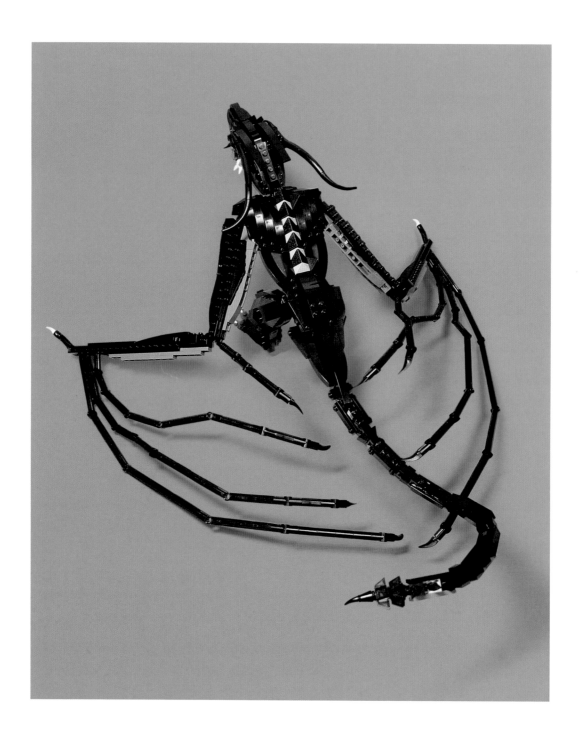

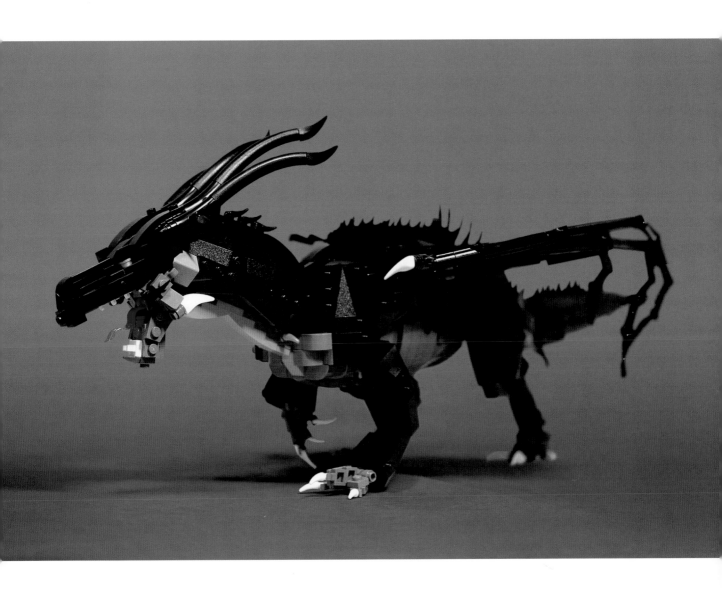

Ken Ito

(opposite) Toward the Sky 2012
(above) Stormbringer 2013 (~1000 pieces)

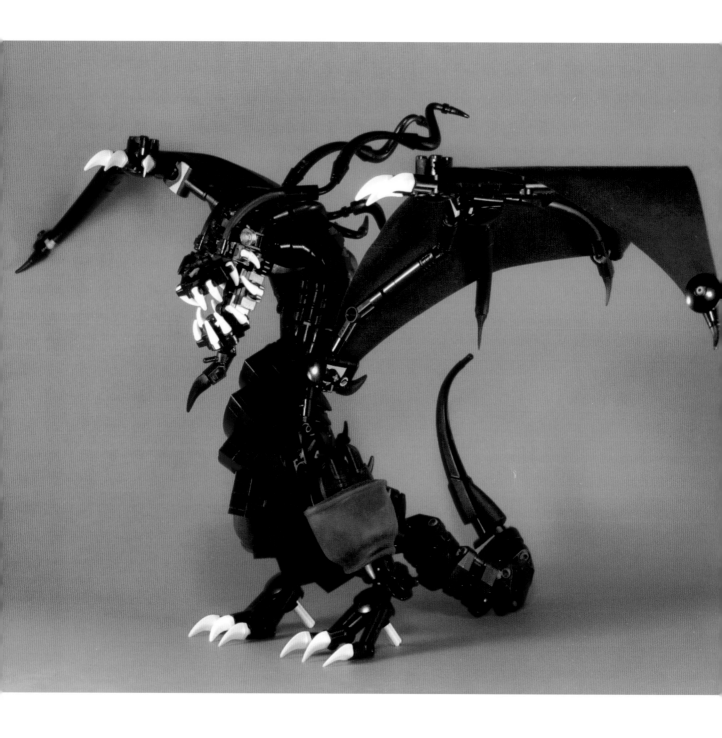

Mike Nieves
Overlord Dragon 2013 (600 pieces)

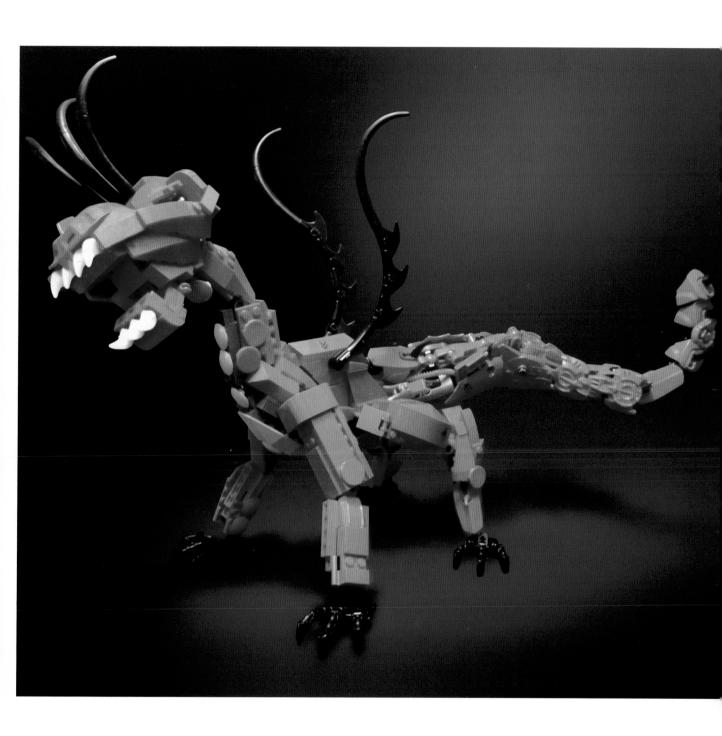

Nathan DeCastro
Juvenile Draconis Diablos 2012 (600+ pieces)

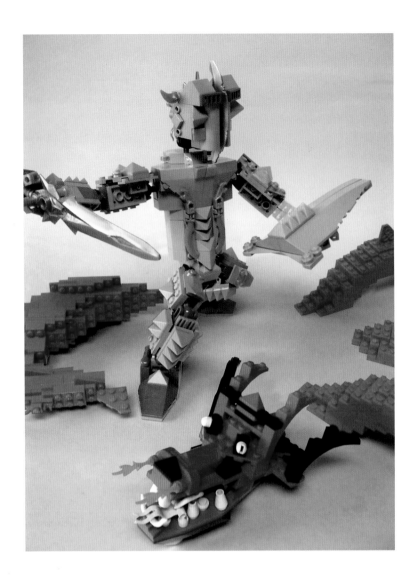

Matt Armstrong
Off with His Head 2011 (200–300 pieces)

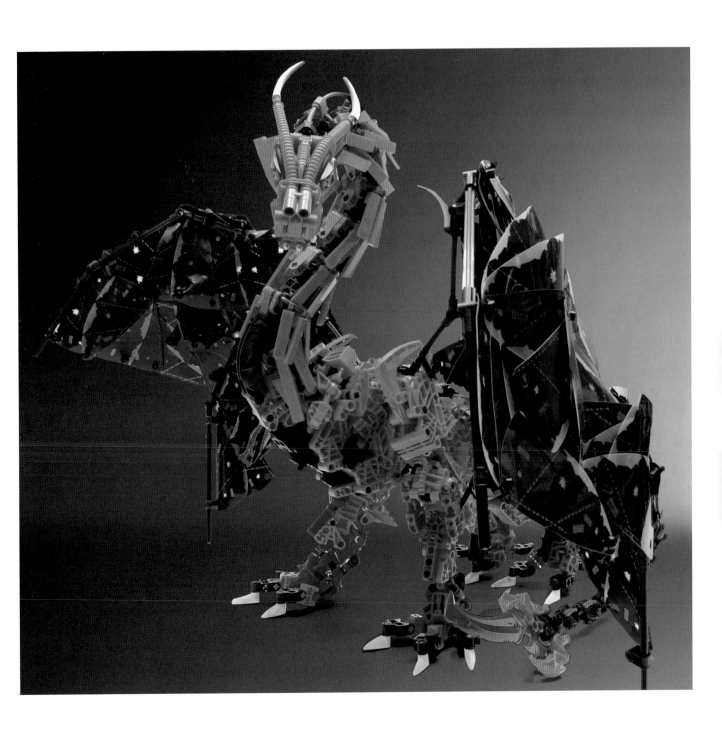

Patrick Biggs
The Vauland Dragon II 2010

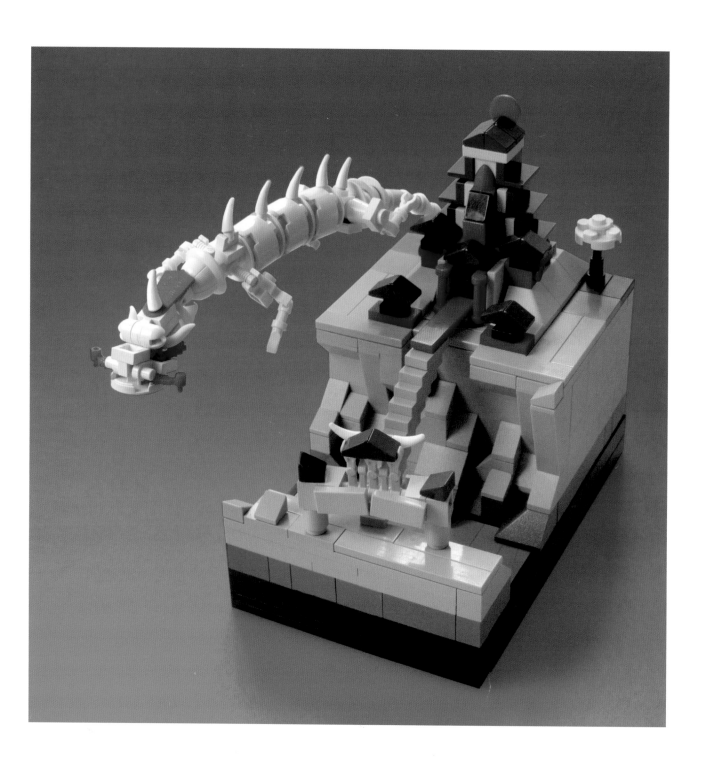

Bartosz Sasiński
Castle of the Rising Sun 2010 (444 pieces)

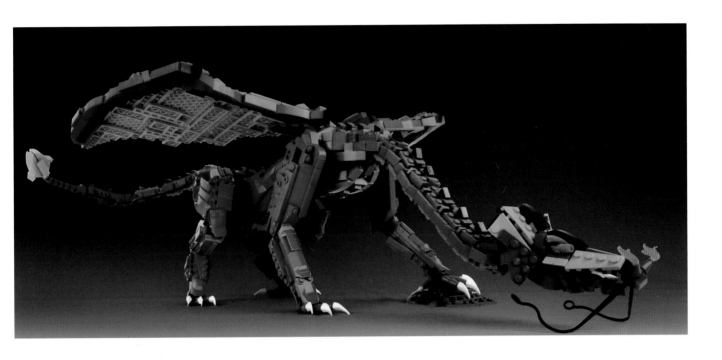

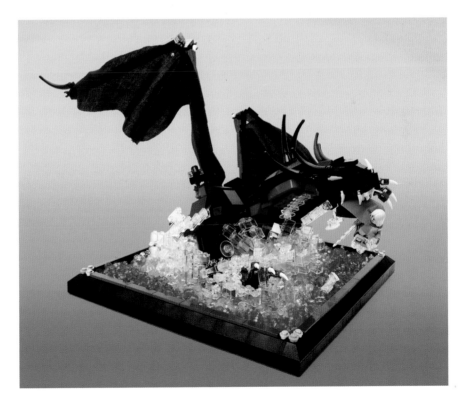

(top)
Tim Goddard
Dragon 2013

(bottom)
Mark Erickson
Snatched 2013 (4000+ pieces)

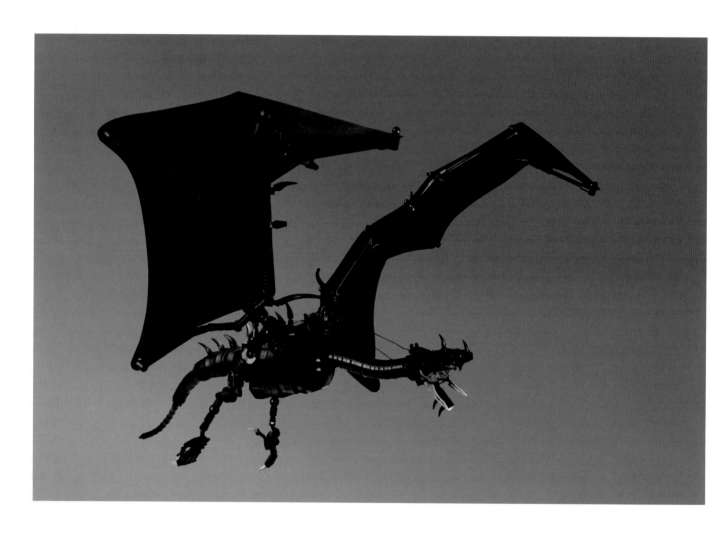

Elliott Feldman
Fell Beast (The Lord of the Rings) 2014 (~400 pieces)

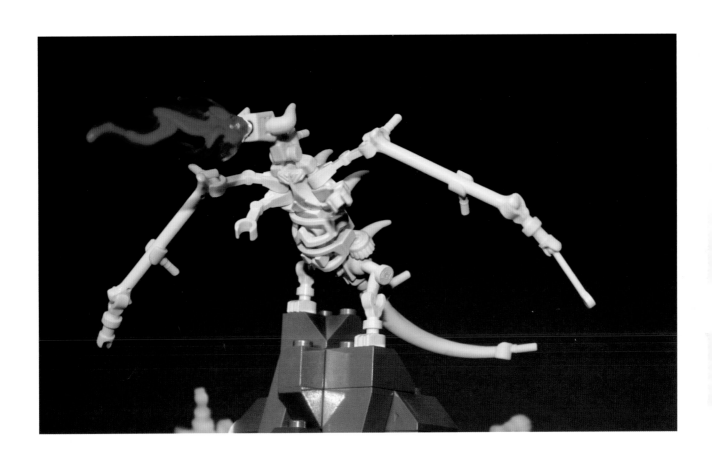

Sean and Steph Mayo
Micro Bone Dragon 2012

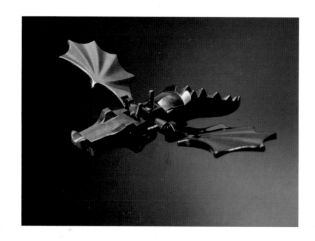

(above)
Lukasz Wiktorowicz
Sierconus Coralus 2012 (14 pieces)

(opposite)
Sylvain Amacher
Ringwraith on Fell Beast 2013 (~800 pieces)

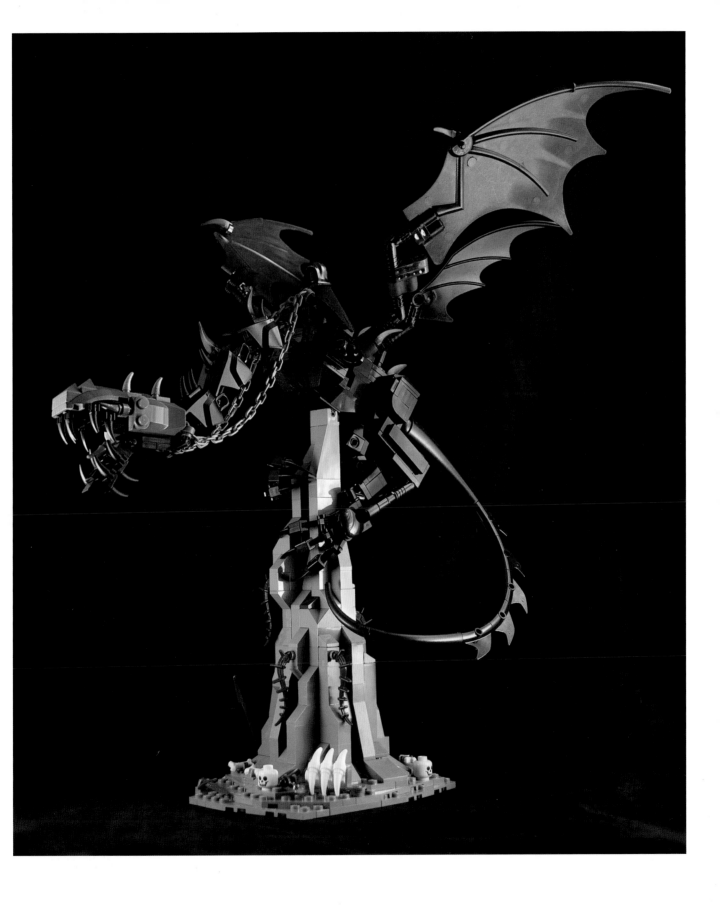

Jurassica

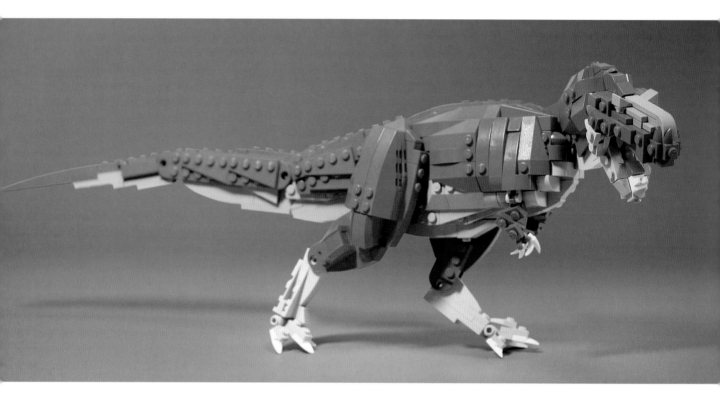

Ken Ito

(above) Tyranosaurus rex 2013 (~400 pieces)
(opposite) Kronosaurus 2011 (~500 pieces)

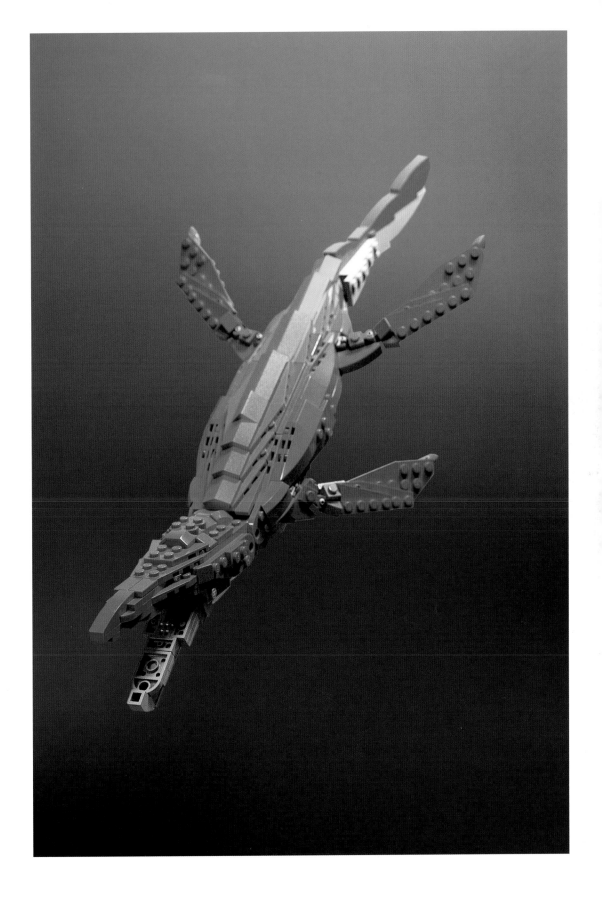

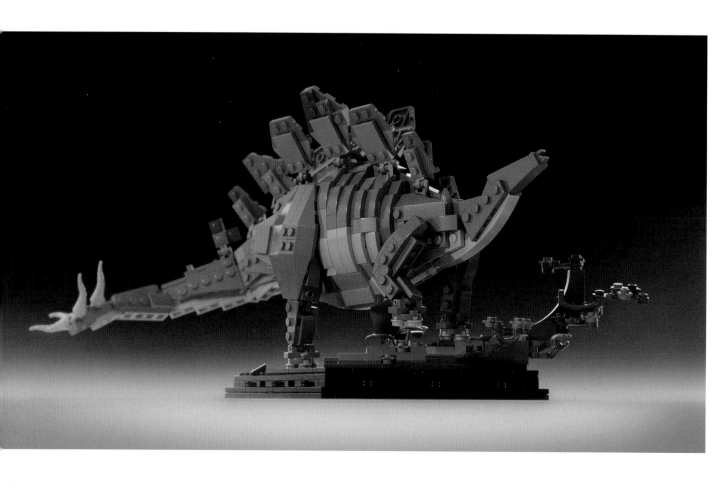

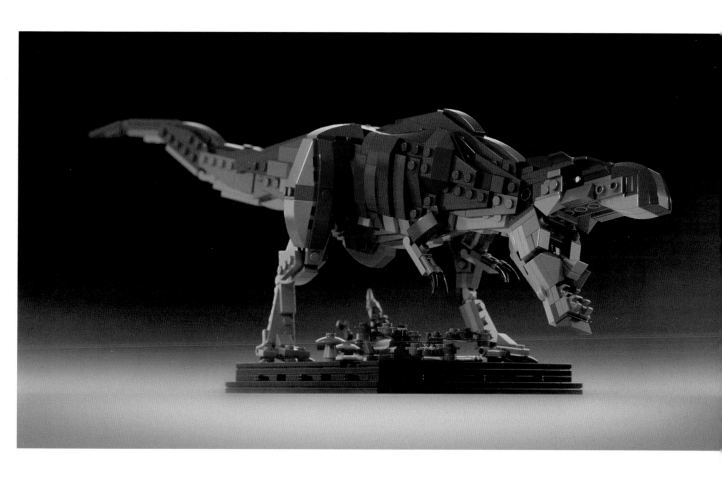

Sami Mustonen

(opposite) Bricksauria | Stegosaurus [digital render] 2014 (766 pieces)
(above) Bricksauria | Tyrannosaurus rex [digital render] 2013 (721 pieces)

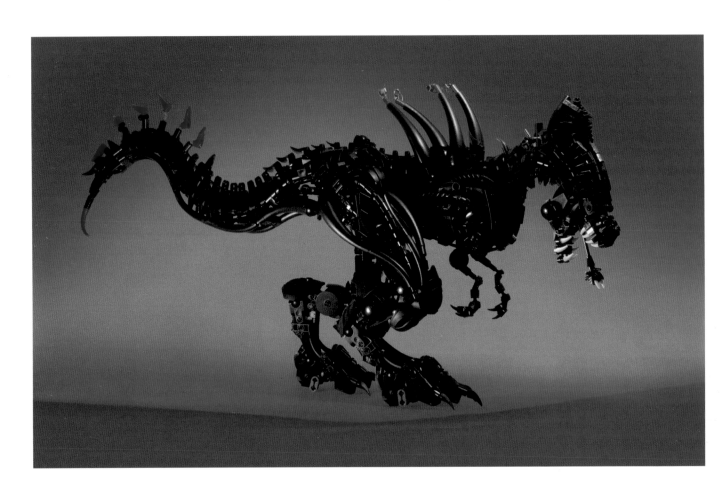

Mike Nieves
Xenomorph Rex 2012 (~2000 pieces)

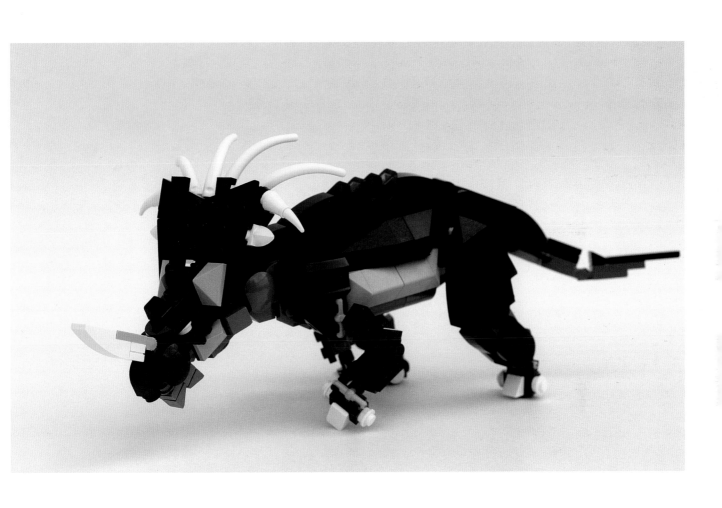

Ken Ito
Styracosaurus 2010 (~300 pieces)

Evil Attunement

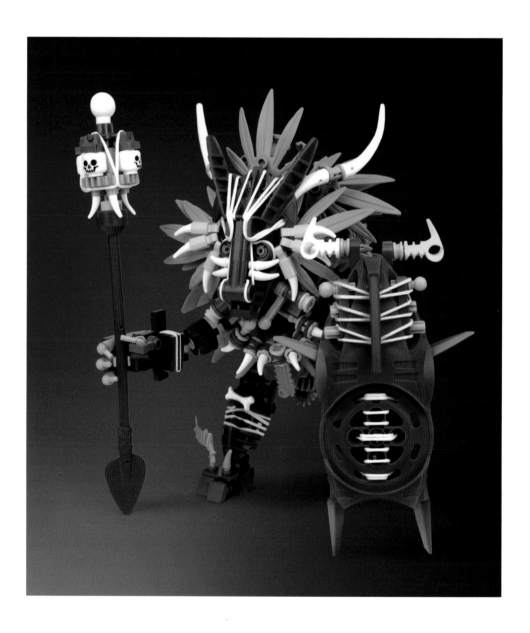

(above)
Nicolaas Vás
Tribull 2013

(opposite)
Hankyung Ryu
Witchdoctor – Bot 2011 (364 pieces)

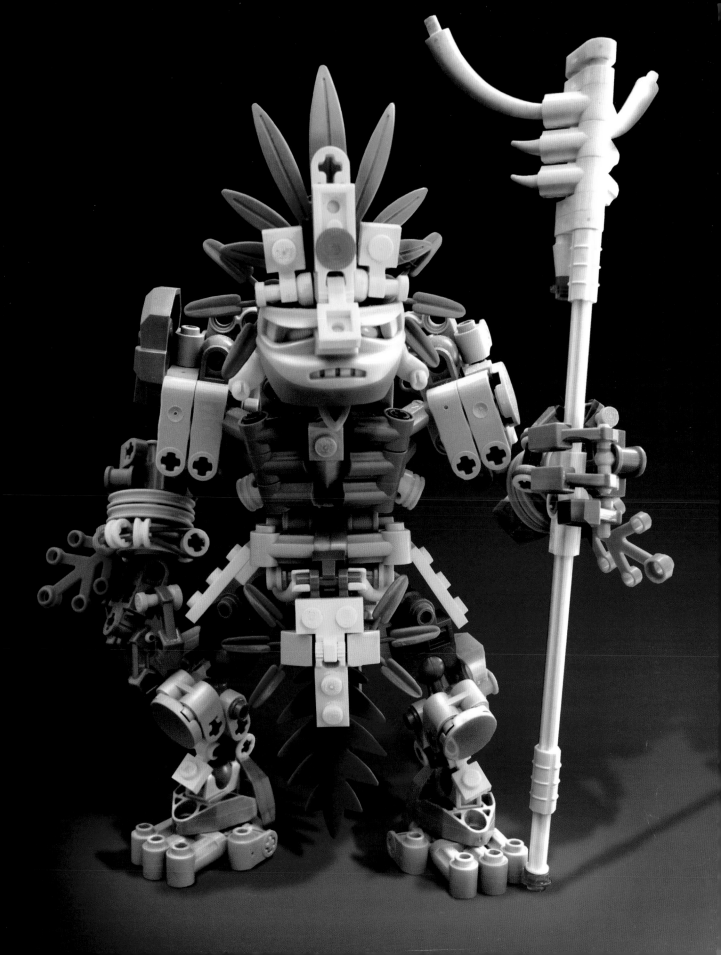

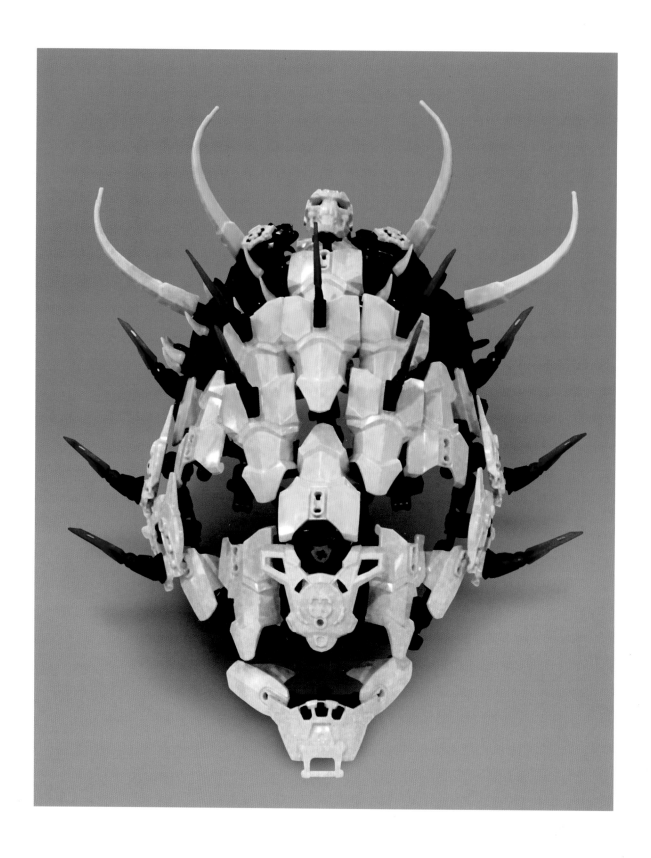

Norbert Labuguen
Witch Doctor Masque (Hero Factory) 2011 (250 pieces)

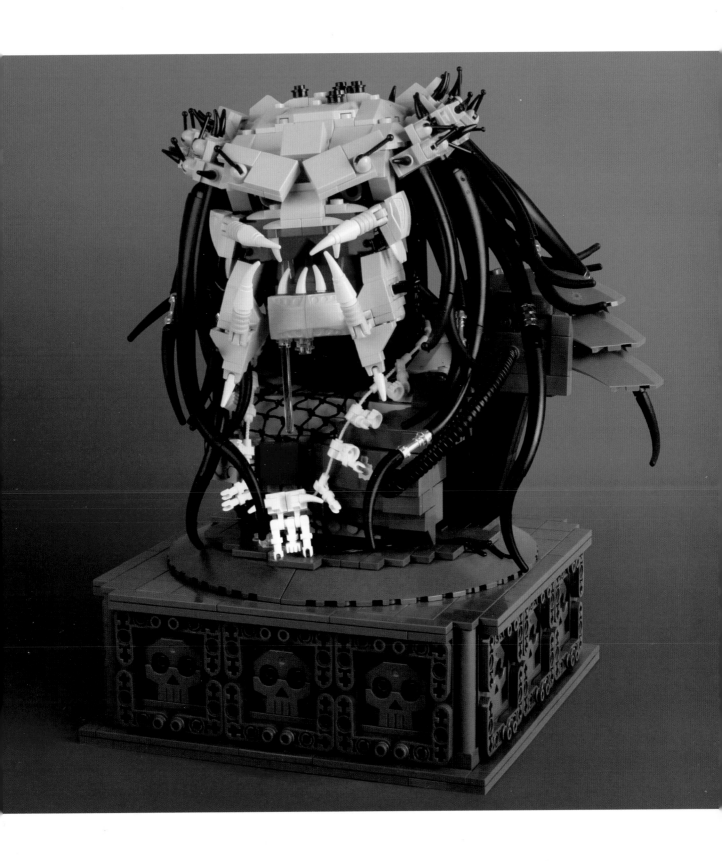

Adam
Predator 2008 (2000+ pieces)

Skin and Bones

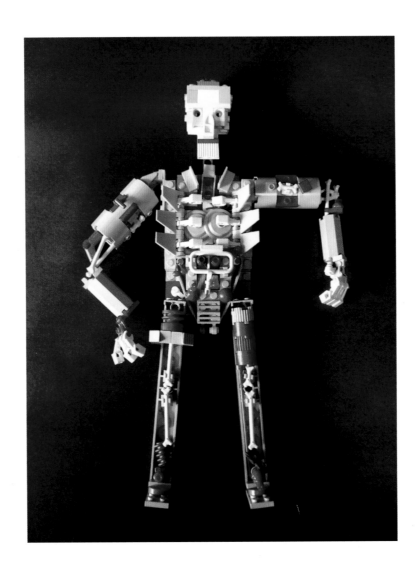

(above)
Matt Armstrong
Inside an AFOL 2012 (175–200 pieces)

(opposite)
Chris Maddison
Zombie! 2013

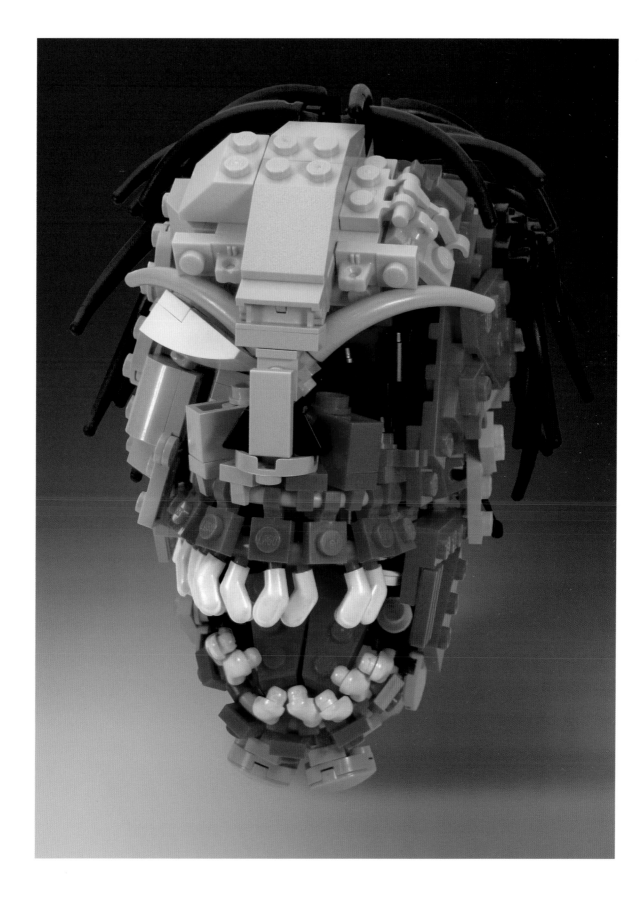

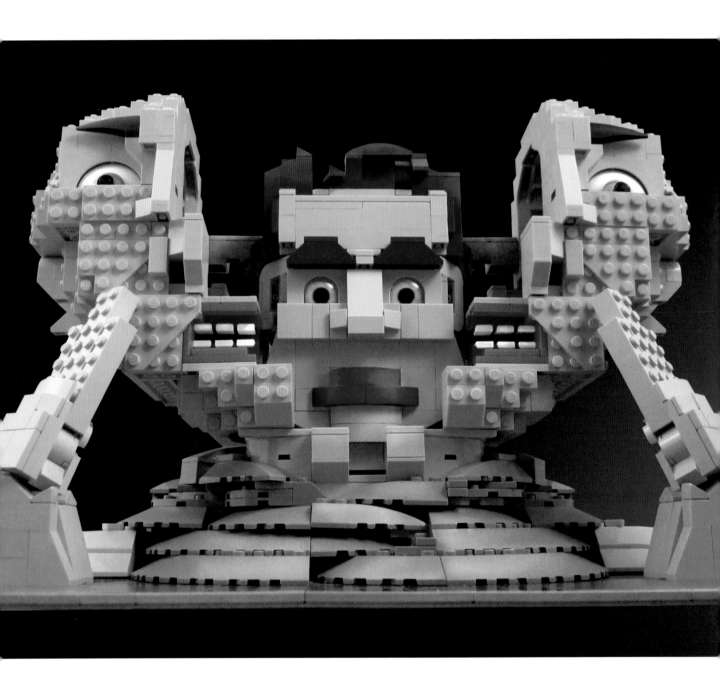

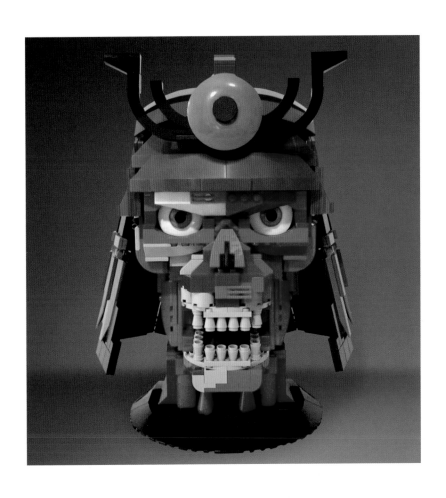

(opposite)
Stuart Delahay
"Two Weeks" 2013

(above)
Shawn Snyder
Zombie Samurai 2008 (~1000 pieces)

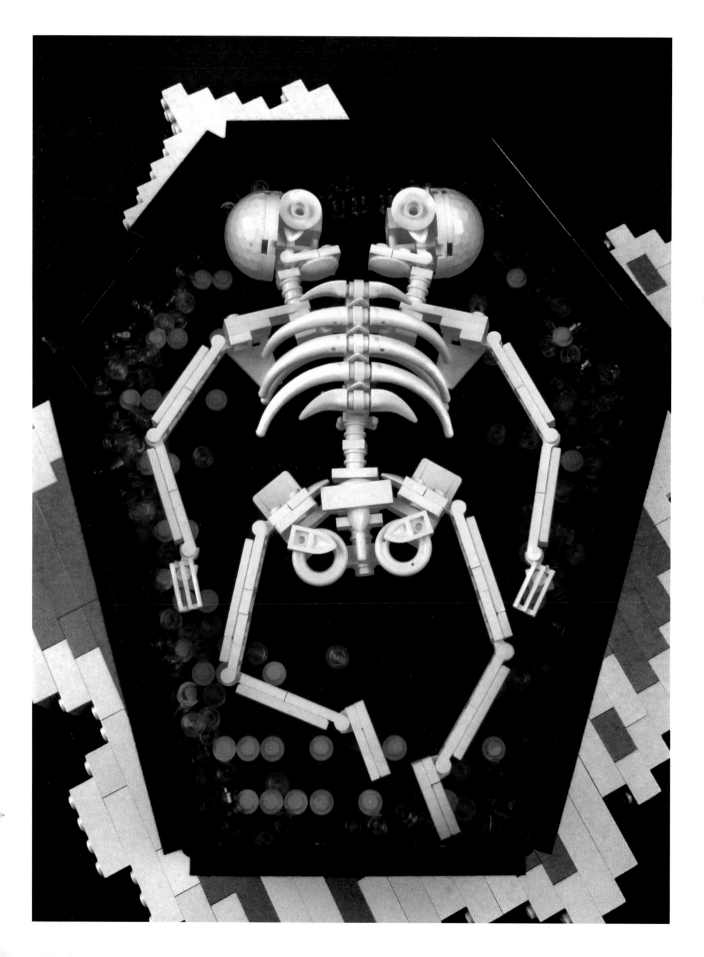

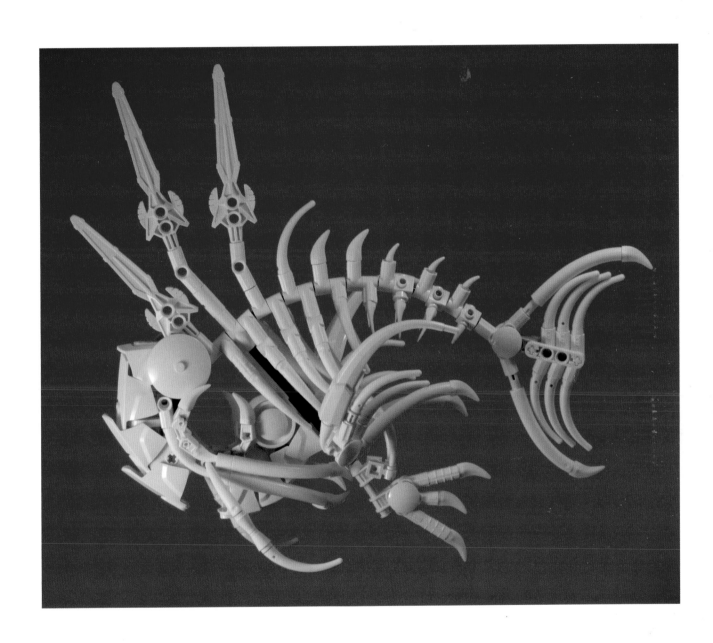

(opposite)
Stuart Delahay
Gemini 2013

(above)
Mike Nieves
Magikarp Skeleton 2011 (~200 pieces)

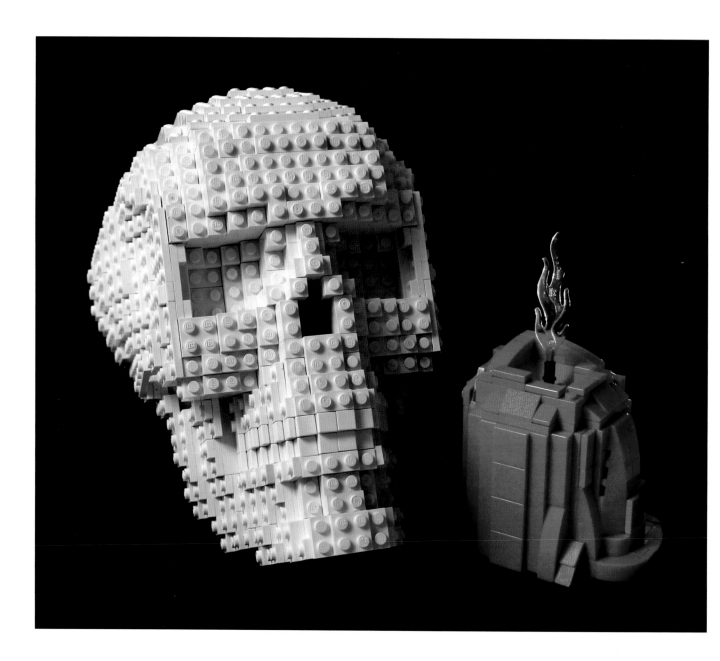

Tom Remy
Skull and Candle 2014 (~1800 pieces)

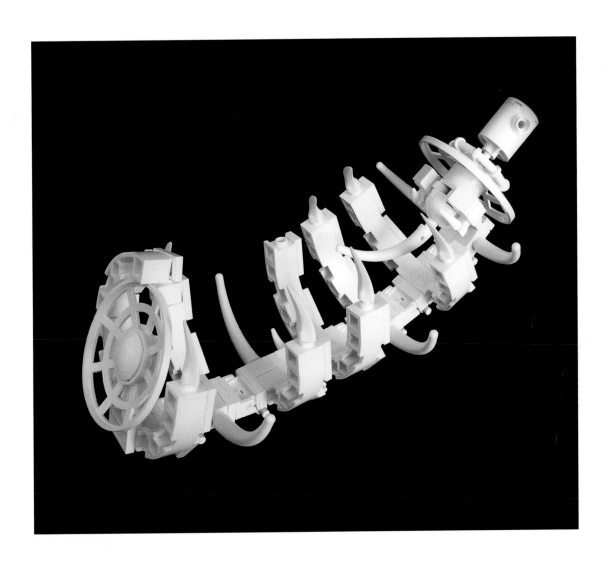

Cole Blaq
Tuff to the Bone 2011

Almost Human

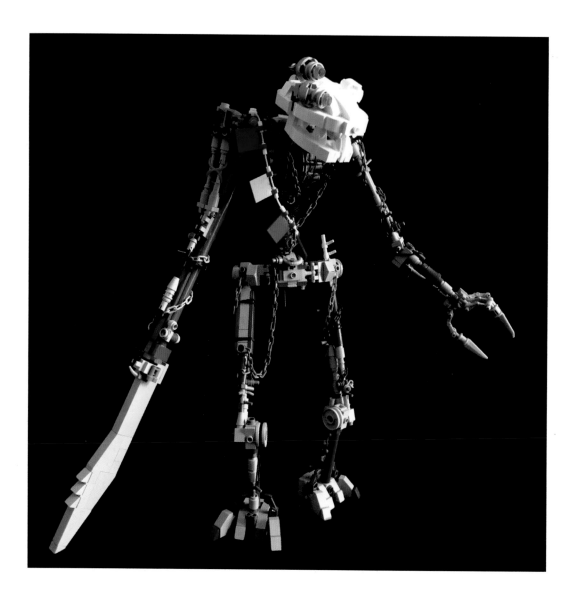

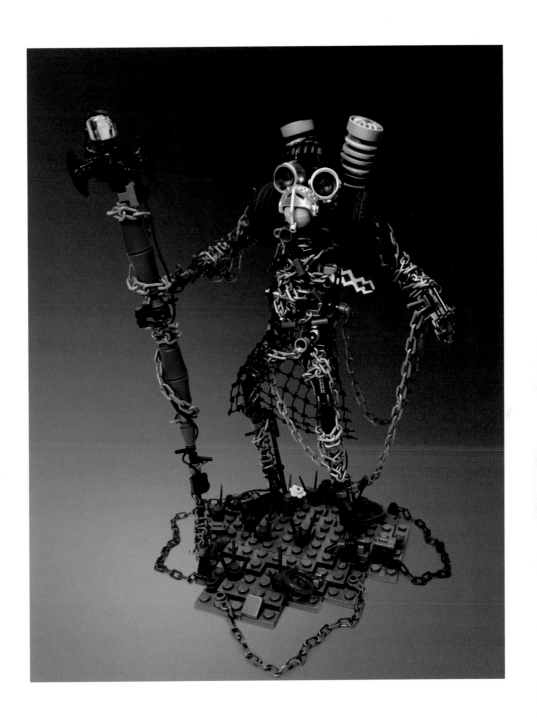

Kevin Fedde

(opposite) Hunter 2009 (~400 pieces)
(above) Priest of Chains 2009

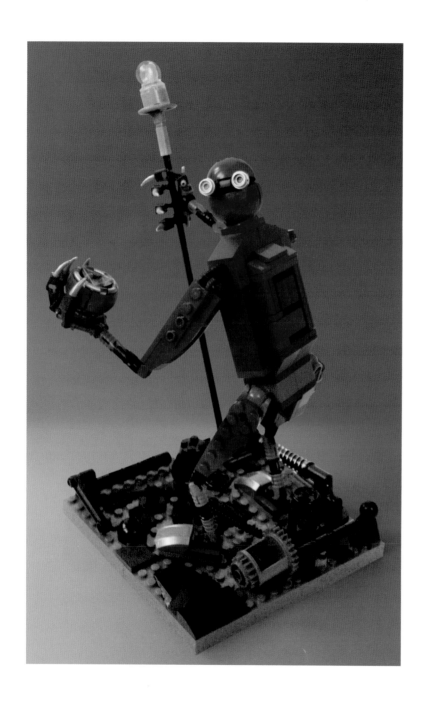

Okay Yaramanoglu
Sculpture of 9 2010 (210 pieces)

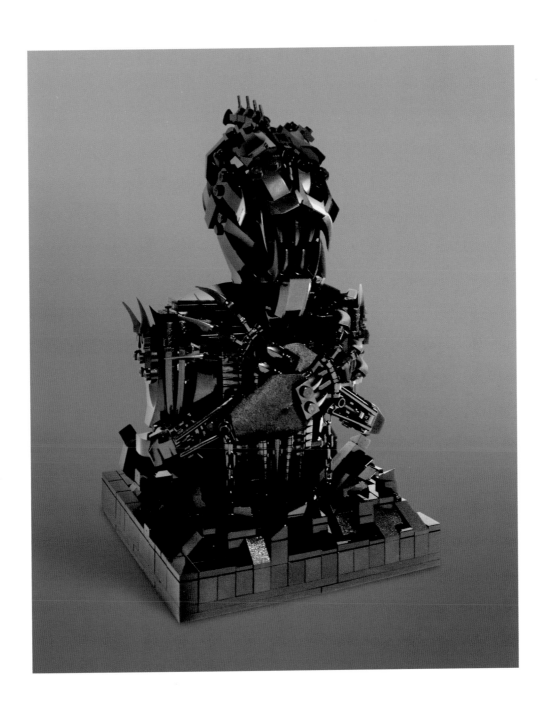

Markus Aspacher
Final Fantasy – Anima 2014 (~450 pieces)

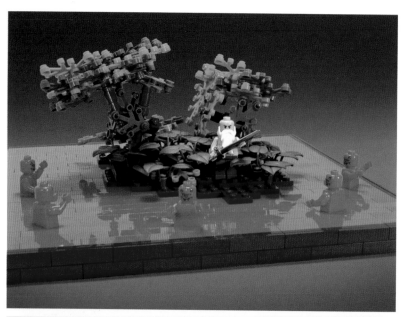

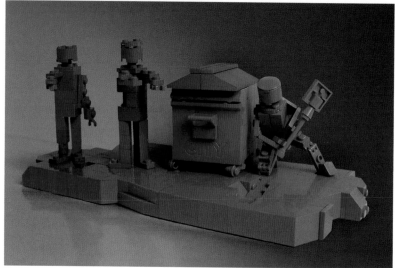

(top)
Daniel Shehadeh
The Contrast of Two Worlds 2010

(bottom)
Mateusz Btaszczyk
Brainzzz 2013 (188 pieces)

(opposite)
Tyler Halliwell
Giant 2013 (~800 pieces)

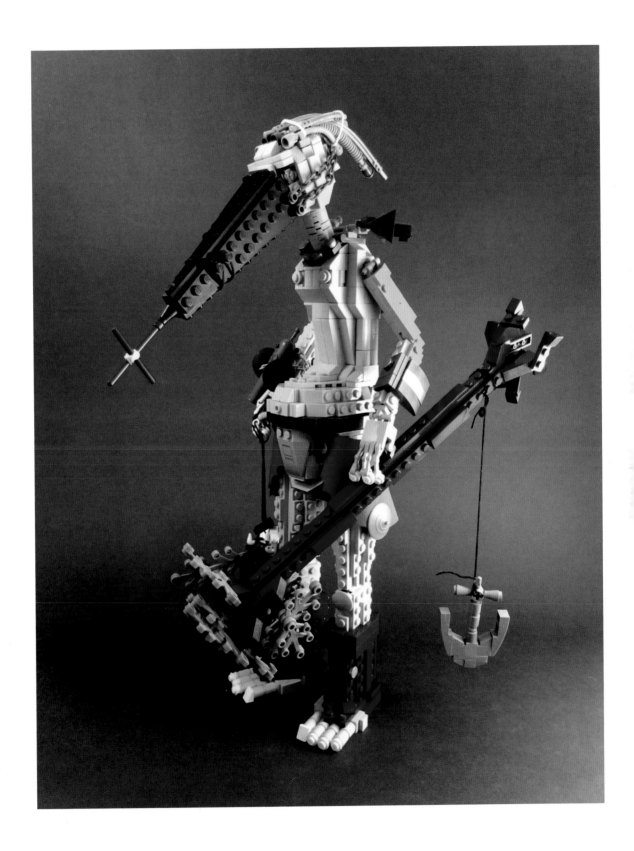

Disrepair

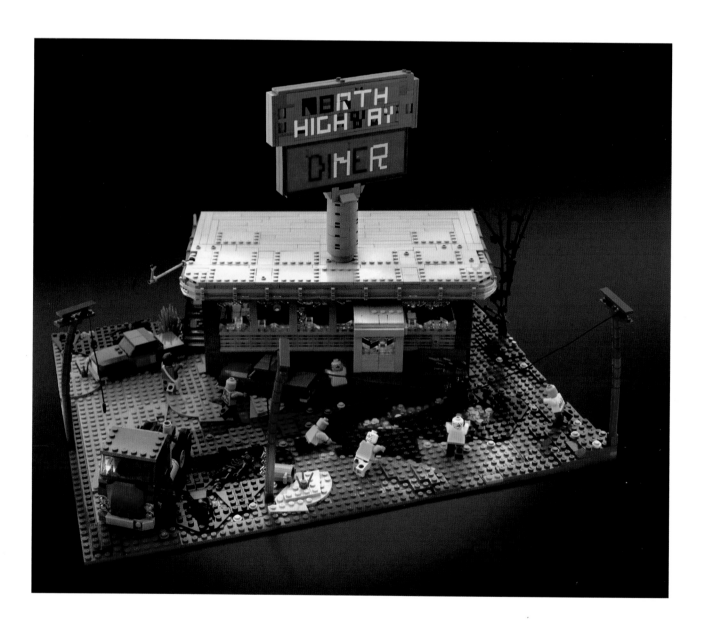

Evan Bordessa

(above) North Highway Diner 2013 (~3000 pieces)
(opposite top) Trinity Apartment Blocks 2013 (~9000 pieces)
(opposite bottom) Gator Airboat 2012 (~100 pieces)

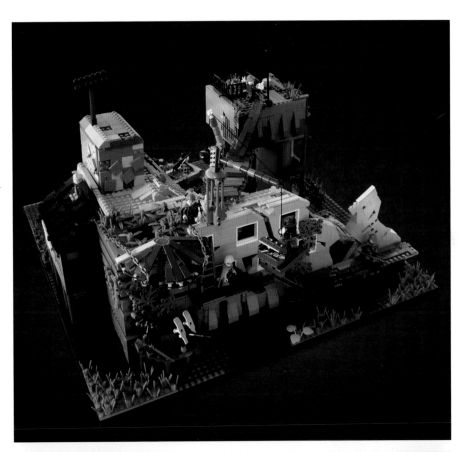

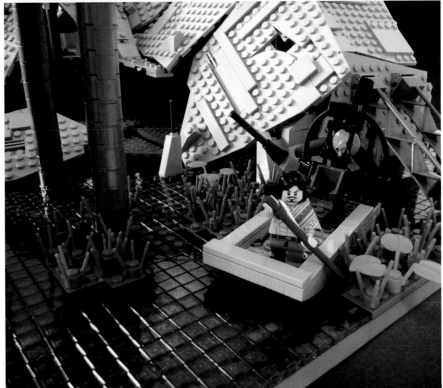

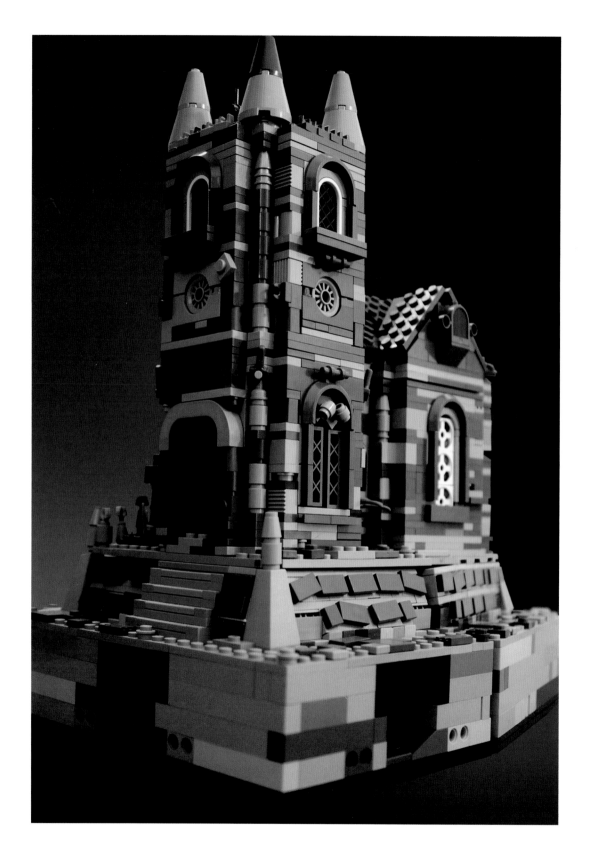

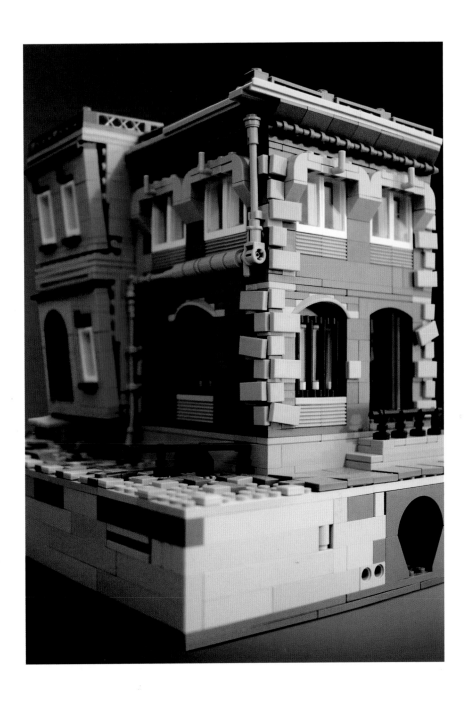

Nicholas de Vry

(opposite) Haunted Church 2011
(above) Alley Way 2011

Dark Towers

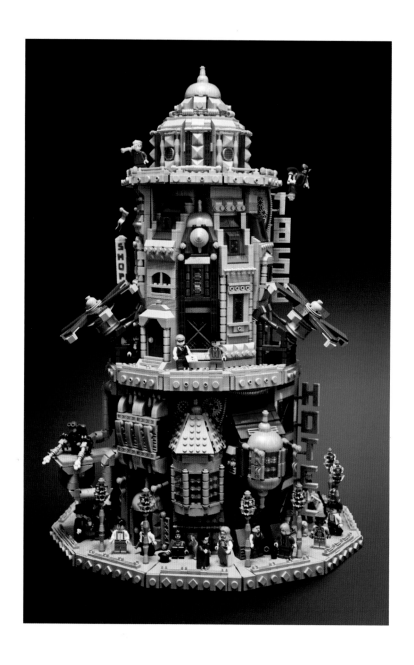

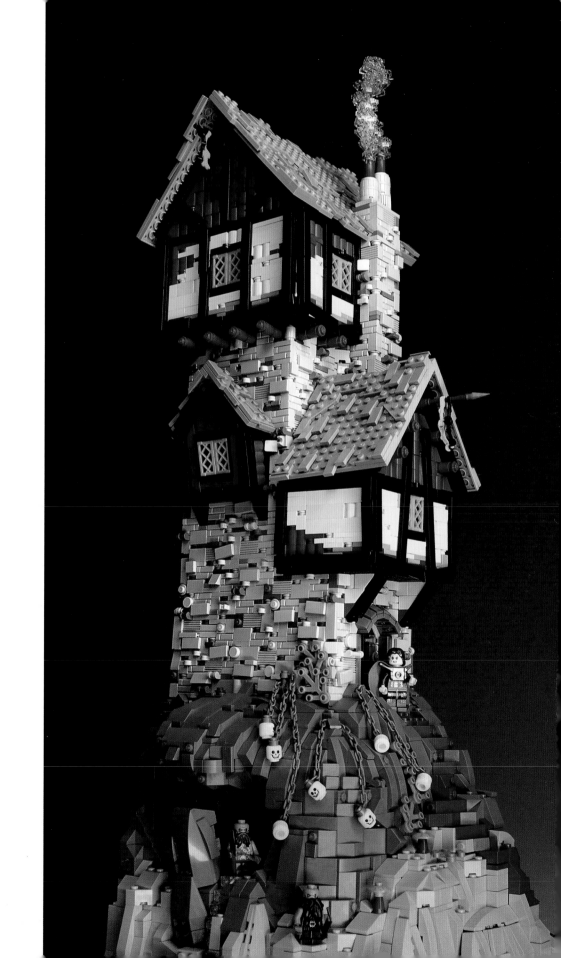

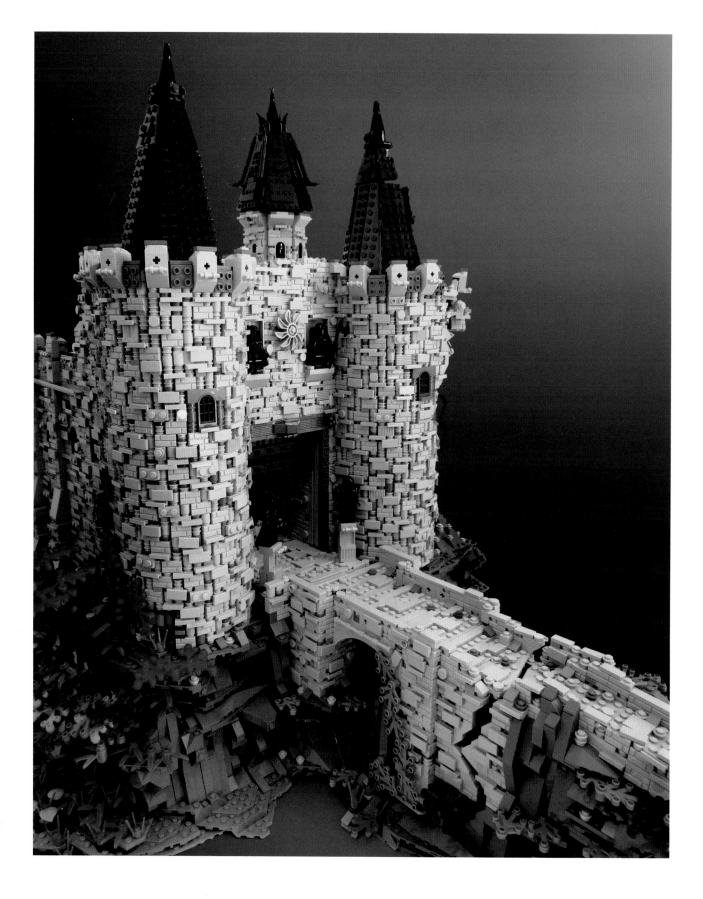

Lionel Martin
Untitled 2013 (1500+ pieces)

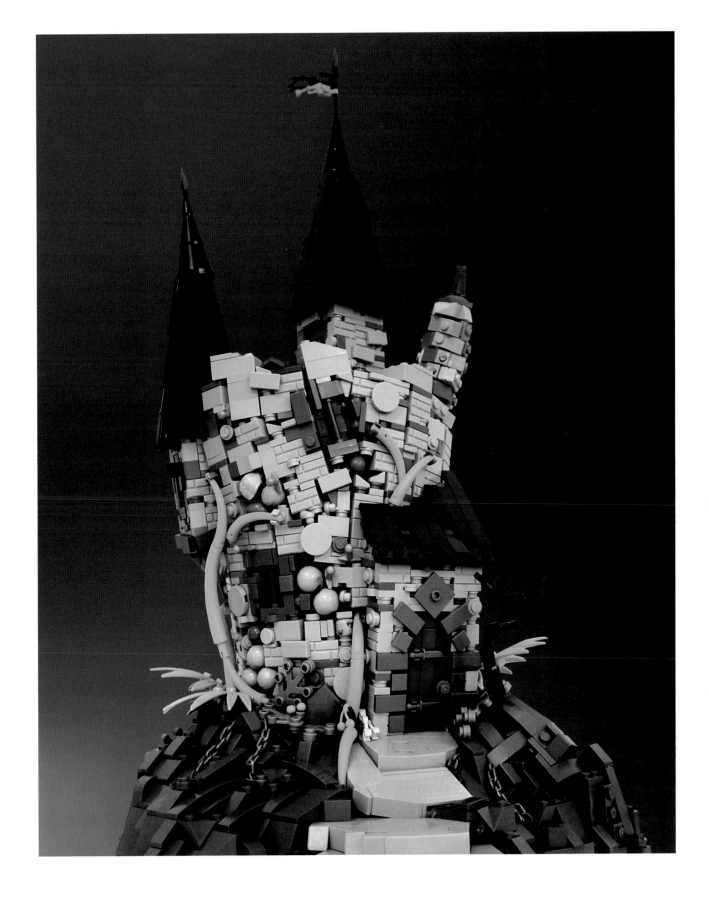

David Hensel
Moruth Outpost 2013 (~800 pieces)

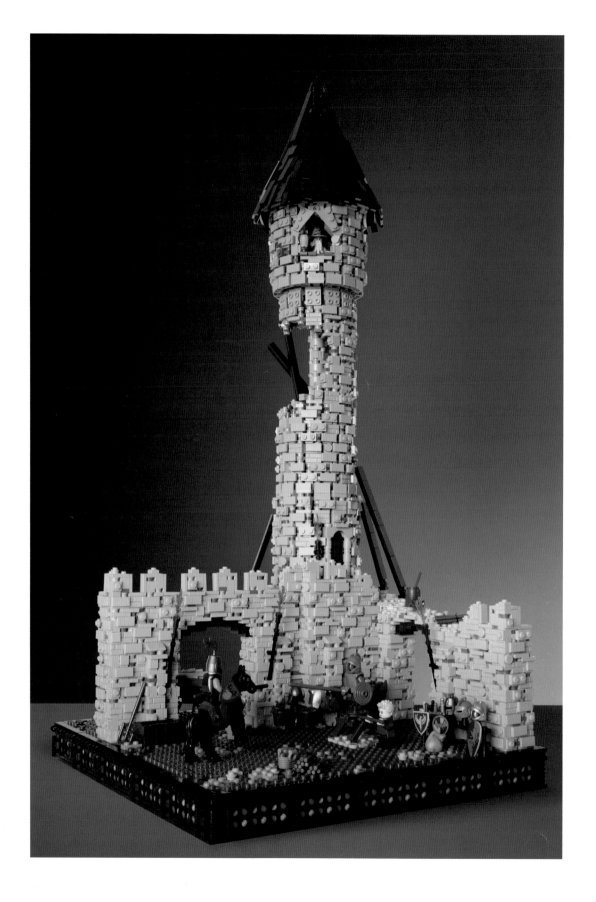

Luke Hutchinson
The Sword in the Stone 2013

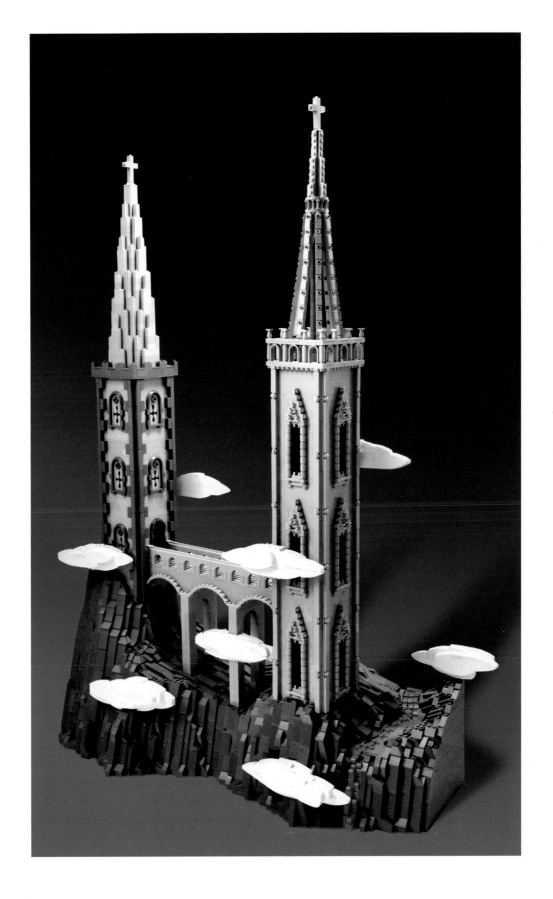

Lukasz Wiktorowicz
Twin Towers 2013

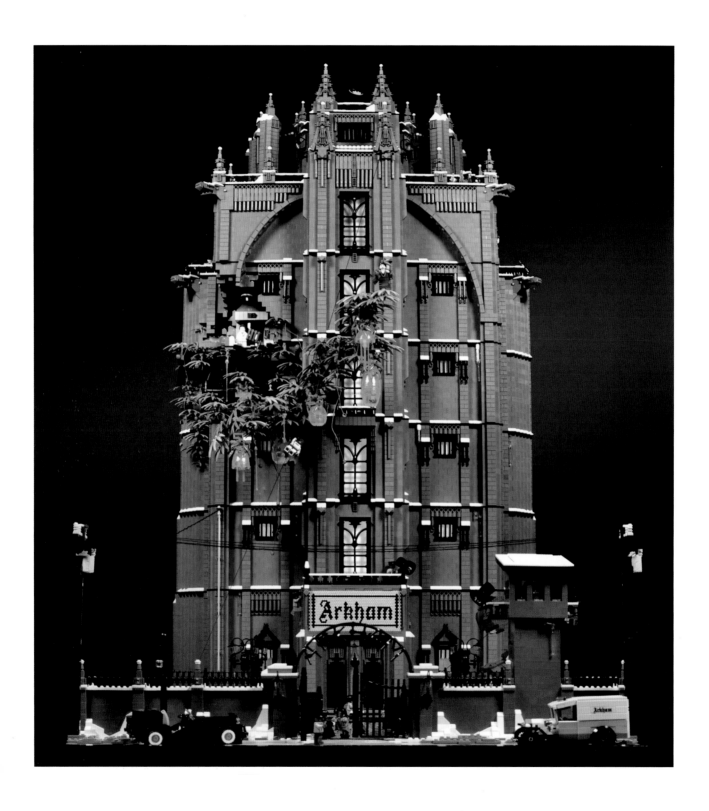

Thorsten Bonsch
Arkham Asylum 2012–2013 (~36,000 pieces)

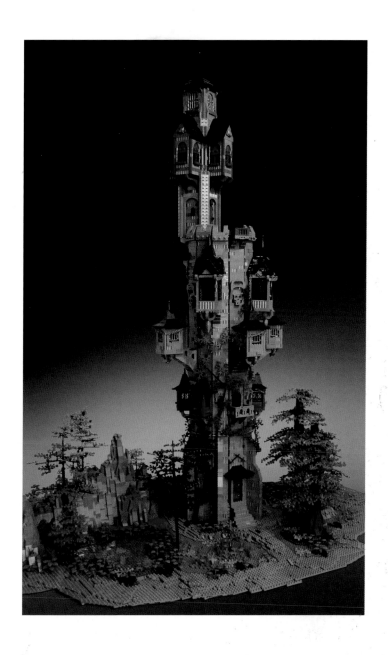

Paweł Michalak
The Tower 2012 (~8000–10,000 pieces)

Desolate

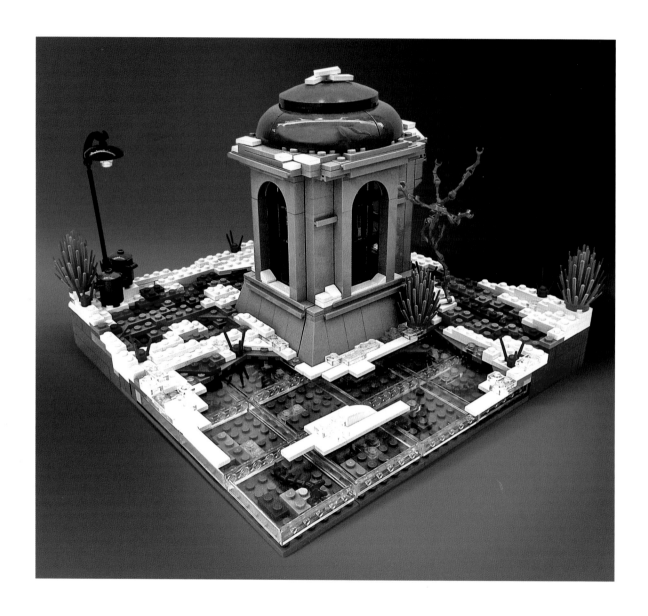

(above)
Günther Möbius
Winter Pavilion 2012 (~800 pieces)

(opposite)
David Hensel
Crow's Nest 2013 (1600 pieces)

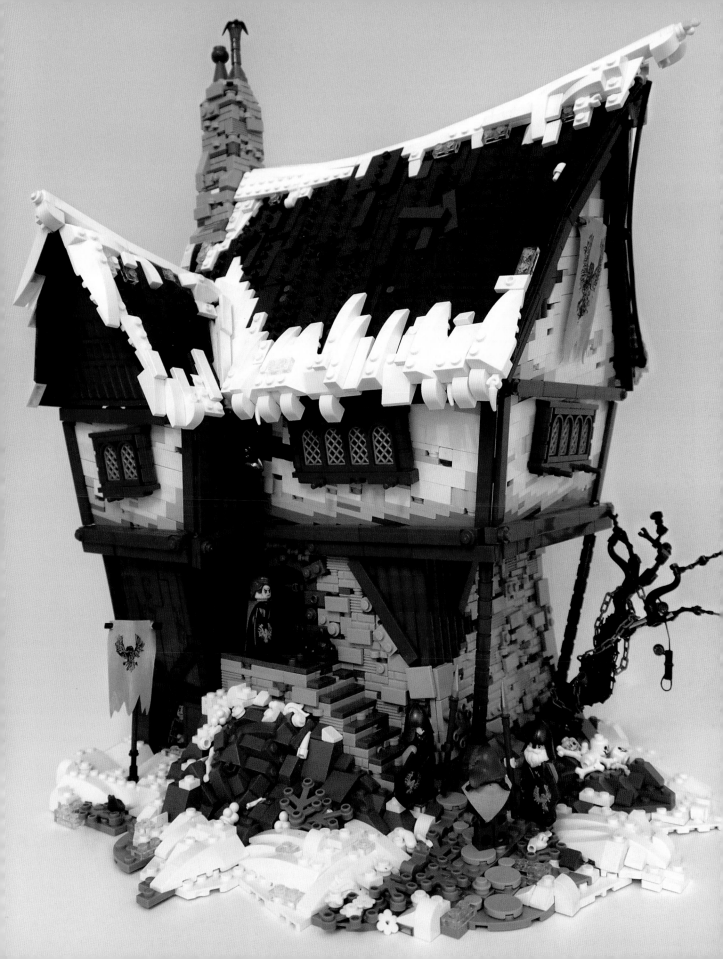

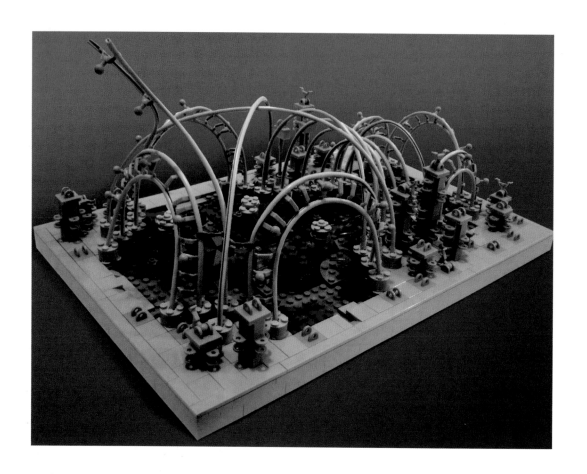

Chris Edwards
Gaudia 2013

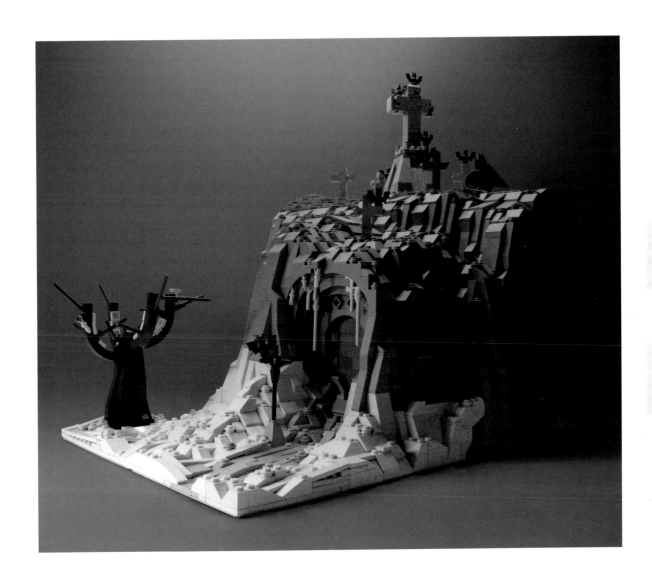

Lucasz Wiktorowicz
The Last Court 2012

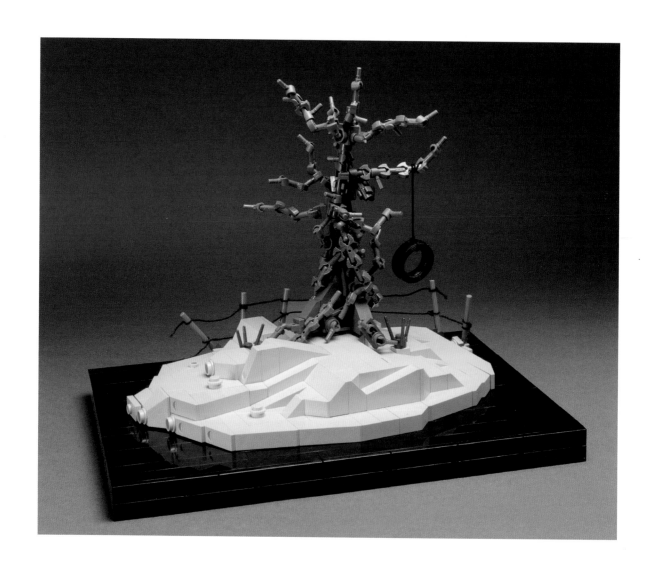

Peter Reid
Wasteland 2009 (247 pieces)

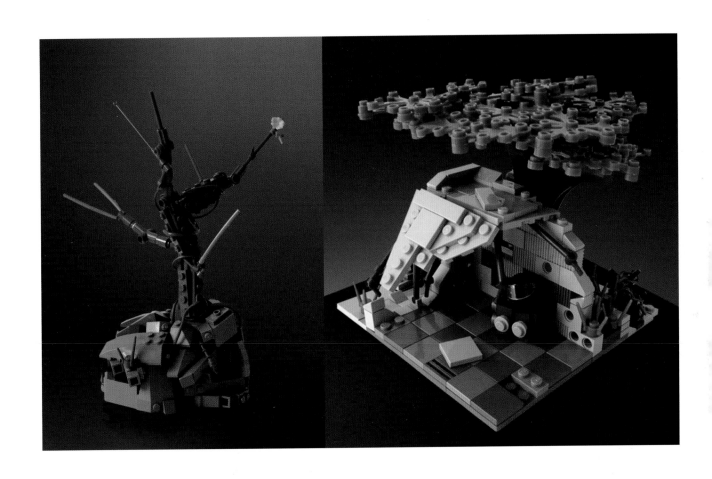

(left)
Jonas Kramm
Hope 2013

(right)
Evan Bordessa
Bricks of the Dead – 16×16 Challenge 2012 (~250 pieces)

155

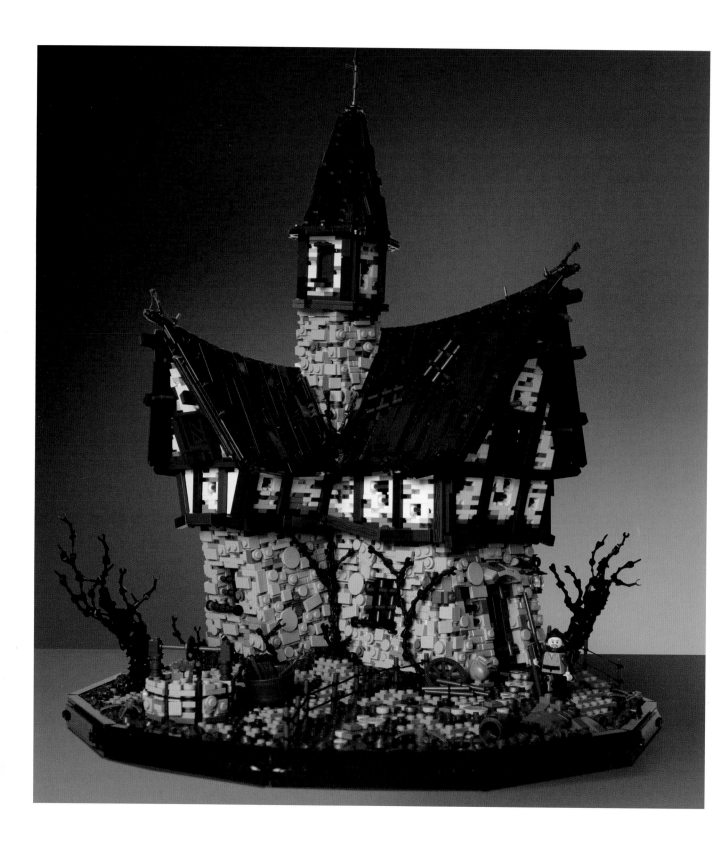

Luke Hutchinson
Gloomy Gulch 2014

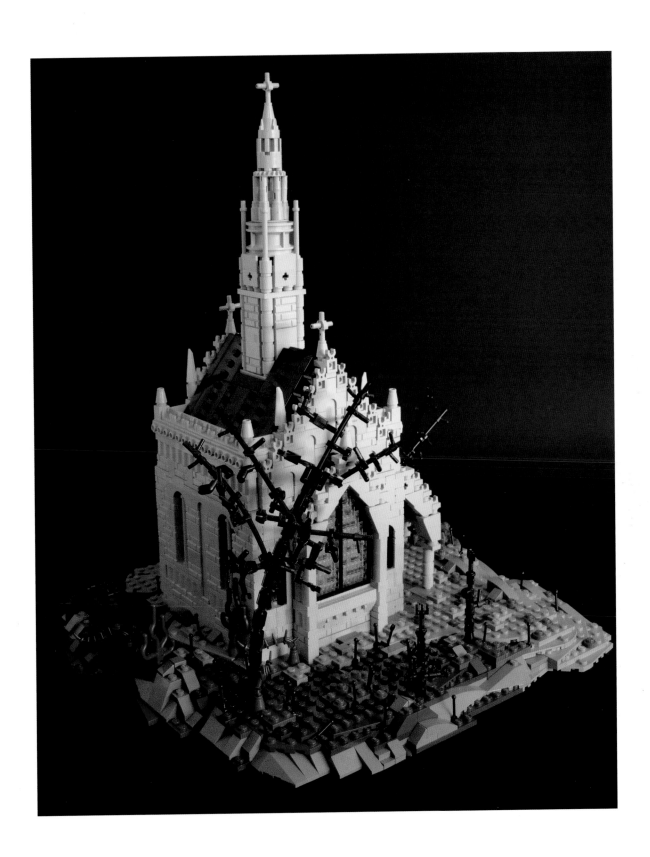

Maciej Kocot
The Nocturnal Chapel 2014 (~1000 pieces)

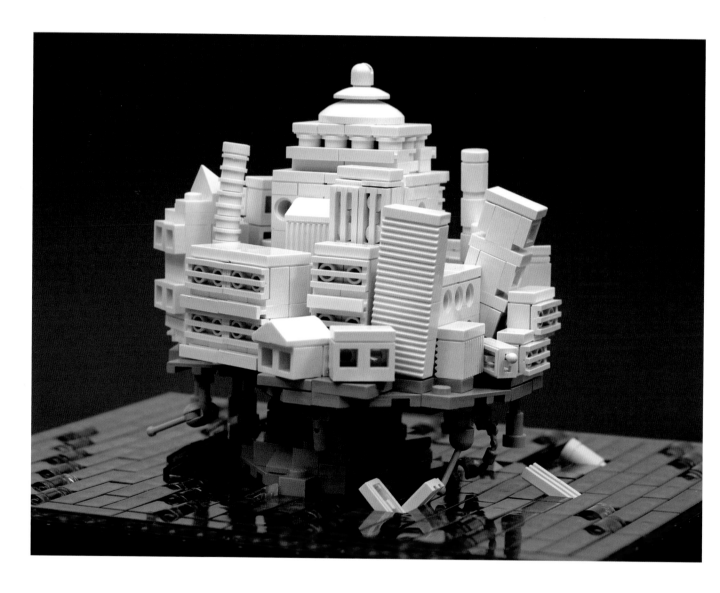

Jason Allemann
Abandoned Sea City 2014 (~300 pieces)

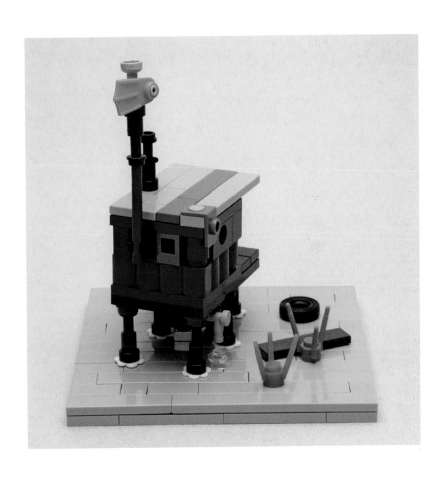

Rob van Hoesel
Stranded 2013 (~125 pieces)

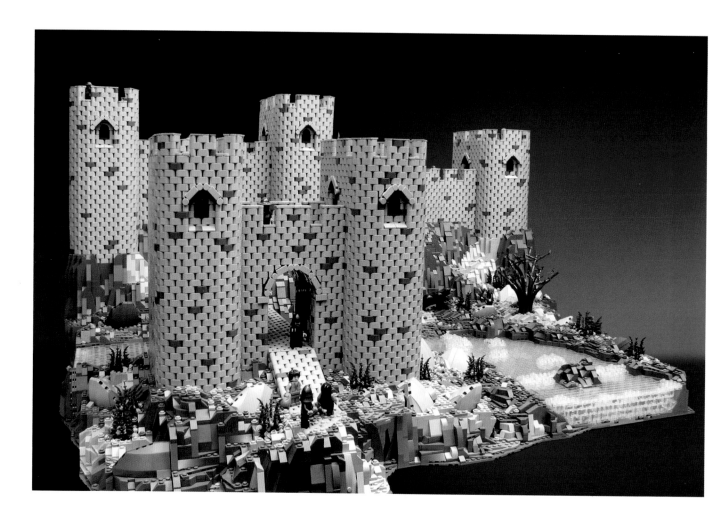

Gareth Johnstone
Elador 2013

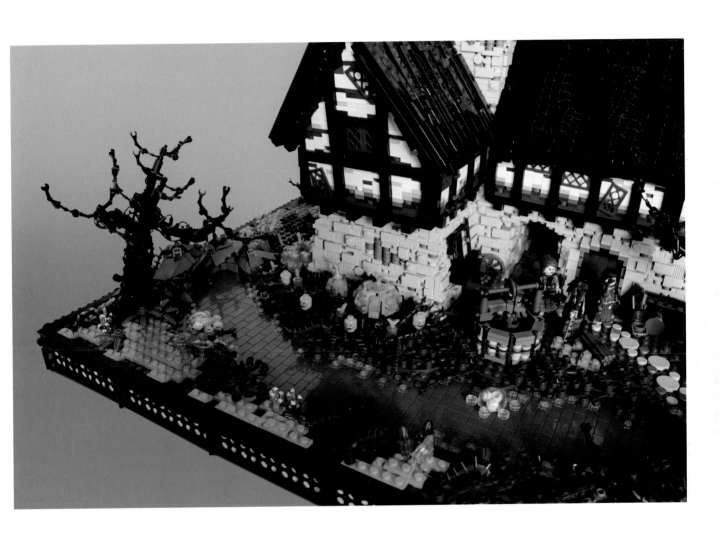

Luke Hutchinson
Mystic Manor 2013

Brian Kescenovitz

LEGO is my perfect artistic medium. It is a vast, ever expanding, reusable toolset to bring your imagination to life. It is simple enough for children to use, but complex enough that, like most art forms, you can never truly master it. But what is it about LEGO that I believe fits me better than other artistic mediums? Ironically, the answer is not found in the vast creative freedom LEGO allows, but rather in the limitations it imposes.

For better or worse, I tend to be a bit of a perfectionist in my creative pursuits. I change and tweak and revise and redo things until they are just so, and LEGO certainly lends itself to doing just that. Don't like how a certain brick or section of a build looks? Just pull it off and redo it—no mess, no fuss, no waiting for paint to dry or erasing wayward pencil marks. It's a good deal simpler to use than traditional artistic mediums. So simple, in fact, that a hopeless perfectionist such as myself could potentially continue to change and tweak things indefinitely and never actually finish the piece . . . right?

Ah, but there in lies the beauty of LEGO as a medium for someone like me. Though there is certainly no end to the types of creations that you can build with LEGO, you do have a finite selection of colors and pieces to work with. You are also limited by the ways in which individual pieces can interact with and attach to other pieces.

These limits allow me to focus on a few important aspects of design, like form and composition, and not worry about making the perfect brushstroke or mixing just the right shade of mauve. So for me, LEGO is a less daunting framework within which to create things.

Indeed, rather than restricting my creativity, I find that working within the LEGO framework inspires the confidence to take chances and push the limits of what is possible. And that, my friends, is where it really gets fun: taking those humble little bricks and finessing them into something that is so much more than the sum of its parts. It's like solving a puzzle; finding just the right combination of parts to use or coming up with a new way to connect a piece brings with it an immense sense of satisfaction and enjoyment.

Of course, being fussy is not a requirement to build with LEGO. The medium lends itself to all ages and levels of ability, from Master Builders to children picking up bricks for that magical first time. But for me at least, working in LEGO provides me with something of great value that I struggle to find in many of my other pursuits: the ability to actually finish what I start.

Broken 2013 (~210 pieces)

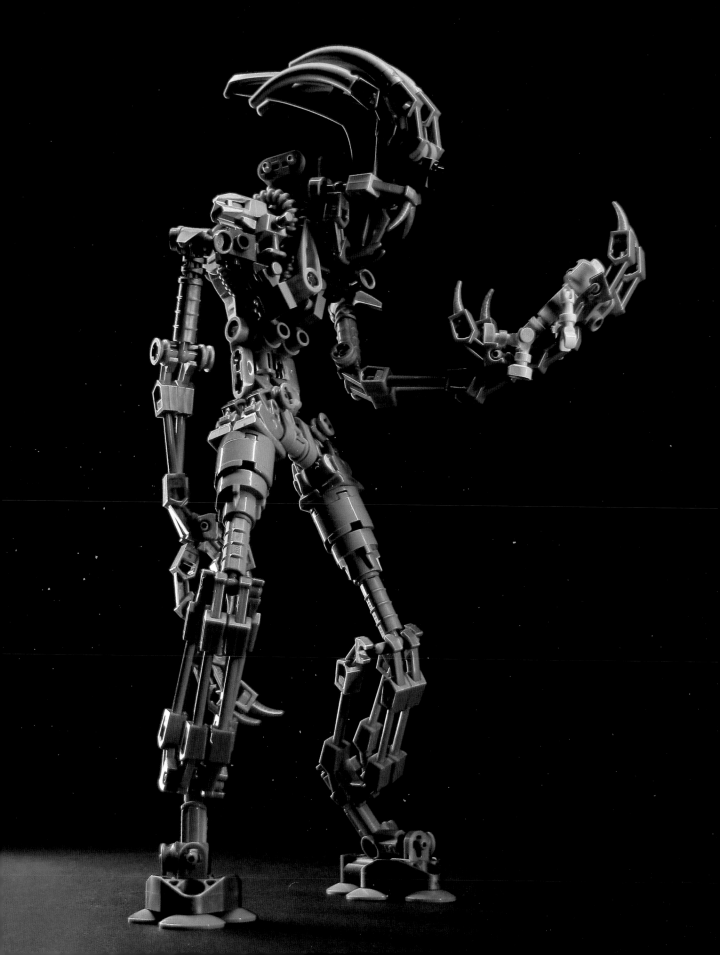

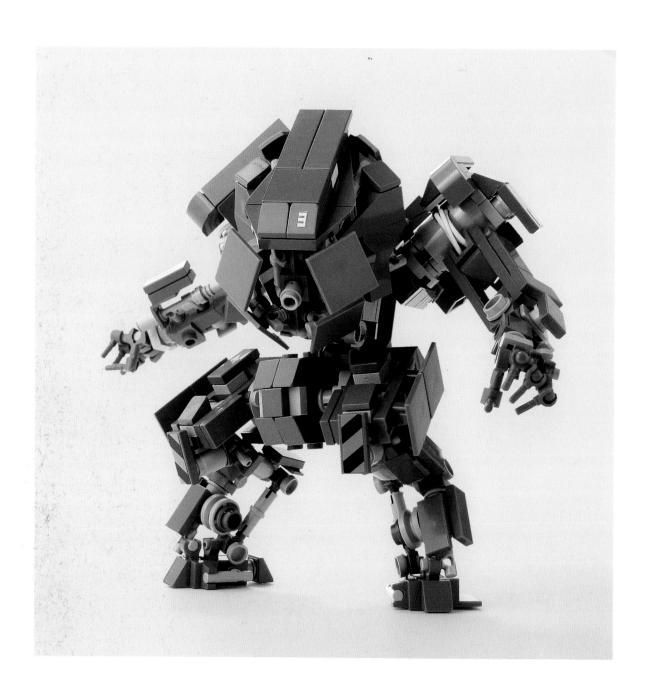

WEAVER Heavy Combat Armor 2013 (~410 pieces)

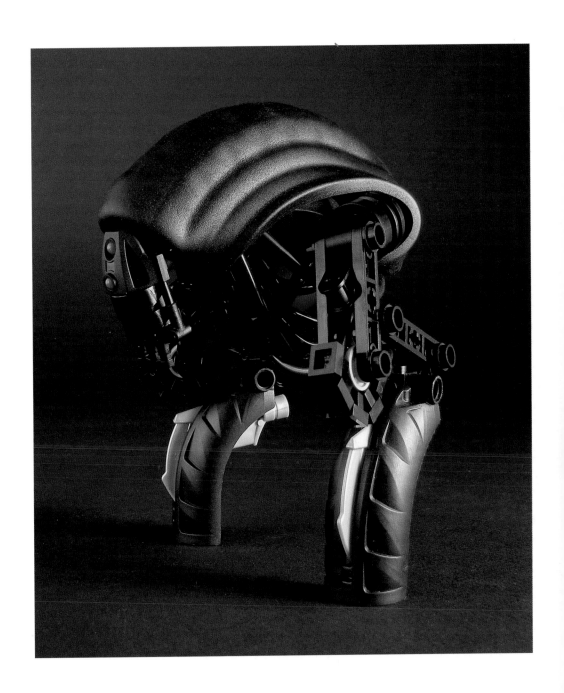

Dreamstalker 2013 (~85 pieces)

LEGO Venus de Milo 2012 (25 pieces)

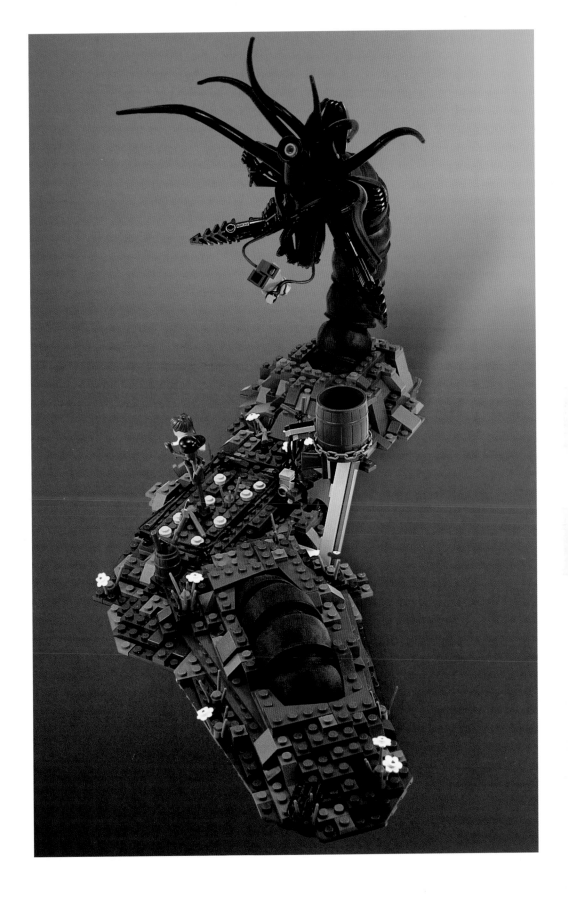

Ephram's Garden 2008 (~600 pieces)

Indulgences

Kosmas Santosa
A Box of Chocolate 2014

Matthew Oh
Hershey Bars 2012 (320 pieces)

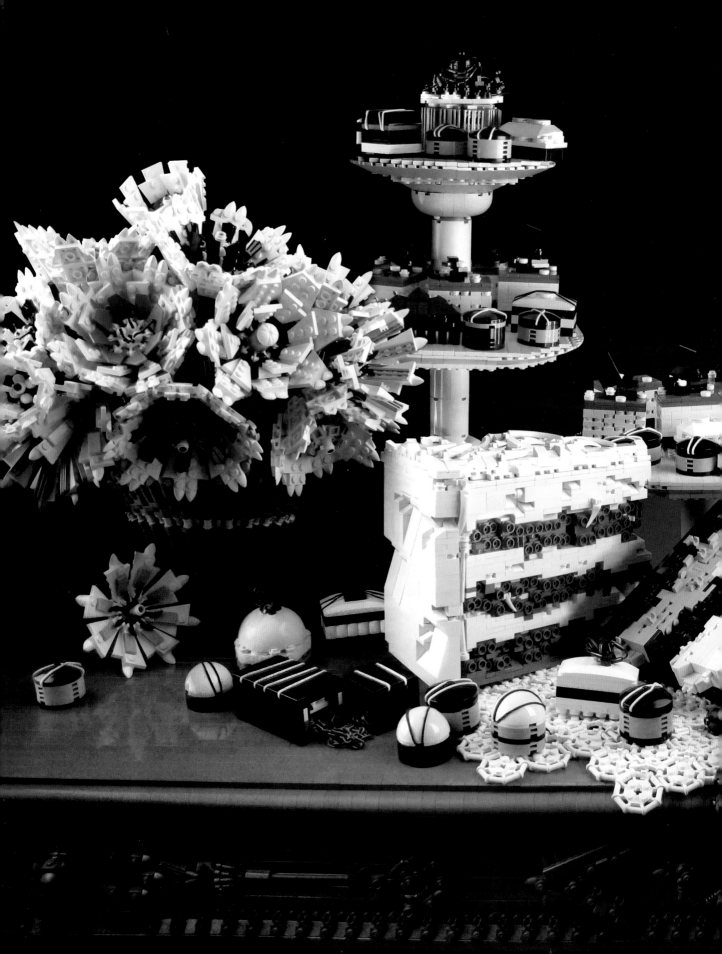

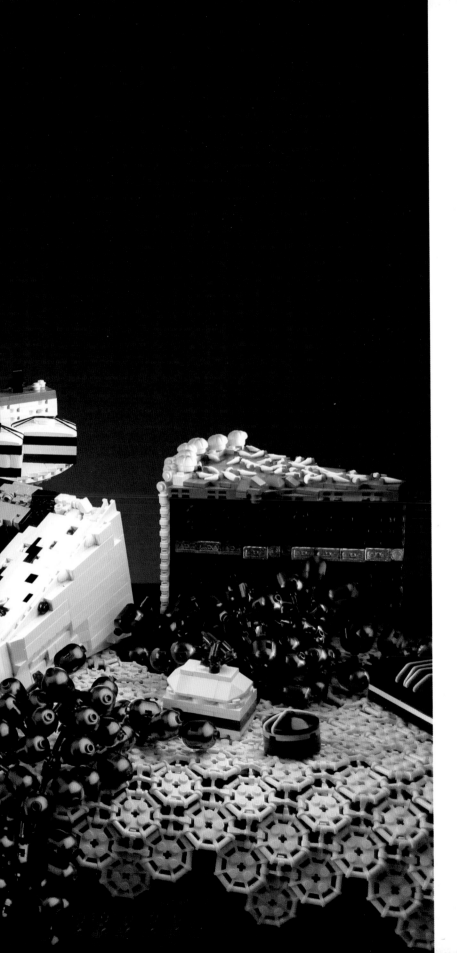

Mike Doyle
Sickening Sweet
2014 (~10,000 pieces)

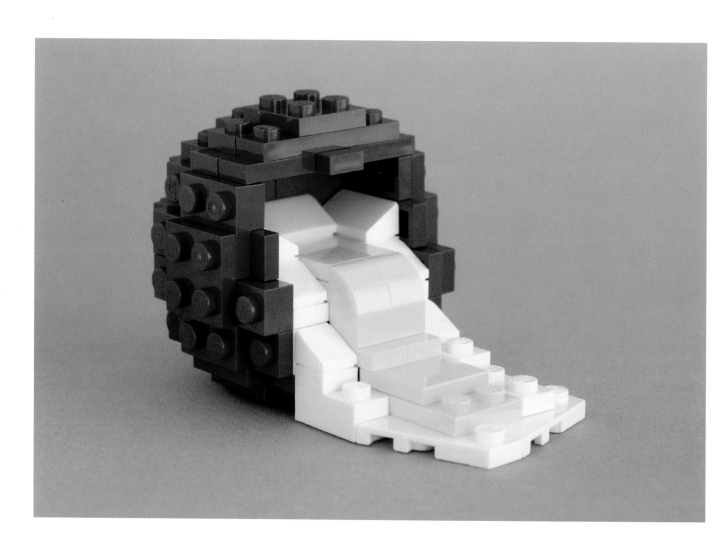

Chris McVeigh
Creme Egg 2013 (115 pieces)

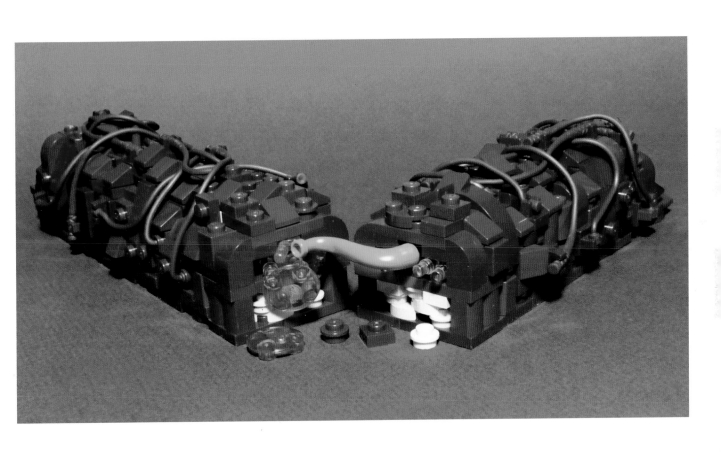

Taylor Baggs
Twix Bar 2012

Make. Pollute. Make.

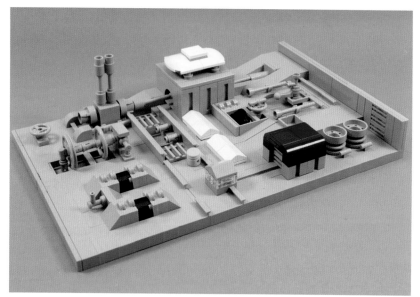

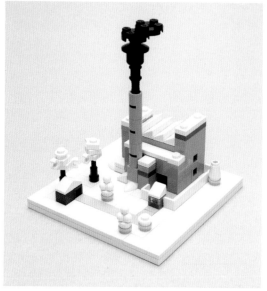

Rob van Hoesel

(top) Home-to-work 2013 (~160 pieces)
(bottom) Sanitation 2013 (~350 pieces)

(opposite)
Kosmas Santosa
A Deep Breath 2014

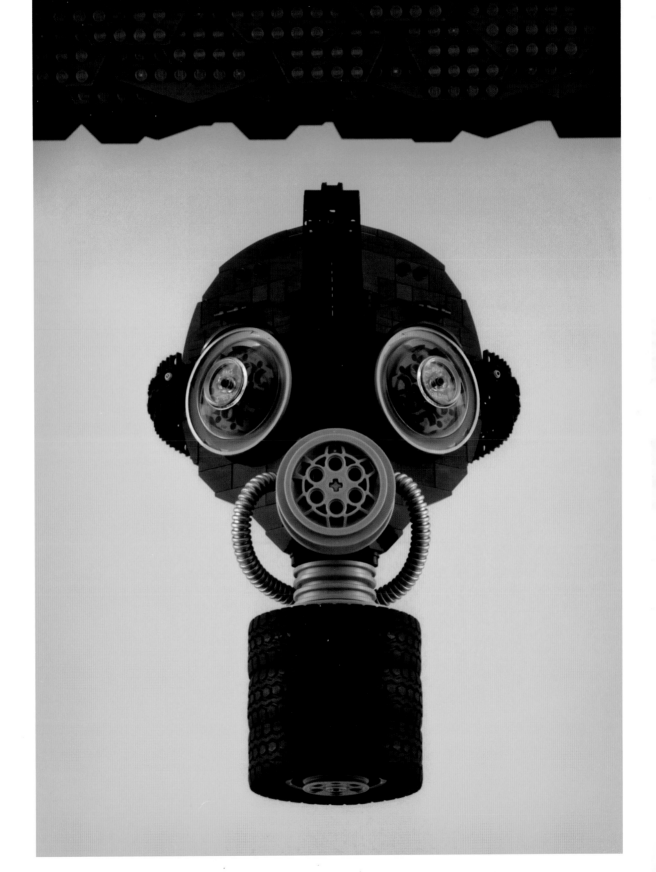

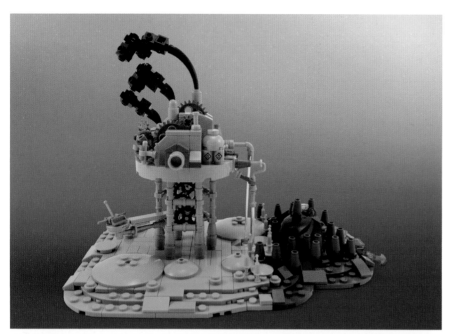

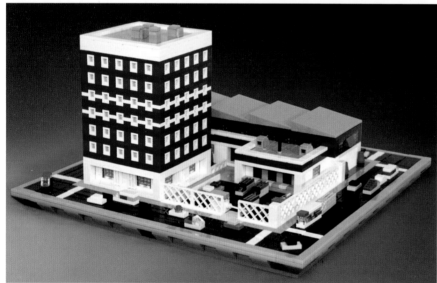

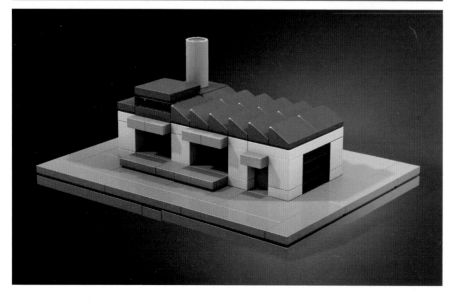

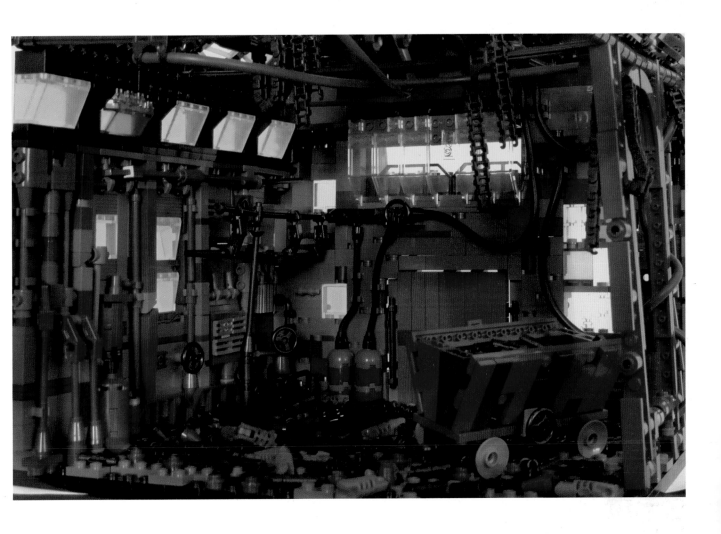

(above)
Maciej Kocot
Abandoned Factory 2014 (~900 pieces)

(opposite top)
Aaron Van Cleave
Going (Toxic) Green 2014 (~750 pieces)

(opposite middle)
Joe Miserendino
Thompson Machine Works 2013 (~1500 pieces)

(opposite bottom)
Nikolay Abalov
Micro Plant [digital render] 2012 (109 pieces)

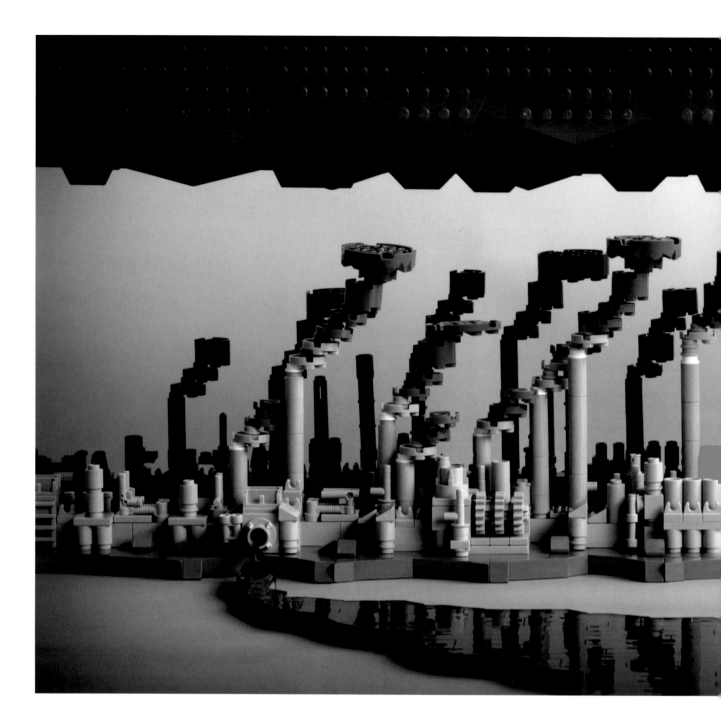

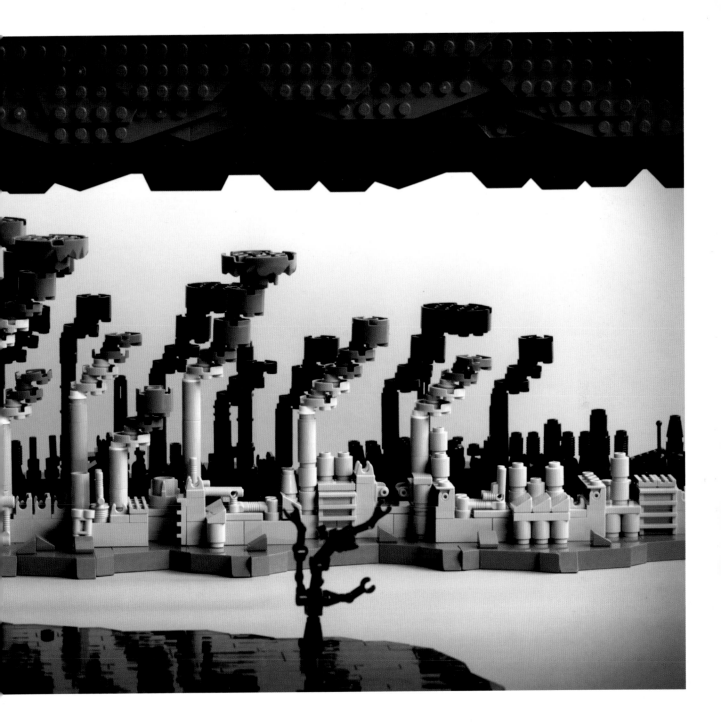

Kosmas Santosa
The Factory 2014

The Robber Barons

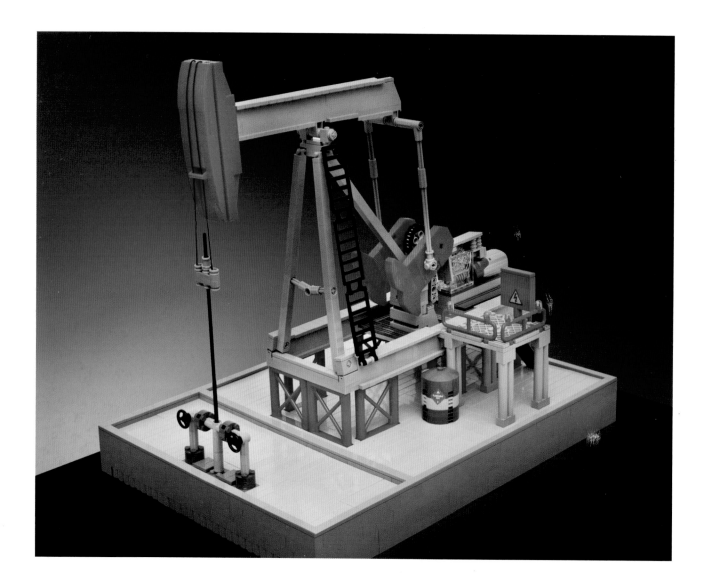

Gilcélio de Souza Chagas
Pumpjack 2013 (~900 pieces)

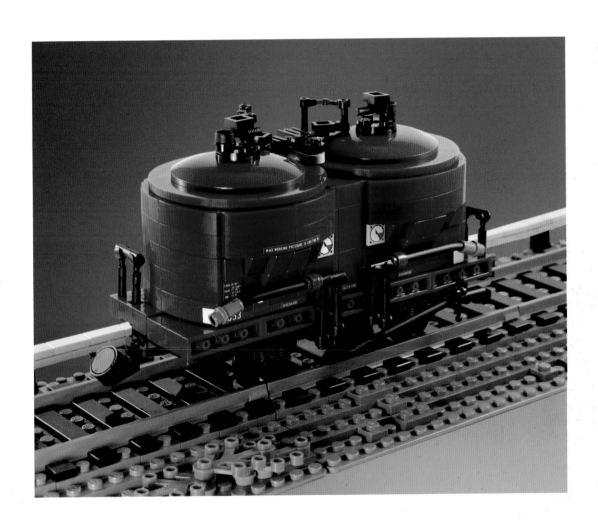

Mike Pianta
Victorian Railways J Cement Hopper 2010 (~300 pieces)

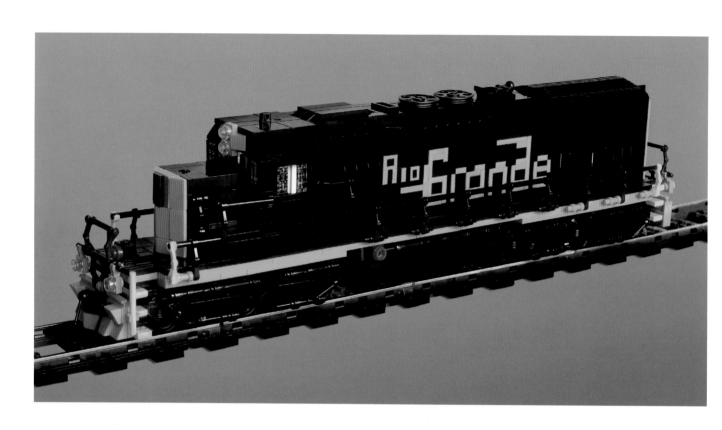

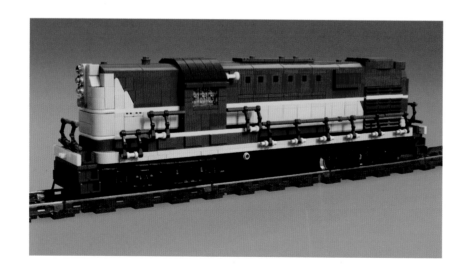

Falk Schulz

(top) The Queen of the Rio Grande 2012 (1365 pieces)
(bottom) 1950s ALCO Roadswitcher 2013 (1270 pieces)

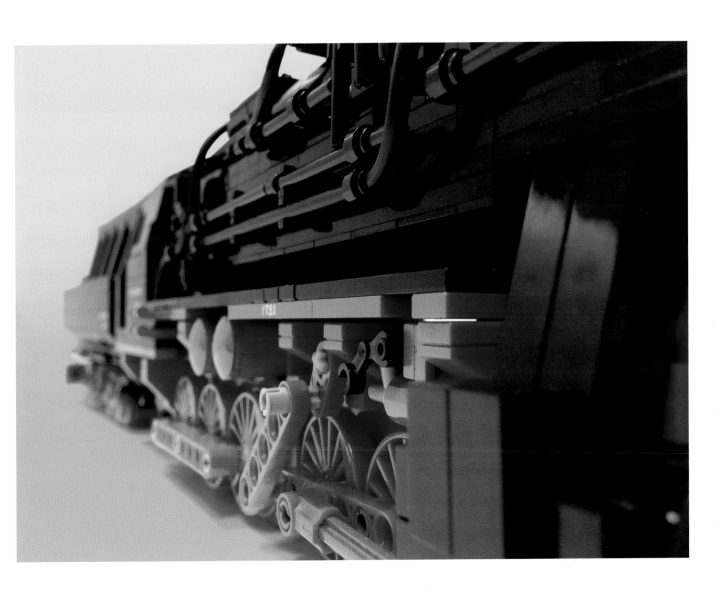

Yo Sub Joo
BR 52 2011 (~800 pieces)

Greed Co., Unlimited

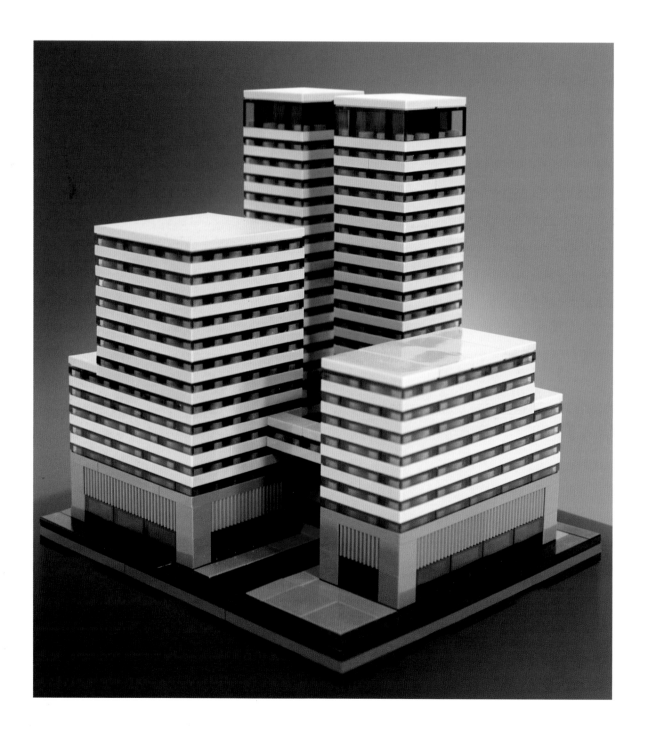

Joe Miserendino
National Secrets 2013 (400–500 pieces)

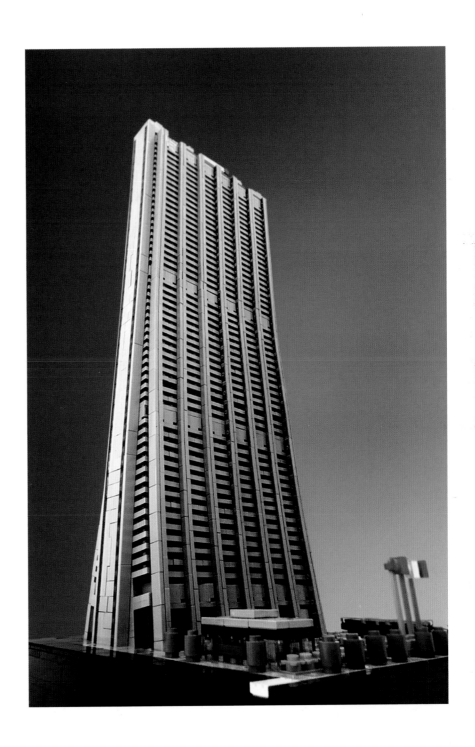

Rocco Buttliere
Chase Tower, Chicago 2014 (~5300 pieces)

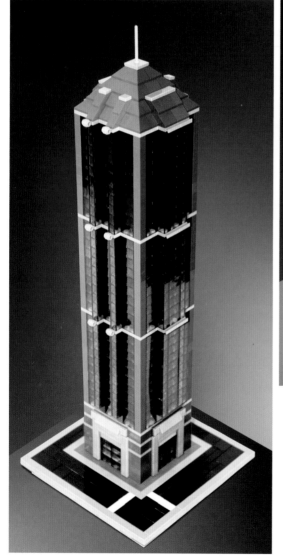
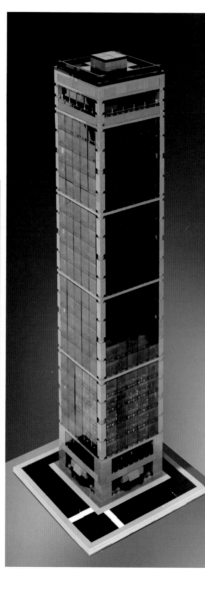
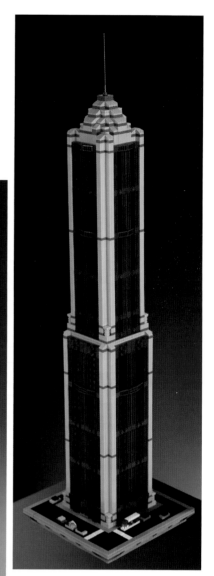

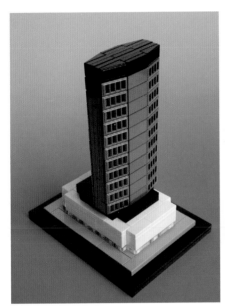

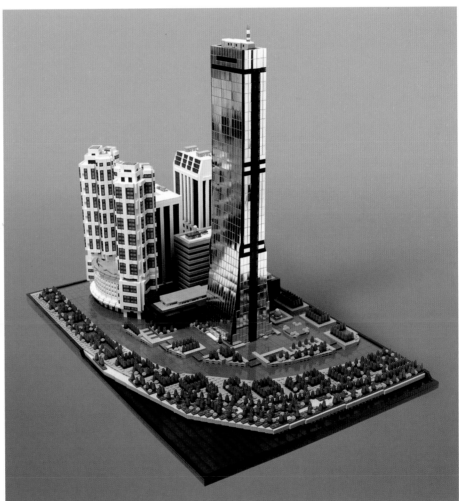

Joe Miserendino

(opposite left) Grayling Tower 2013 (~1000 pieces)
(opposite middle) Dark Inc HQ 2012 (~1200 pieces)
(opposite right) The Bancroft 2011 (~1200 pieces)

(left)
Jens Ohrndorf
MetLife Building, NYC, USA 2011 (~200 pieces)

(right)
Yo Sub Joo
63 Building in Yeouido, Seoul, South Korea 2013 (~14,000 pieces)

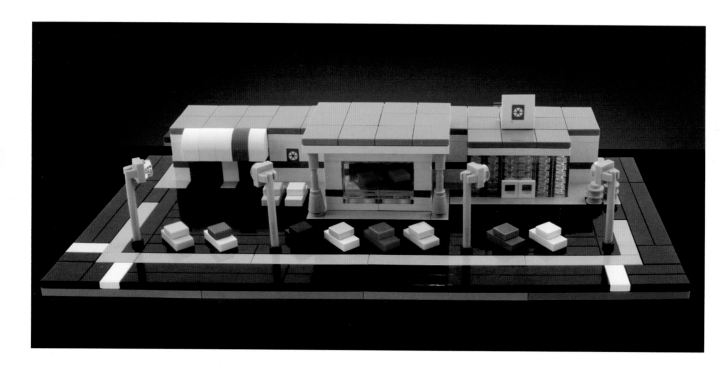

John Stephens
Micropolis Motors 2013 (~375 pieces)

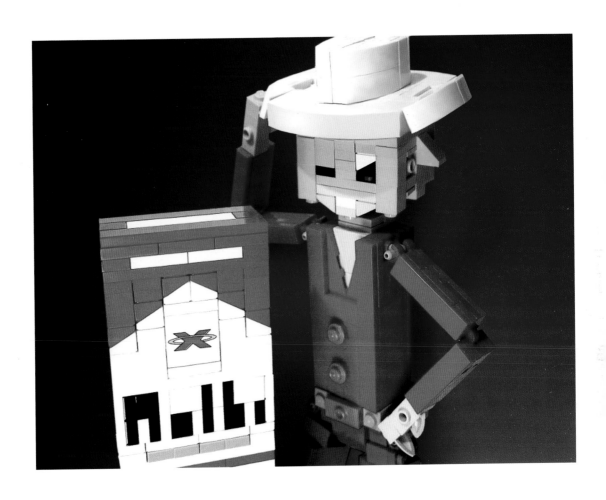

Ieyasu Tse
Cowboy and Marlboro 2011 (~400 pieces)

Oh the Horror!

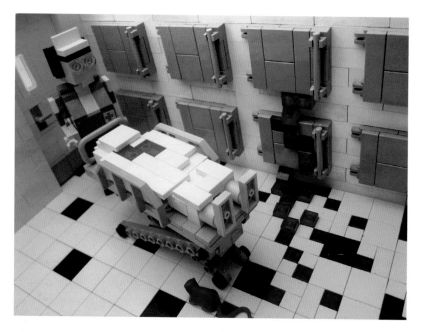

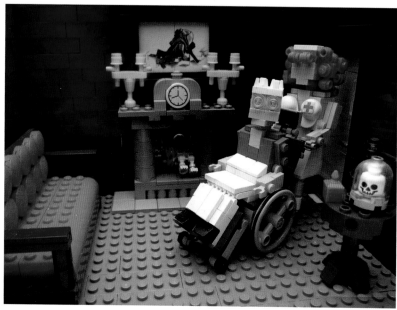

Dan Parker and Team
at Dan Parker LEGO Artist

(top) One for the Freezer 2009 (~900 pieces)
(bottom) Visiting Hours 2009 (~850 pieces)
(opposite top) Cavities 2009 (~1125 pieces)
(opposite left) Removal 2009 (~1040 pieces)
(opposite right) Roommates 2009 (~700 pieces)

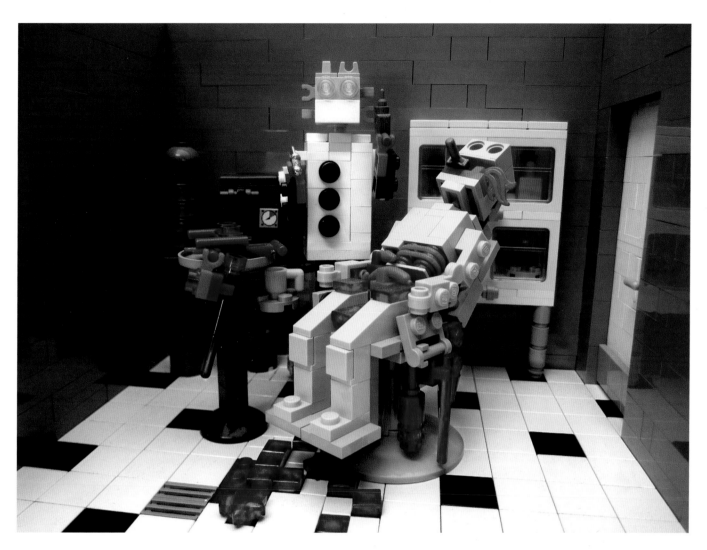

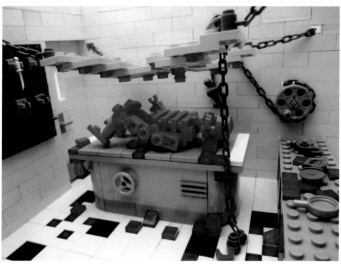

Pits of Fire

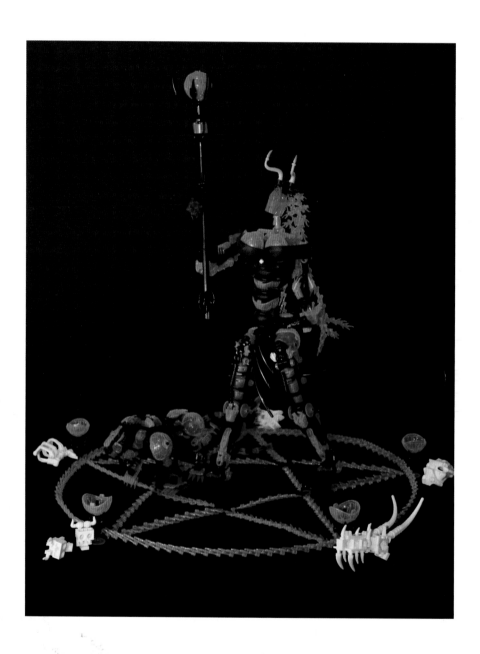

Sean and Steph Mayo
Flame Atronach 2012

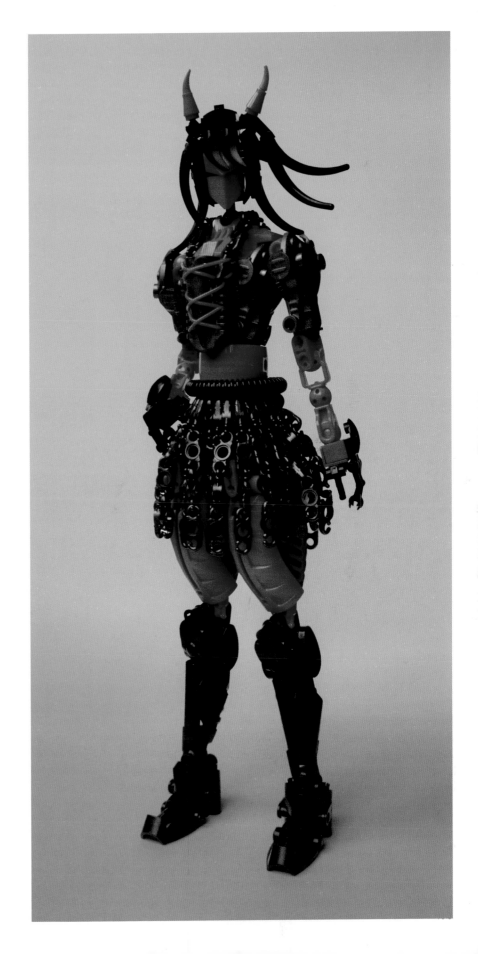

Eero Okkonen
Belsa 2013 (~270 pieces)

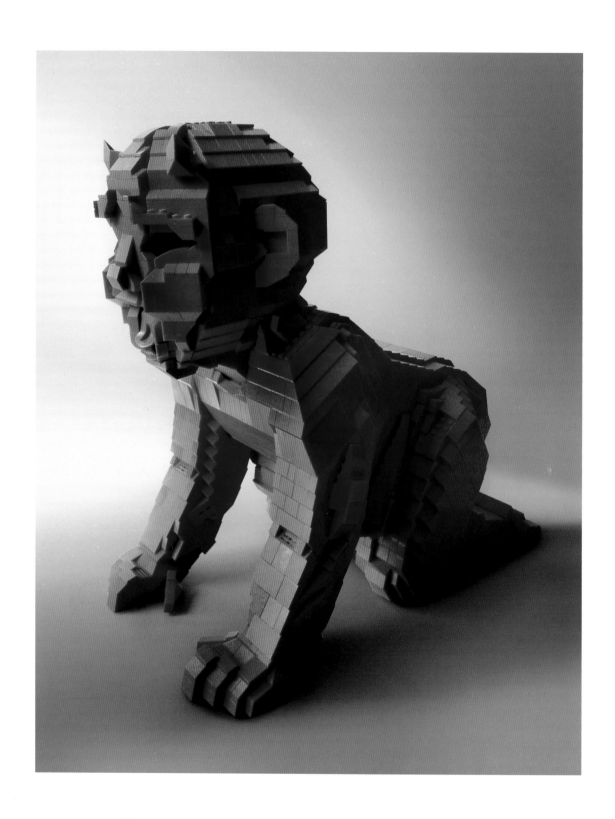

Ekow Nimako
Junior 2013 (~9400 pieces)

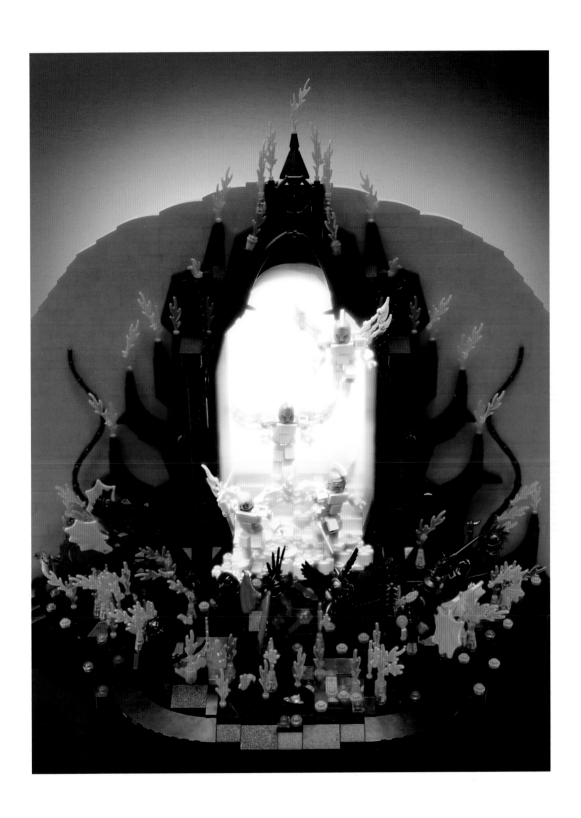

Mark Erickson
Assault on the Underworld 2 2013 (5000+ pieces)

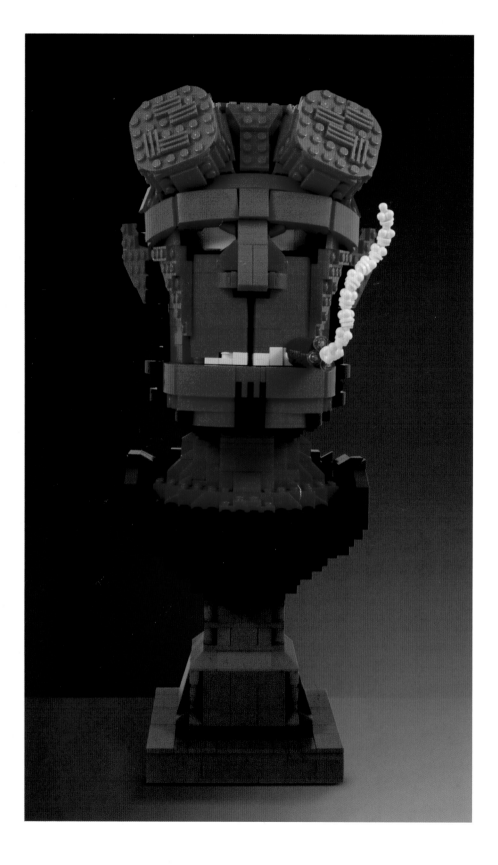

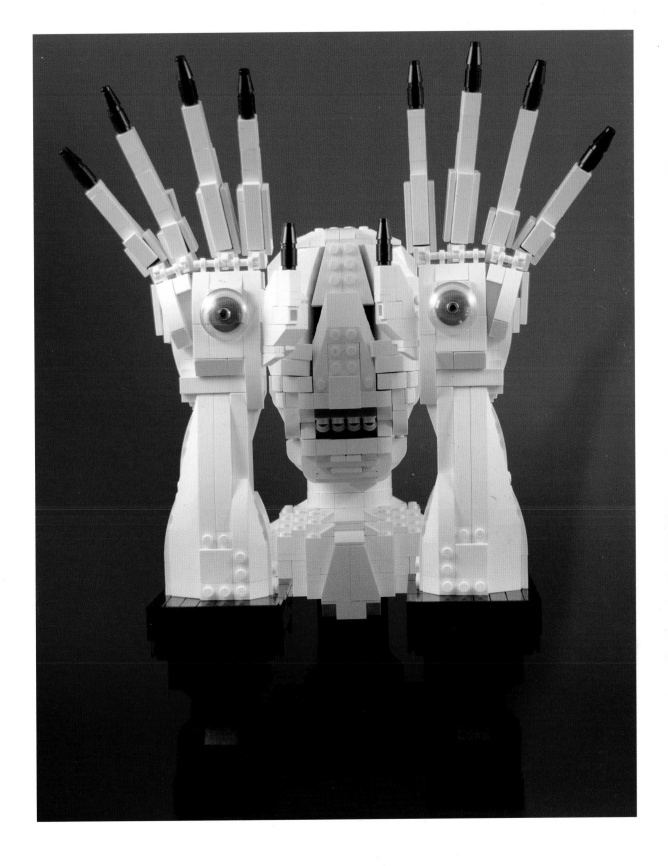

Tyler Halliwell

(opposite) Hellboy 2014
(above) The Pale Man 2014

197

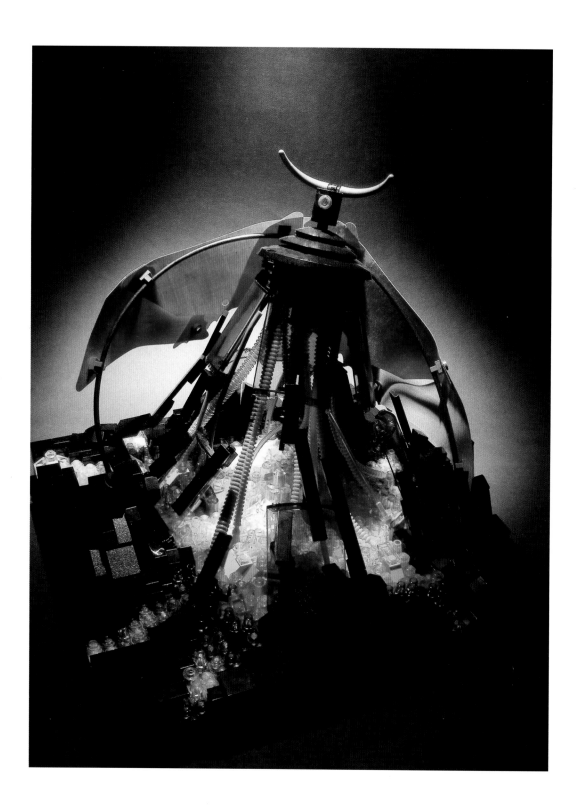

Cole Blaq
Aural Demon 2010

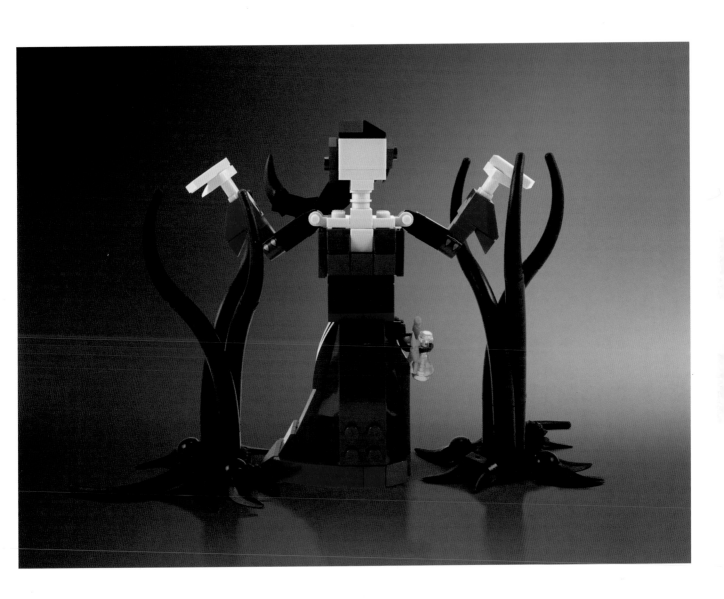

Aaron Van Cleave
Morgan Le Fay 2014 (180 pieces)

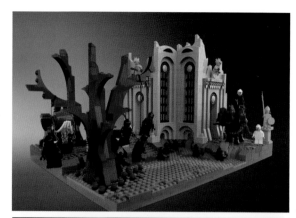

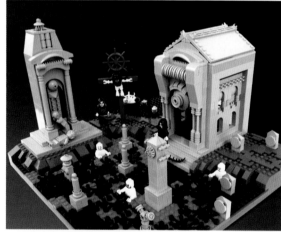

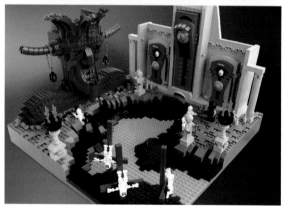

Mihai Marius Mihu

from the
Nine Circles of Hell 2011–2012

(top) Violence
(center) Anger
(bottom) Heresy

(opposite top) Greed
(opposite bottom) Gluttony

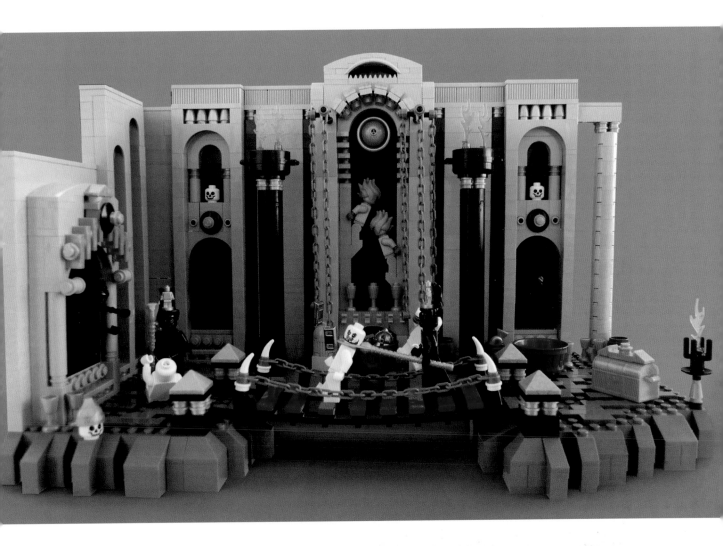

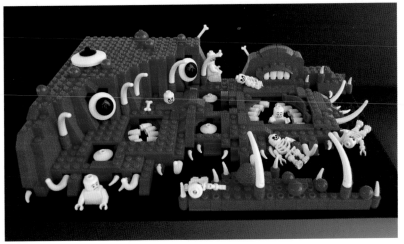

Beastiary

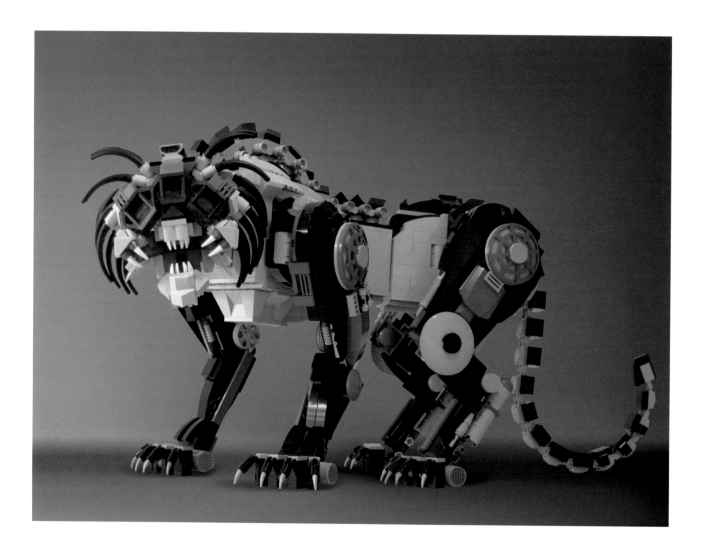

Shawn Snyder
Ultimate Predator 2008

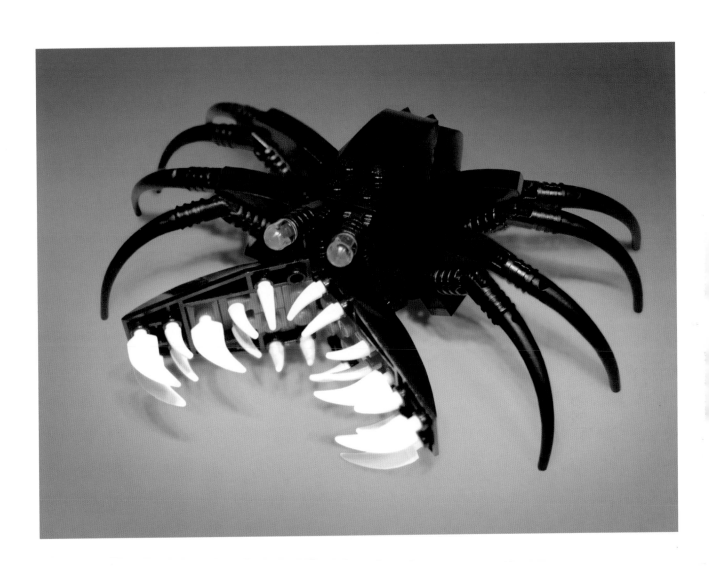

Bart De Dobbelaer
Spider Crab 2010 (100 pieces)

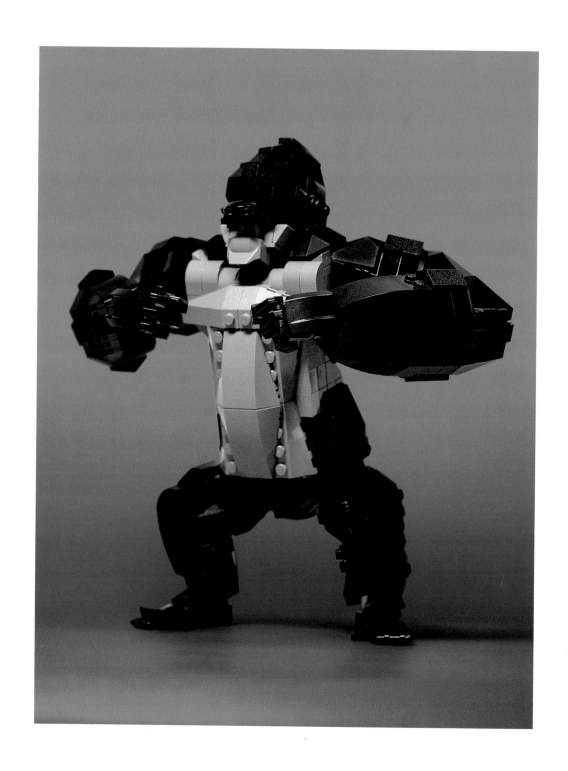

Ken Ito
King Kong 2013 (~350 pieces)

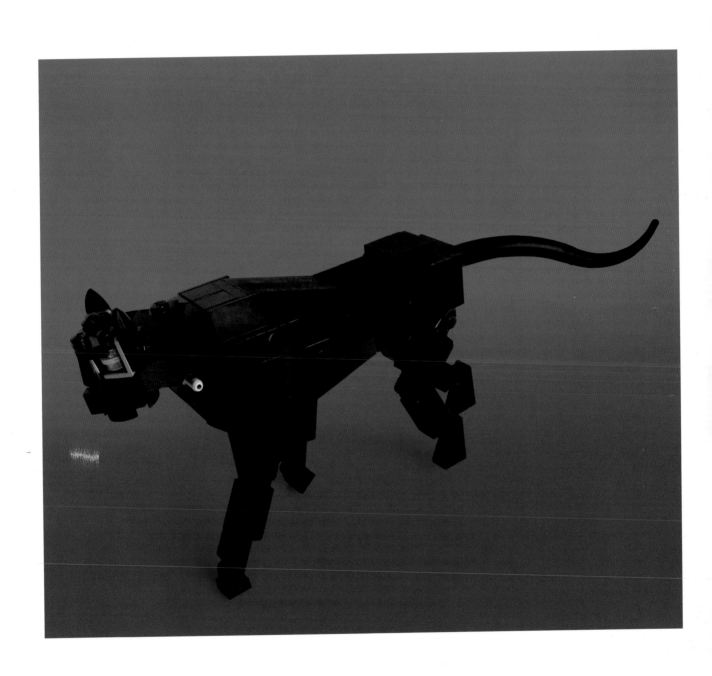

Joe Perez
Black Panther 2012 (~150 pieces)

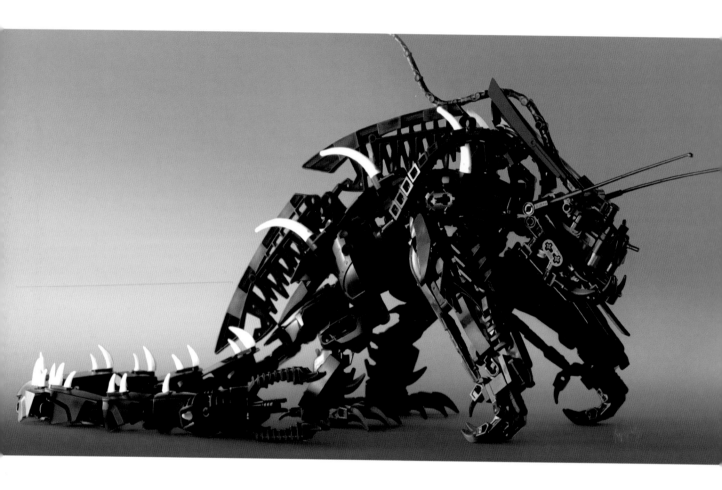

Kosmas Santosa
The Beast 2014

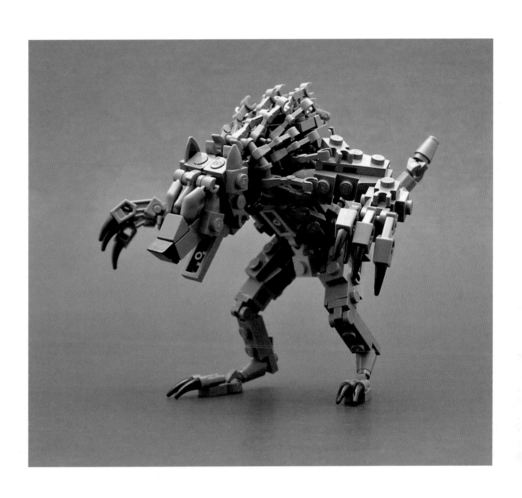

Tyler Clites
Big Bad Wolf 2010

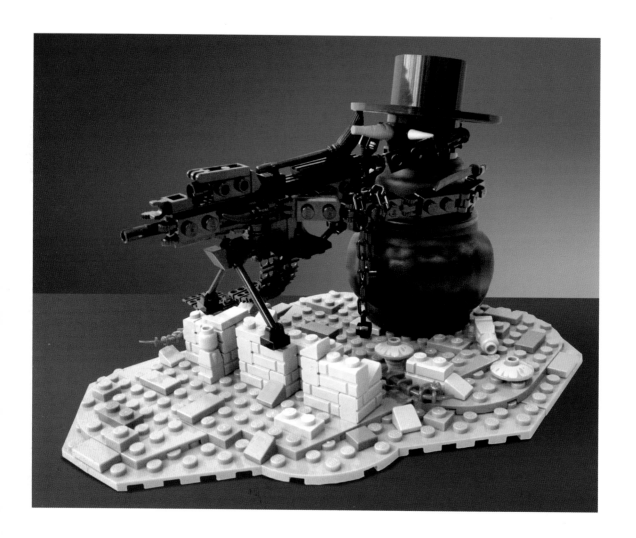

Alexander Megerle
Operation Frostbite 2014 (~210 pieces)

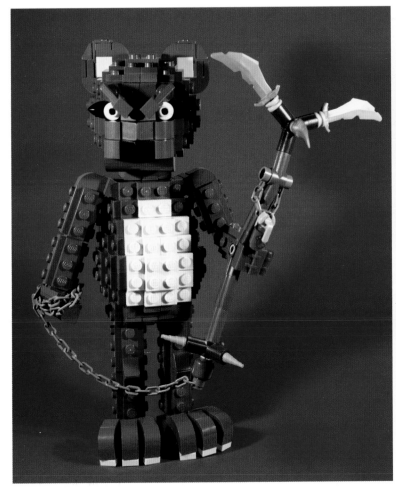
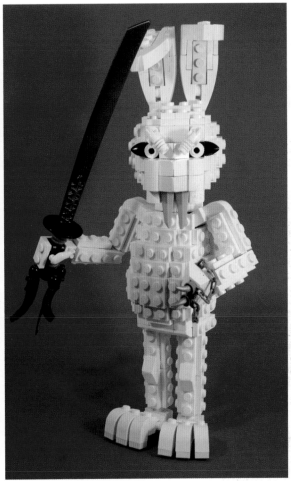

Jimmy Fortel

(left) Scary Bear 2013 (~200 pieces)
(right) Thug Bunny 2013 (~200 pieces)

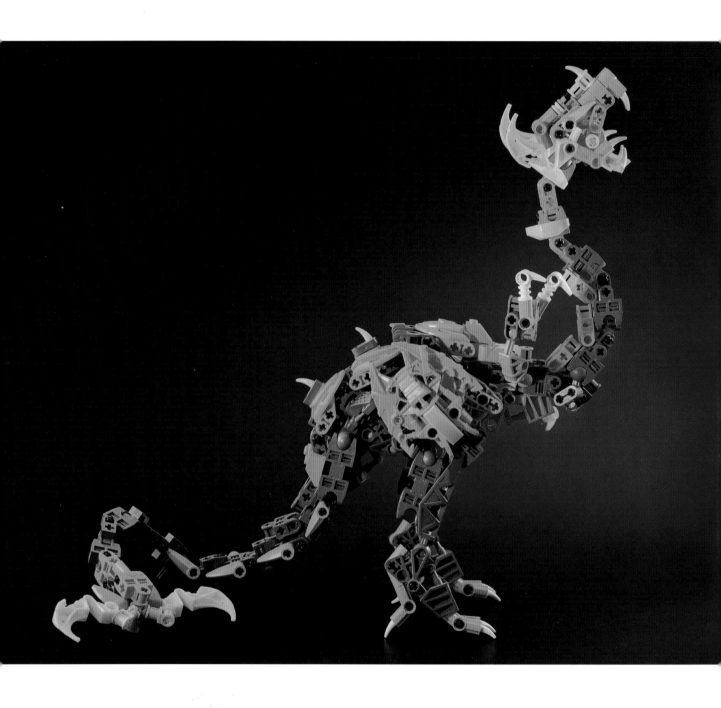

Patrick Biggs
Horizon Dragon 2010 (~350 pieces)

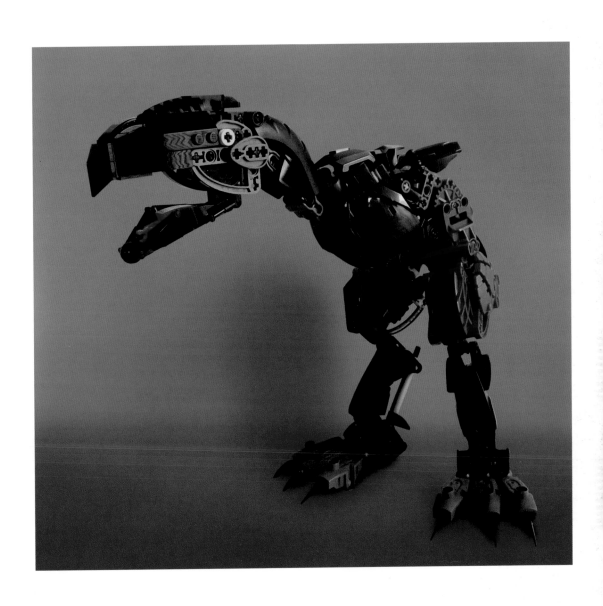

Andrew N. Swink
Terror Bird 2013 (317 pieces)

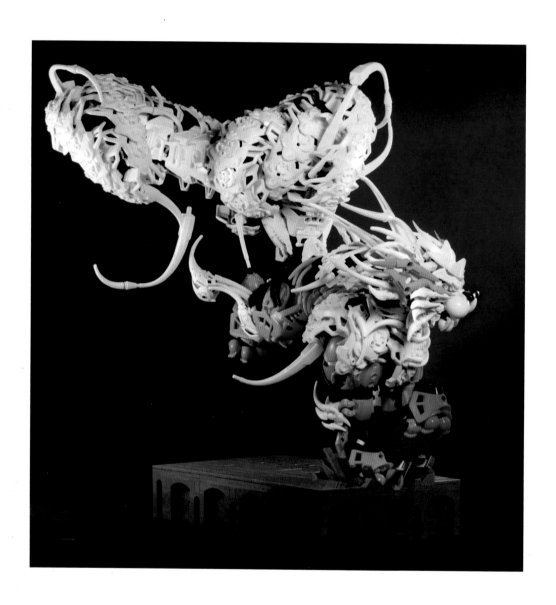

Mike Nieves
Arcanine 2013 (~3000 pieces)

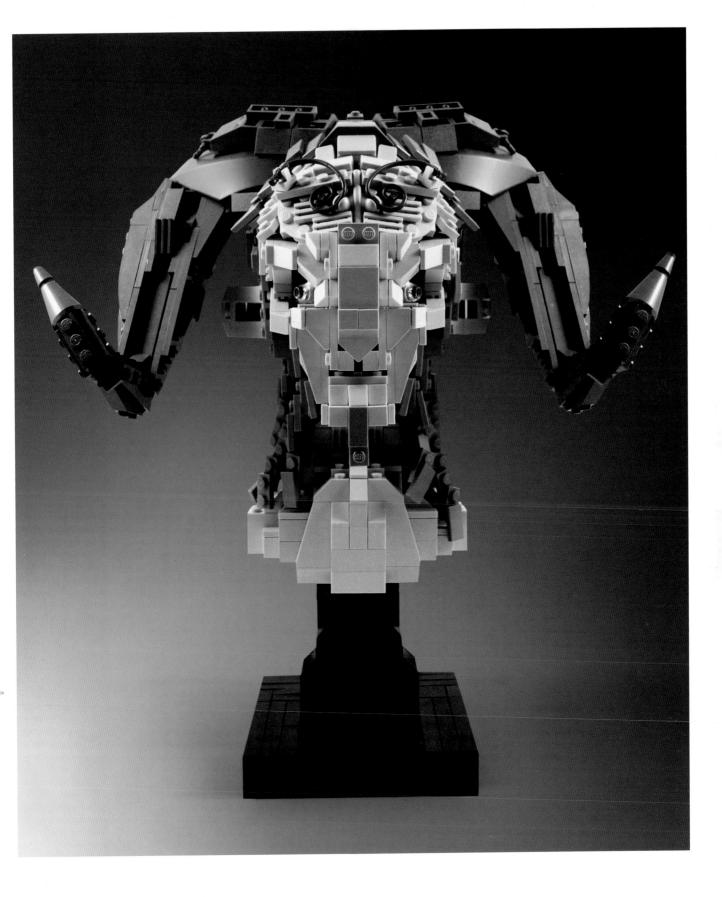

Tyler Halliwell
The Faun 2013 (~800 pieces)

Mecha

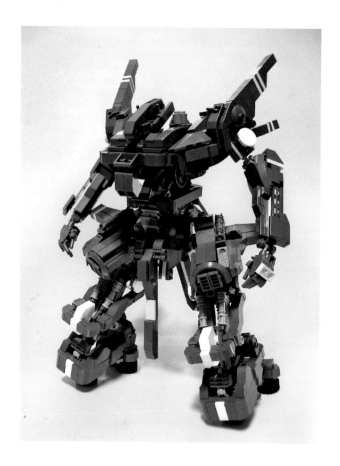

(above)
Izo Yoshimura
Triped 2010

(opposite)
Ryuhei Kawai
LHB-020 DeRosa 2010 (~1000 pieces)

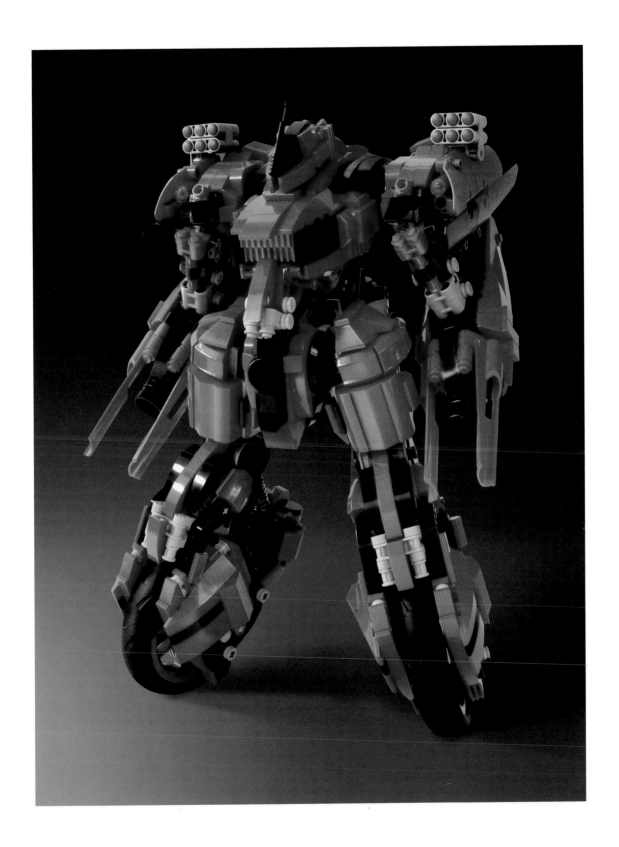

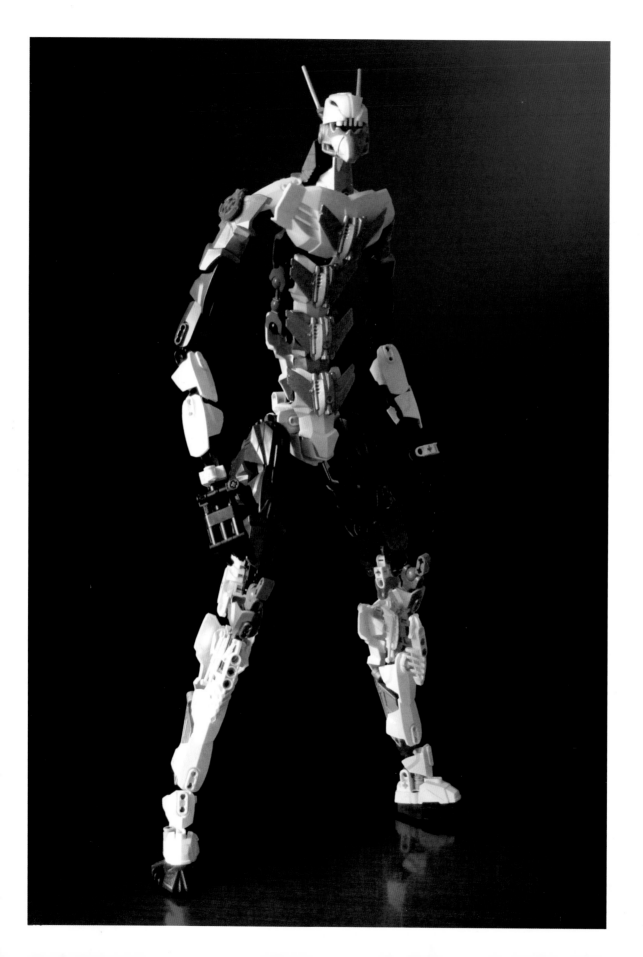

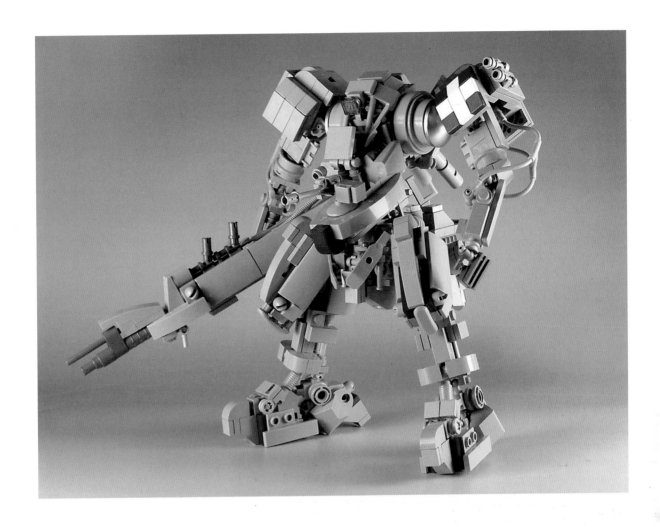

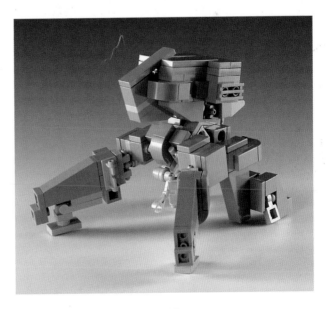

(opposite)
Djordje Dobrosavljevic
Colossus 2013

Izo Yoshimura

(top) Ebeken 2012
(bottom) Tiny Multiped 2012

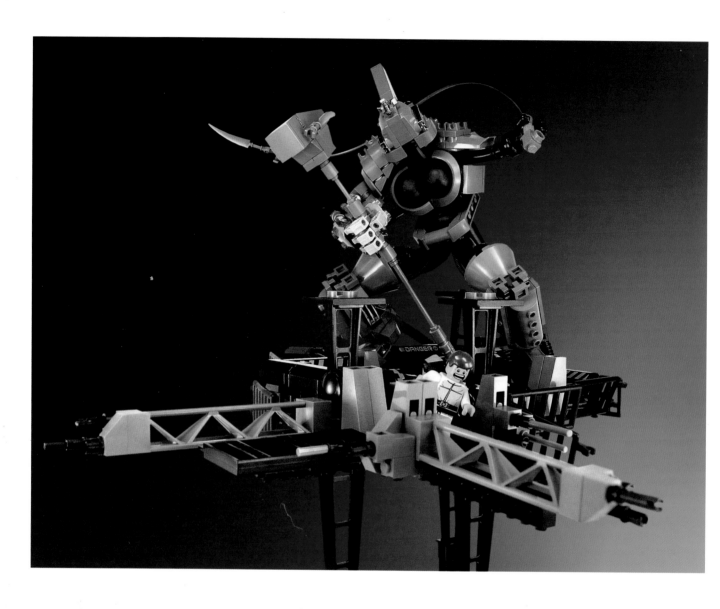

Brian Kescenovitz
Lucy 2008 (~525 pieces)

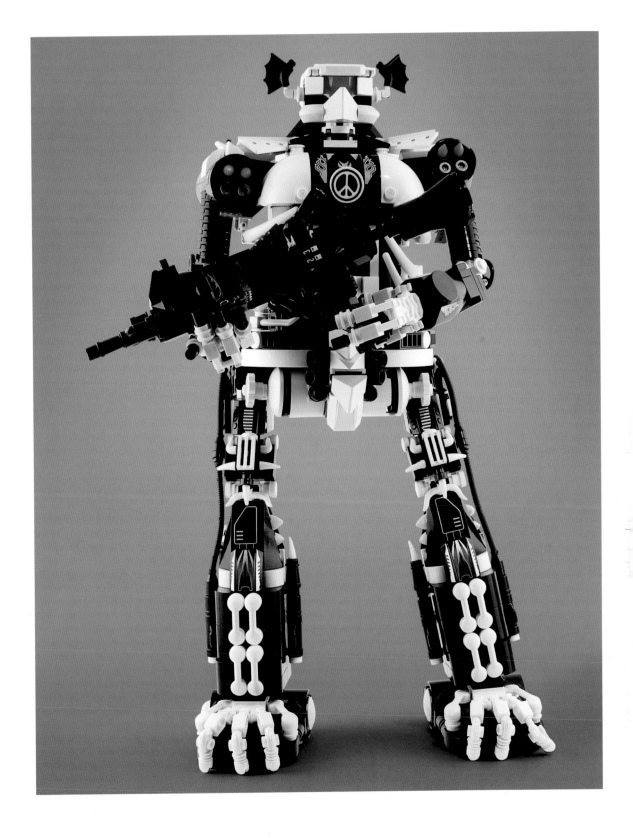

Vinny Paver
The Death Sentence on Patrol 2012 (~600 pieces)

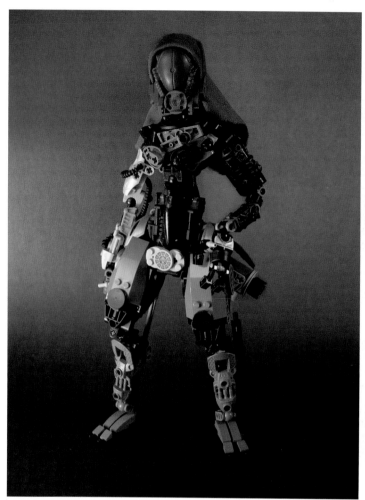

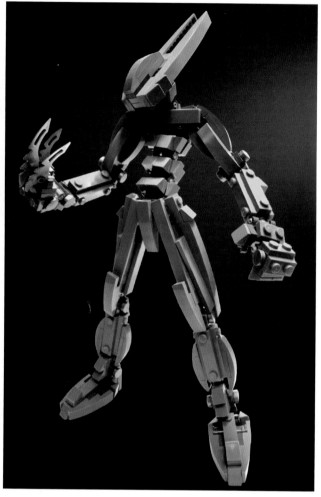

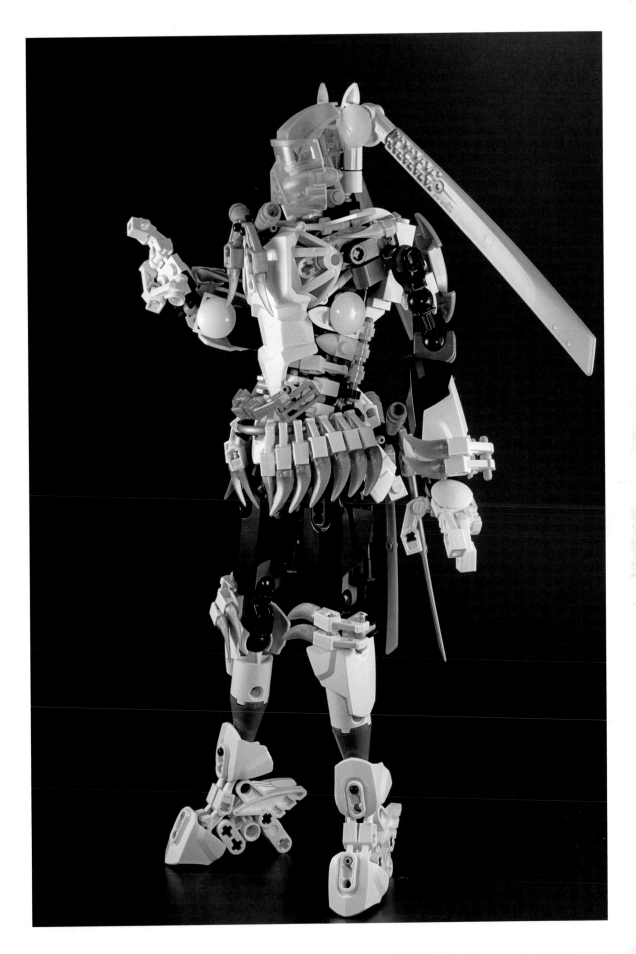

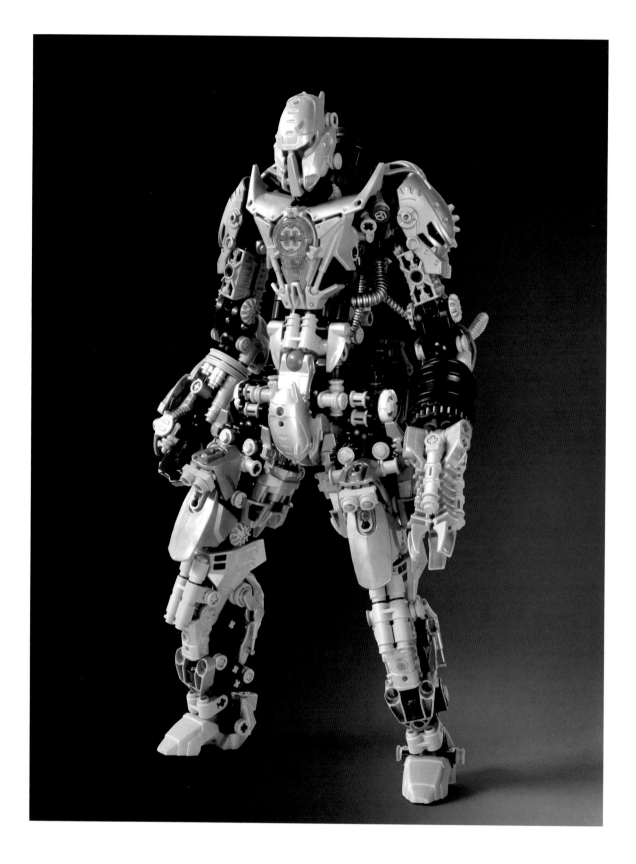

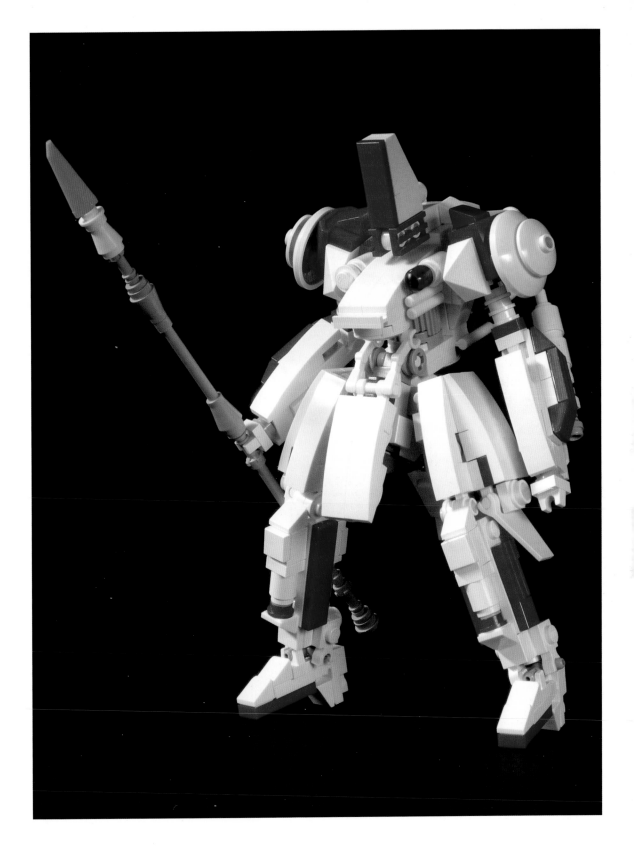

Ryuhei Kawai

(opposite) Dunkan "hierro" Bulk 2012 (~800 pieces)
(above) LHB-ZT-001 Sakigake 2012 (~200 pieces)

223

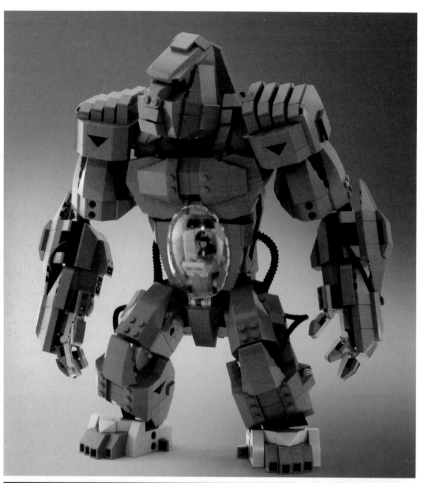

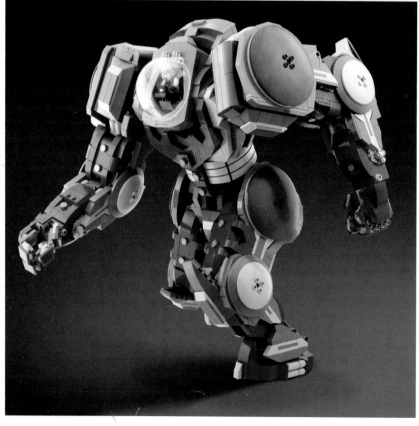

Zane Houston

(top) Ape Armor 2013
(bottom) Atlas 2012

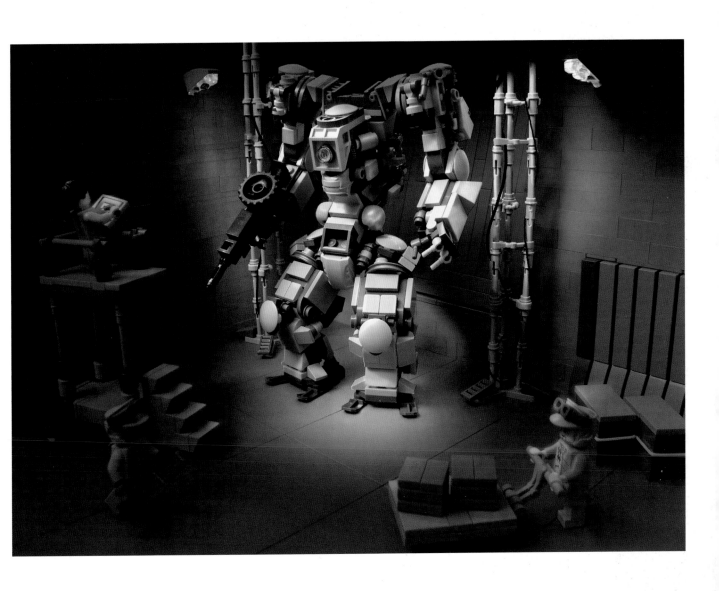

Piotr Hofman
0.5 2013 (~1400 pieces)

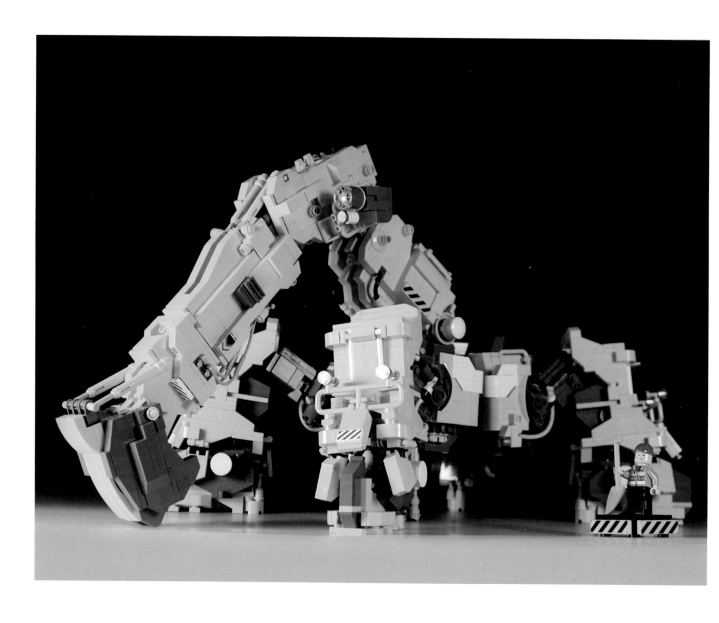

Izo Yoshimura

(above) Gunnlöð 2010
(opposite) A Gunner 2011

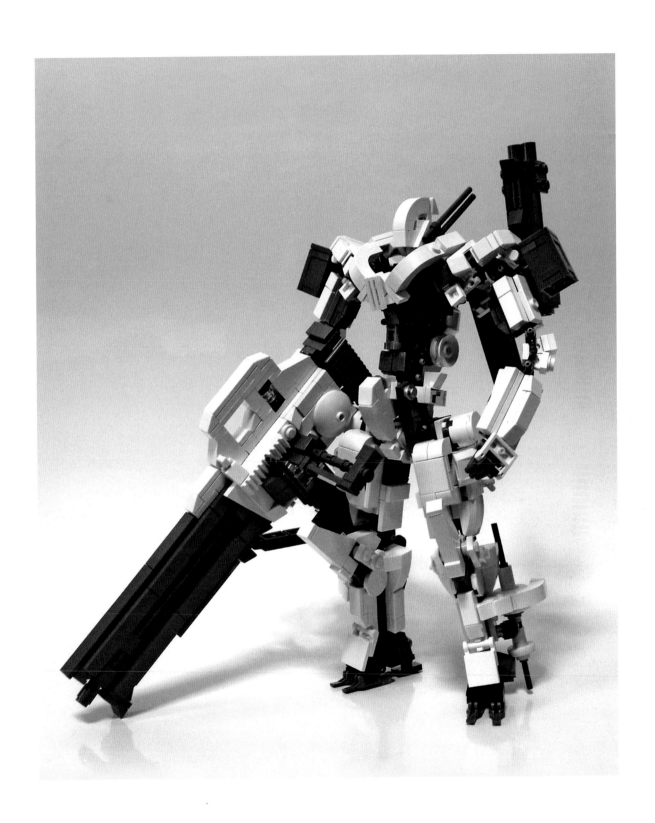

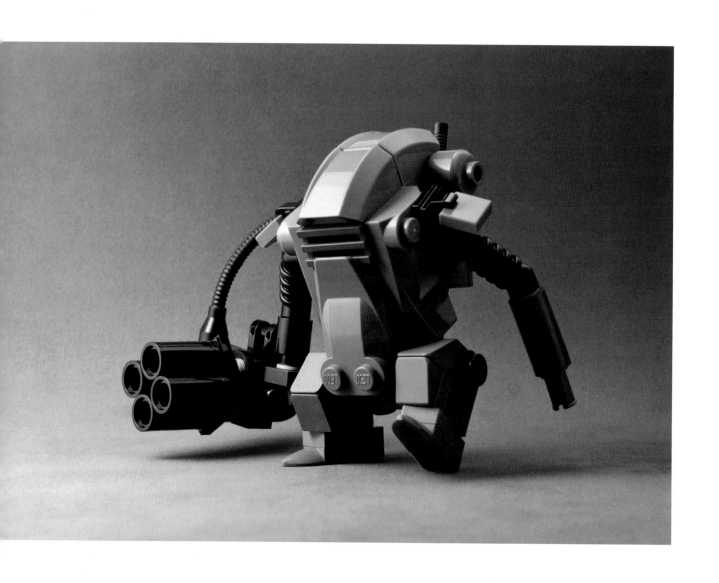

Călin Borş

(above) T04 "Gunner" 2012
(opposite top) T03 "Hazmat" 2012
(opposite left) T02 "Faust" 2012
(opposite right) T05 "Fatboy" 2012

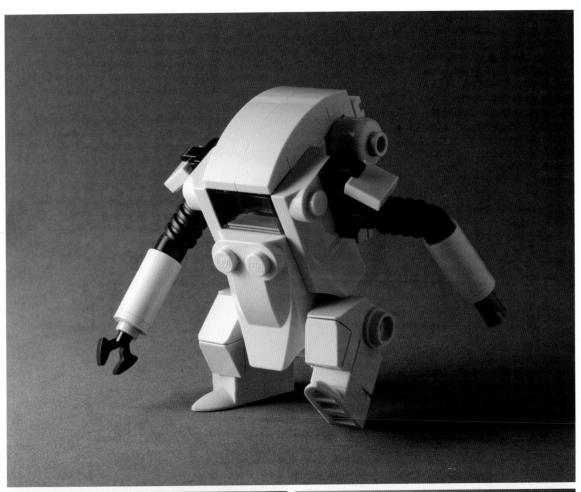

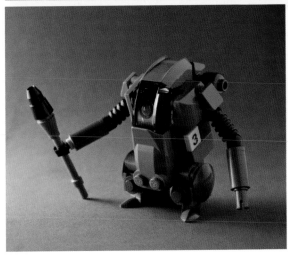

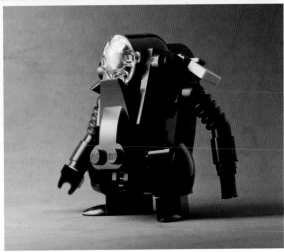

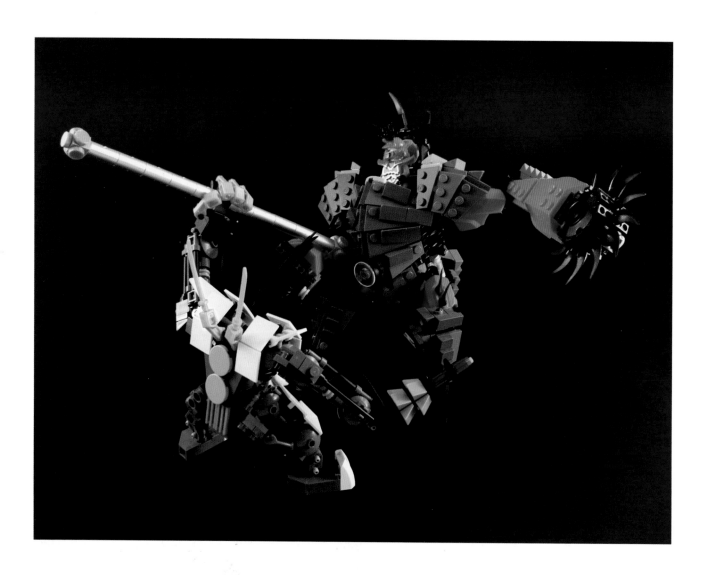

Jarek Książczyk
Faith vs. Saverman – Ninjago Mecha Battle 2013 (~800 pieces)

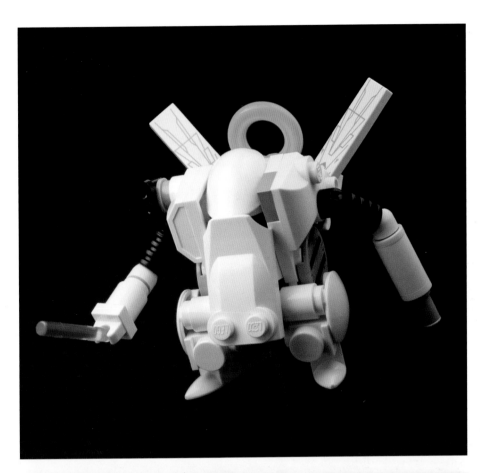

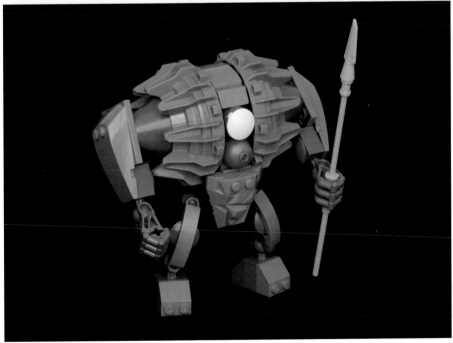

(top)
Călin Borș
T01 "Engel" 2012

(bottom)
Pascal Schmidt
Neo-Angel Raziel 2013 (~150 pieces)

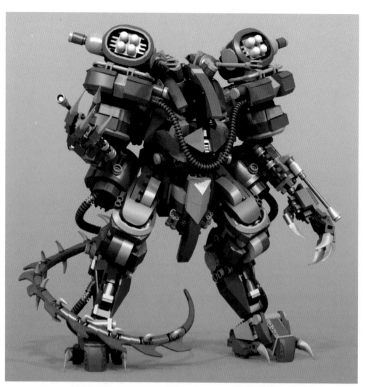

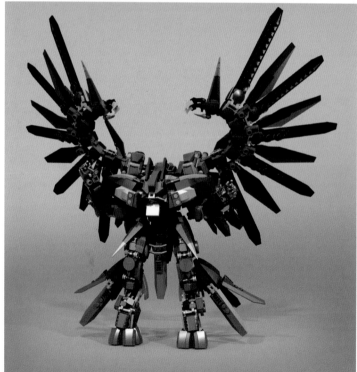

Borisov Igor

(top) Dragon Mech [digital render] 2014 (1052 pieces)
(bottom) "Night Owl" Medium Mech [digital render] 2013 (548 pieces)
(opposite top) Tesla Troops [digital render] 2013 (3904 pieces)

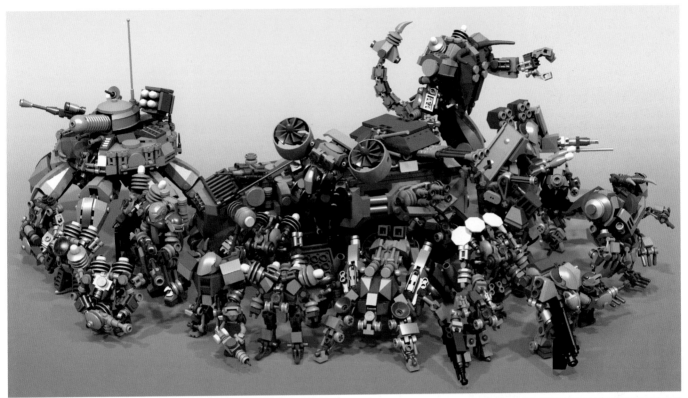

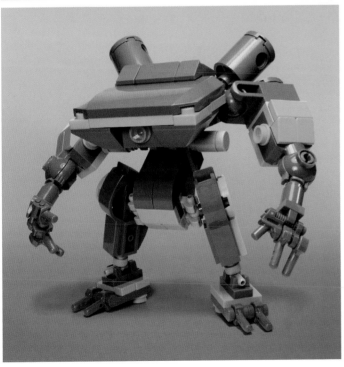

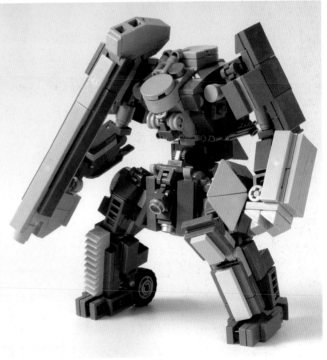

(bottom left)
Angus MacLane
Herbert 2012 (138 pieces)

(bottom right)
Ryuhei Kawai
LHB-ZT-002 SENGEN 2013 (~200 pieces)

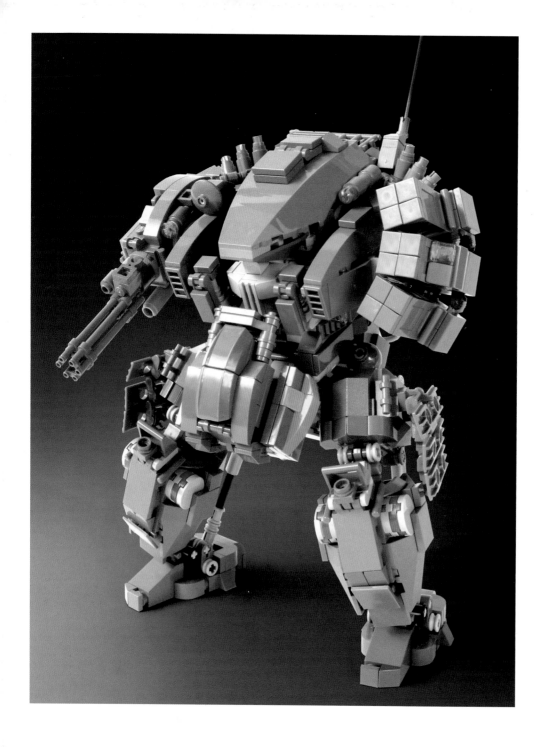

Ryuhei Kawai

(above) LAB-002 FULCRUM 2011 (~700 pieces)
(opposite) LAB-003 URSUS 2012 (~1200 pieces)

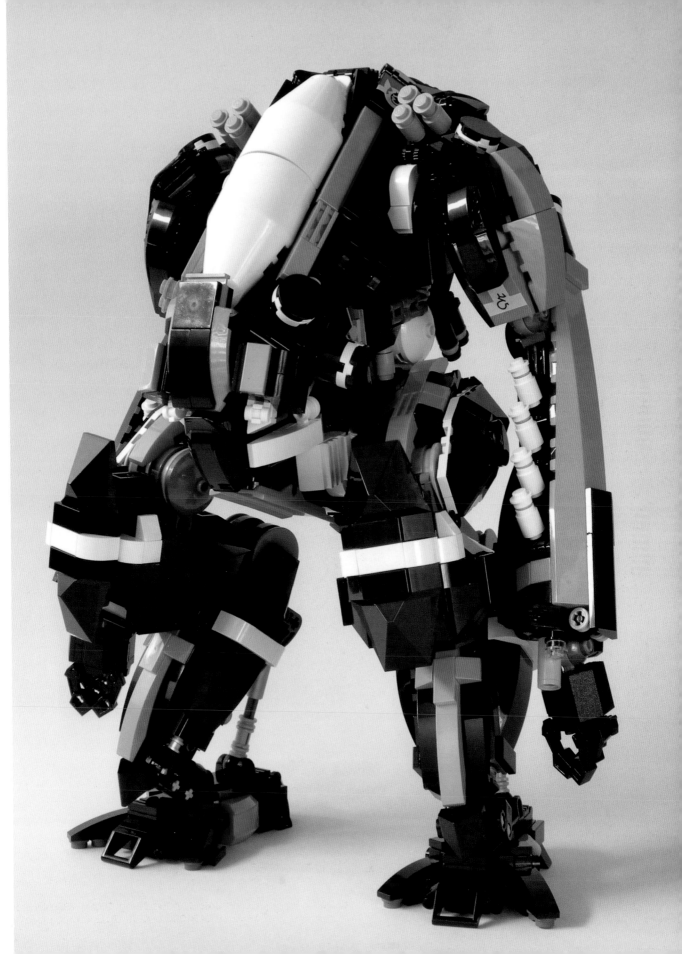

Dark Forces

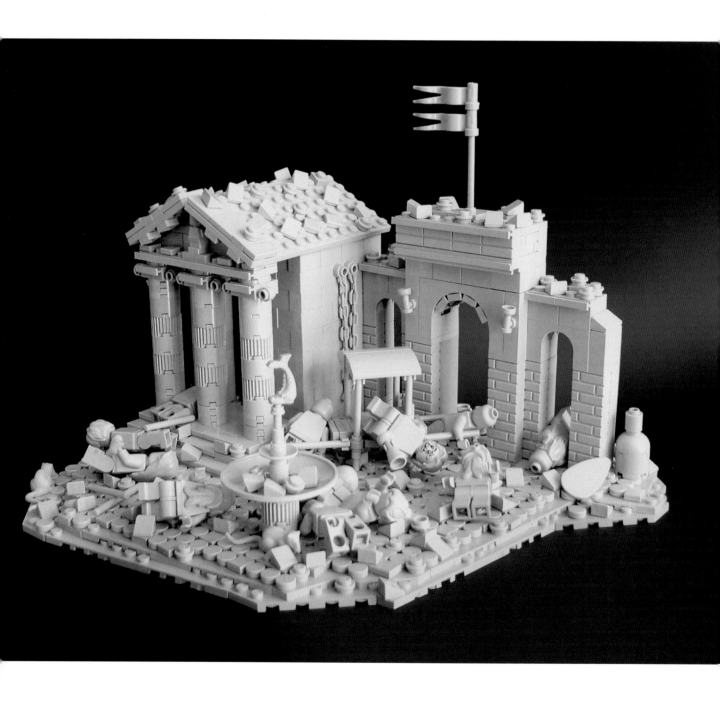

Marcin Danielak
Destruction of Pompeii 2013

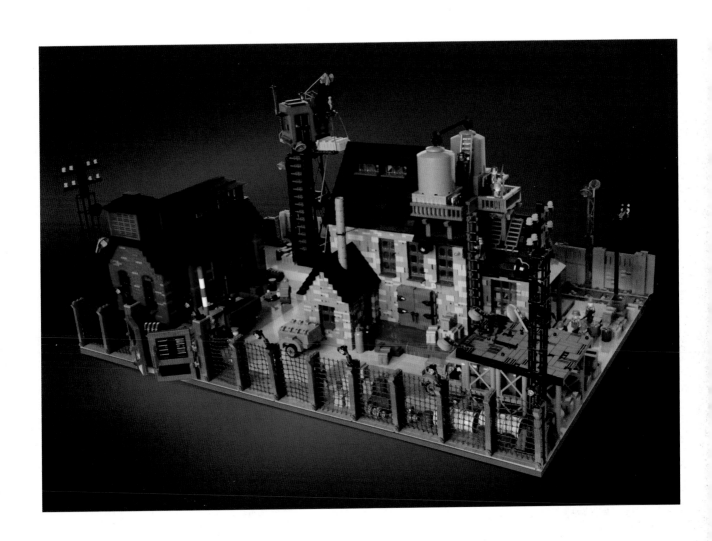

Paweł Michalak
World War II Military Base 2012 (8000–10,000 pieces)

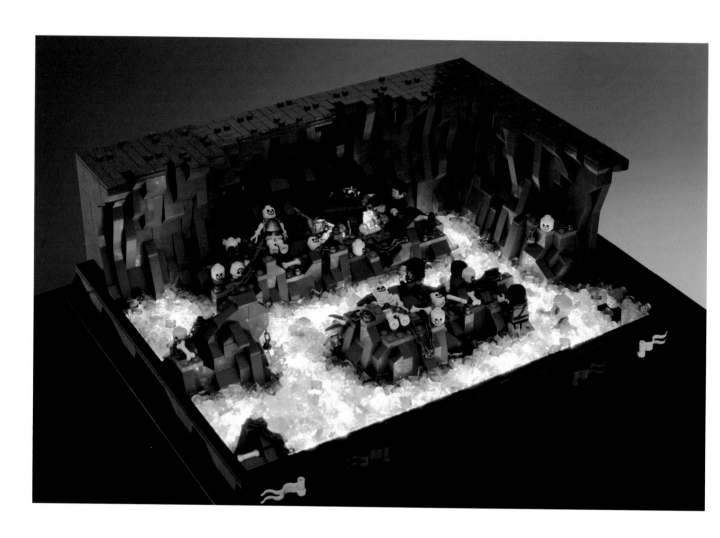

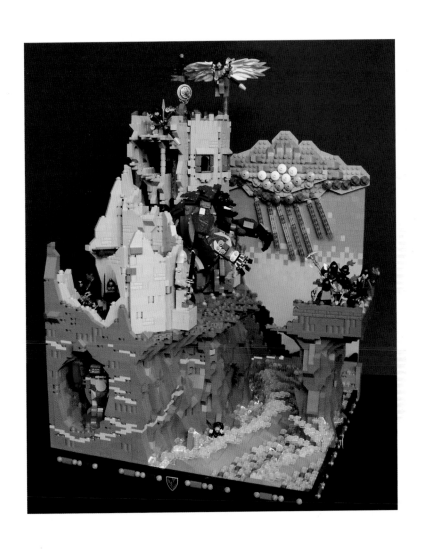

(opposite)
Paul Trach
Magic Cave 2013 (~2800 pieces)

(above)
Gabriel Thomson
Attack on the Causeway 2012 (5000–6000 pieces)

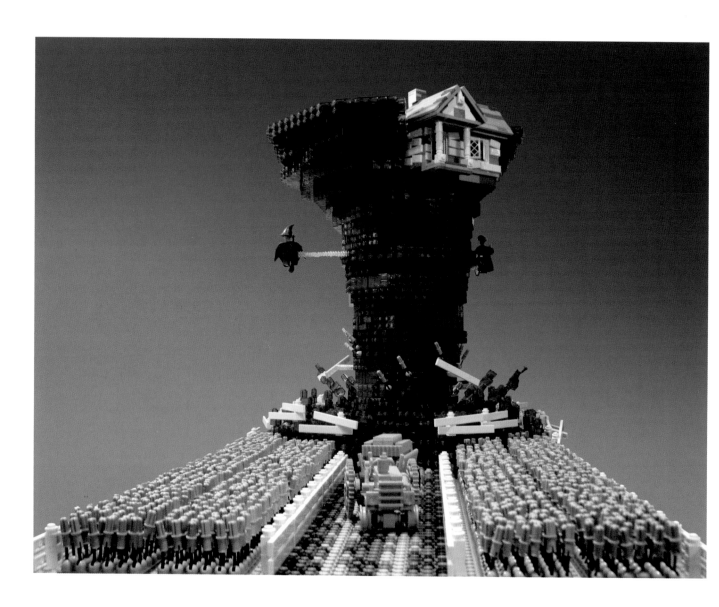

Bart Larrow, Jr.
Wizard of Oz Tornado 2013 (~12,000 pieces)

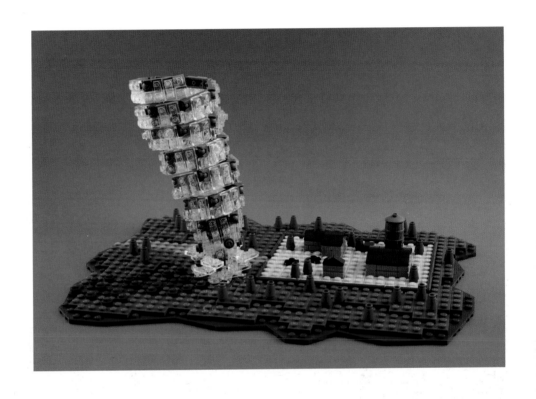

Jimmy Fortel
Watch Out! Here Comes the Micro Tornado 2014 (~300 pieces)

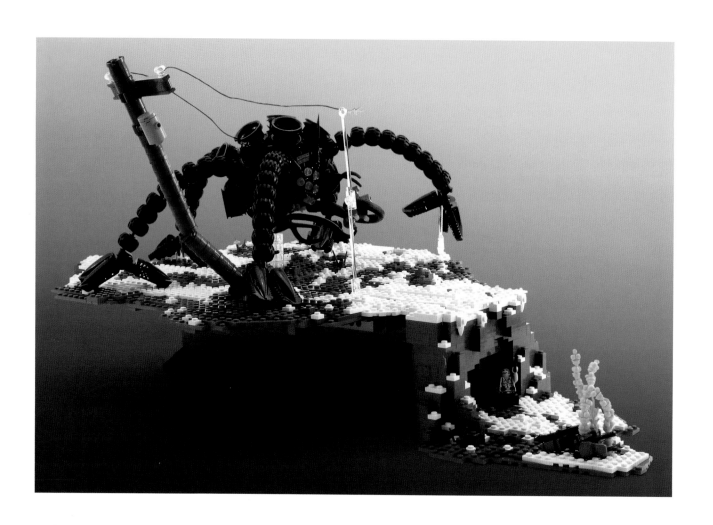

(above)
Justin Vaughn
Howl of Lamentations Unending 2008 (1000 pieces)

(opposite top)
Brian Rinker
Alone 2014 (~600 pieces)

(opposite bottom)
Kristóf Albert
Hand of the Builder 2014 (~850 pieces)

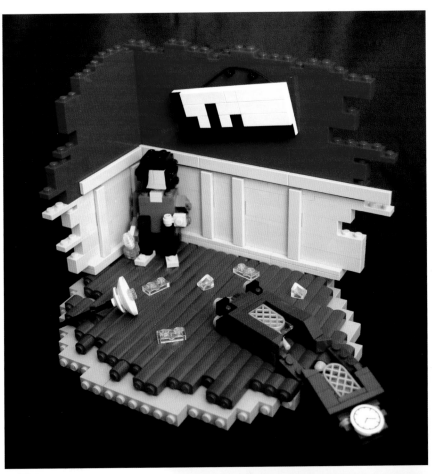

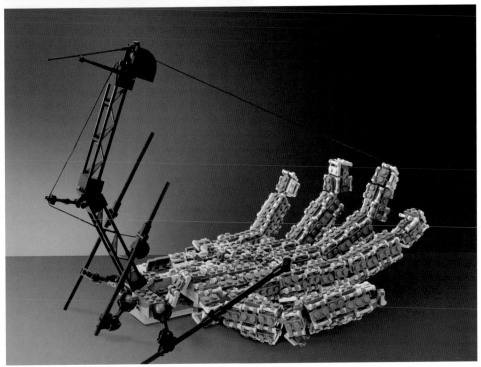

Shadow Play by David Alexander Smith

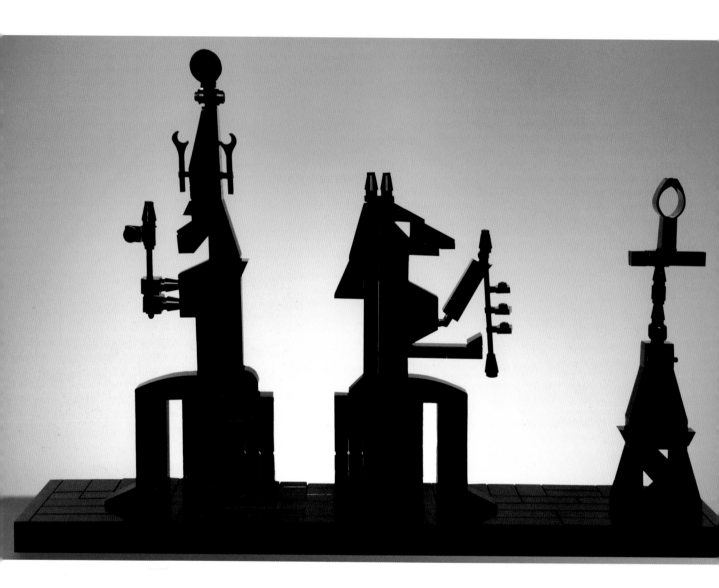

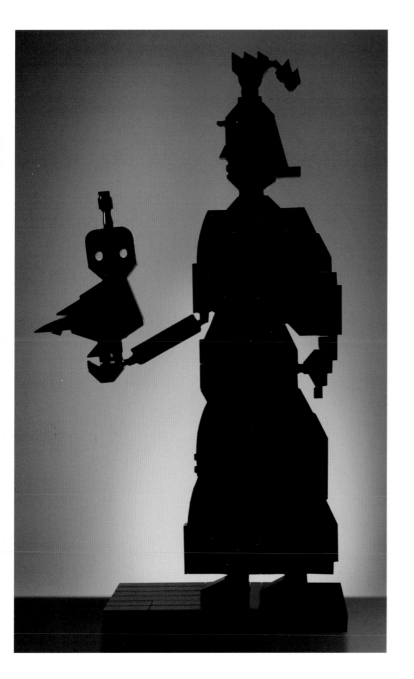

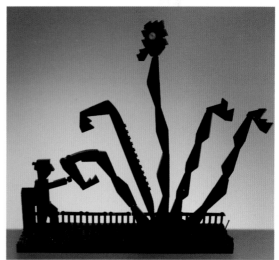

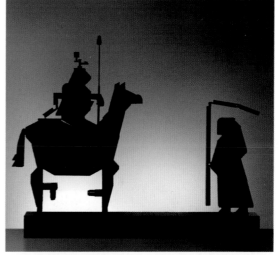

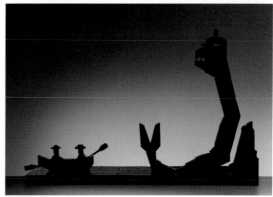

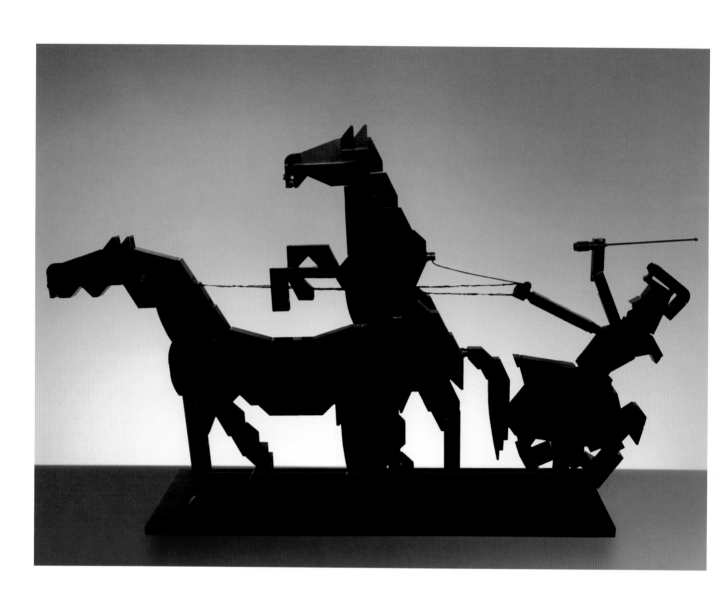

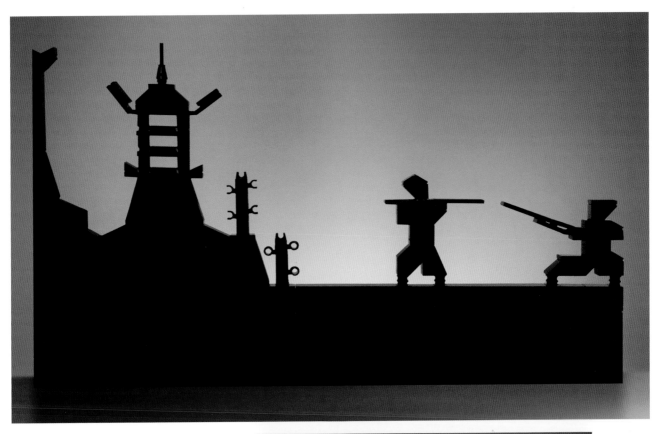

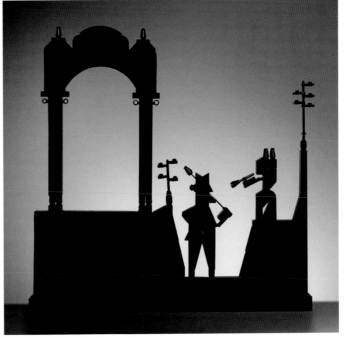

Mythos

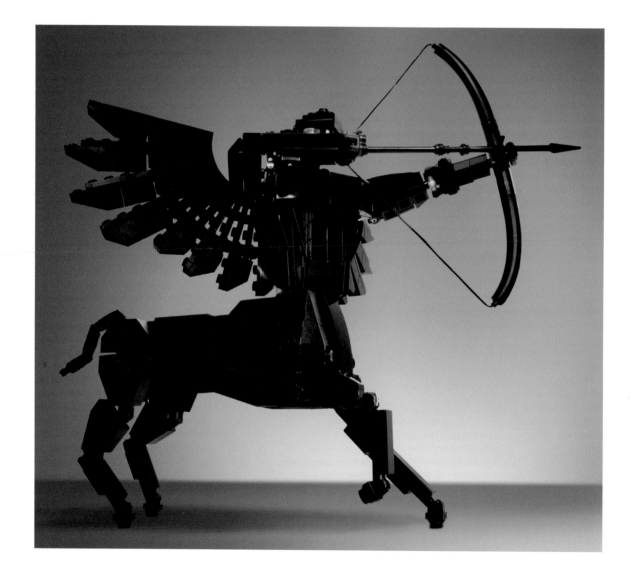

Joe Perez
Winged Centaur 2012

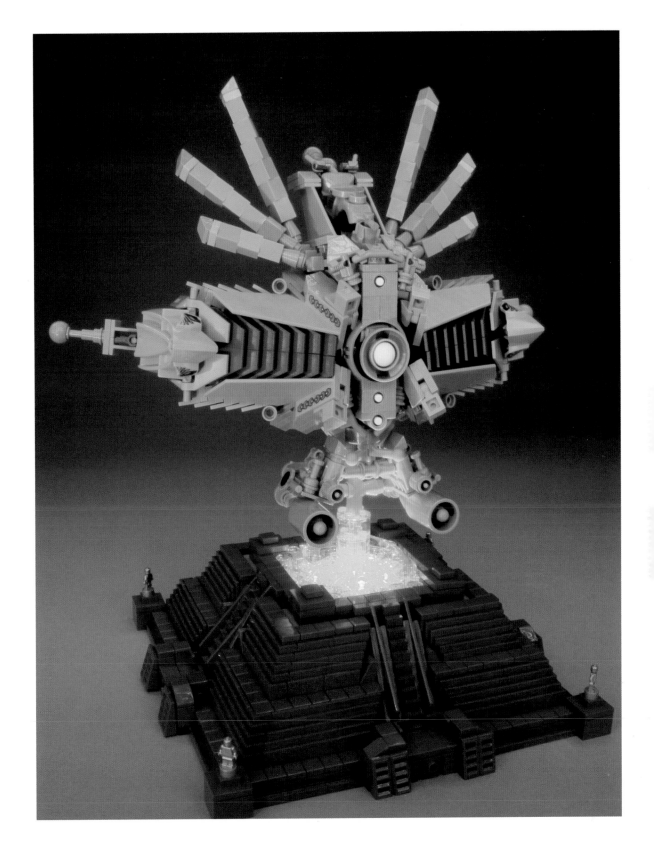

Nicolaas Vás
The Turquoise Lord 2014

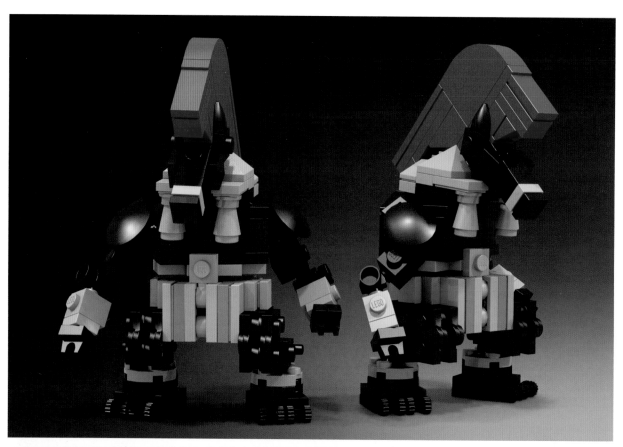

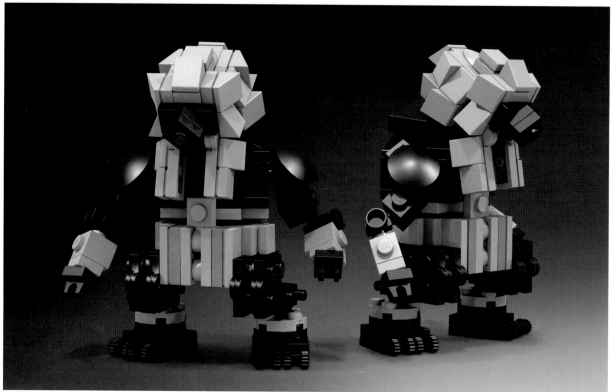

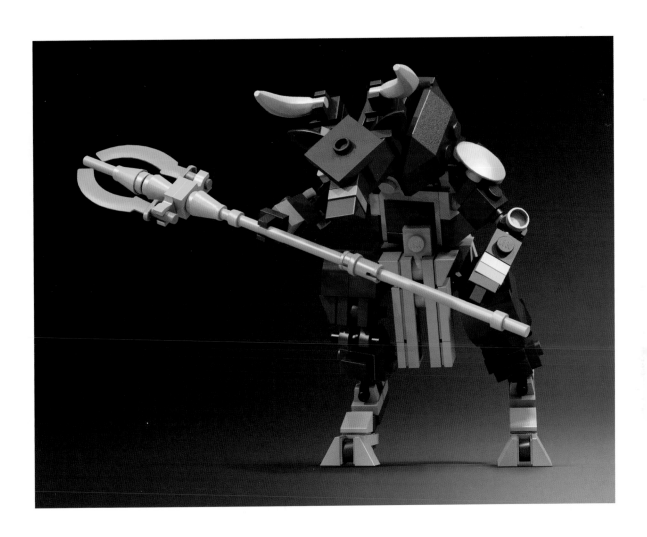

Joe Luk

(opposite top) Ashvins [digital render] 2012 (262 pieces)
(opposite bottom) Sekhmet [digital render] 2012 (262 pieces)
(above) Minotaur [digital render] 2013 (157 pieces)

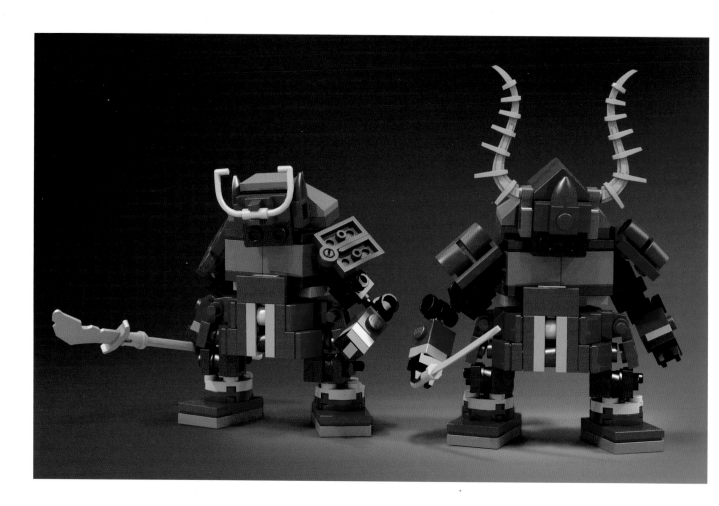

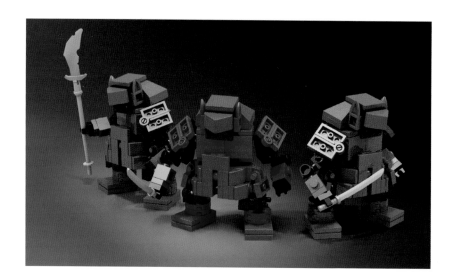

Joe Luk

(top) Red Samurai [digital render] 2012 (210 pieces)
(bottom) Samurai [digital render] 2012 (315 pieces)

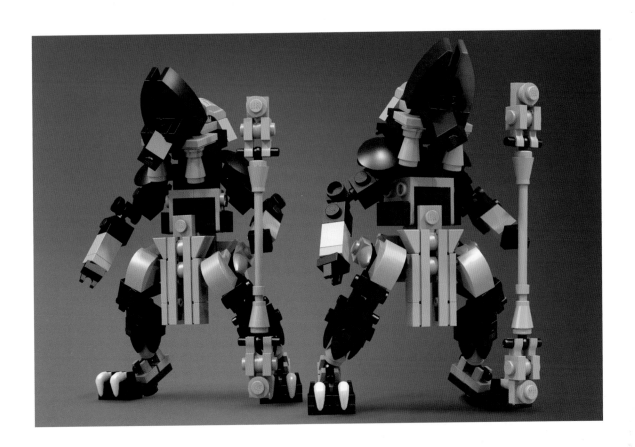

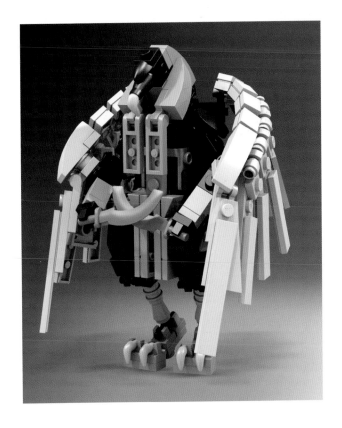

(top) Anubis [digital render] 2013 (306 pieces)
(bottom) Horus [digital render] 2013 (196 pieces)

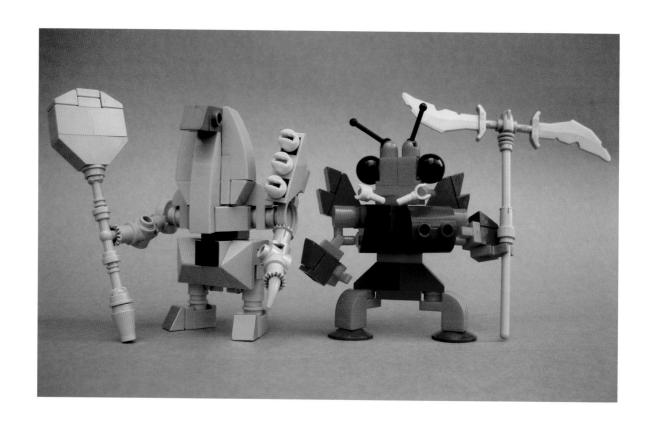

Shannon Sproule
Battle Beasts: Wood Cobra & Fire Ant 2010 (~95 pieces)

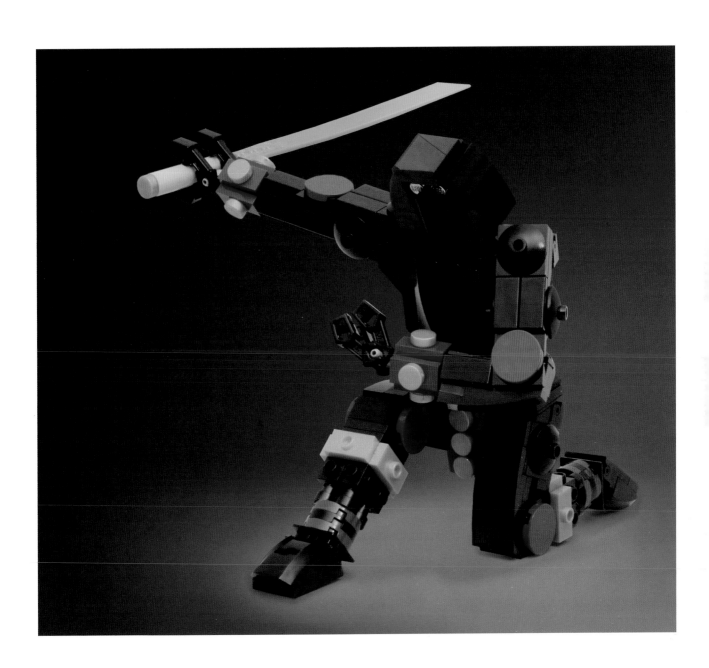

Jason Allemann
Steampunk Ninja 2013 (~150 pieces)

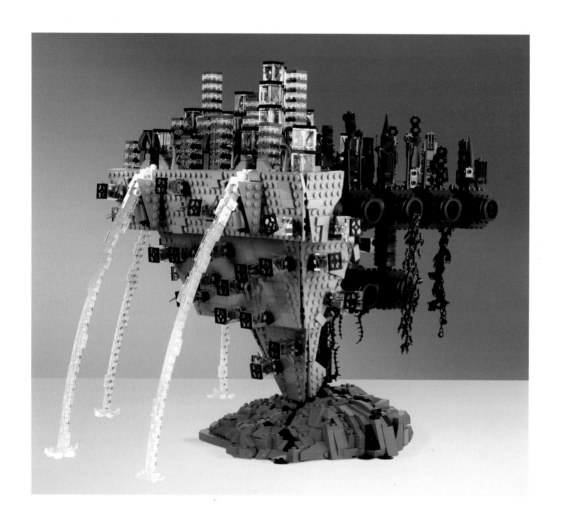

Paul Vermeesch, Ian Spacek, and Max Pointner
Arca 2014 (~8000 pieces)

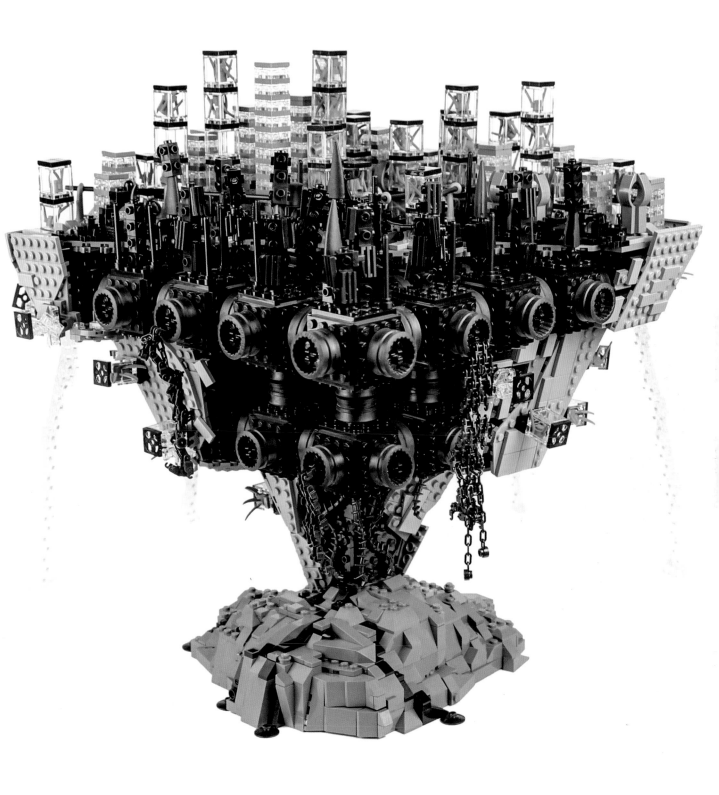

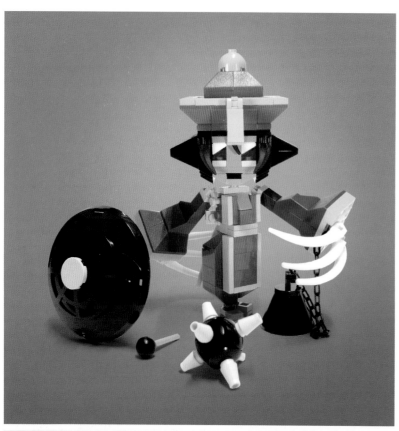

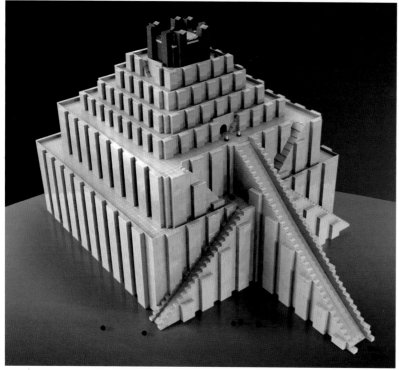

(top)
Ieyasu Tse
Lei-Lei/Hsien-Ko 2011 (~200 pieces)

(bottom)
Michal Herbolt
Etemenanki Zikkurat 2010 (3,000–4,000 pieces)

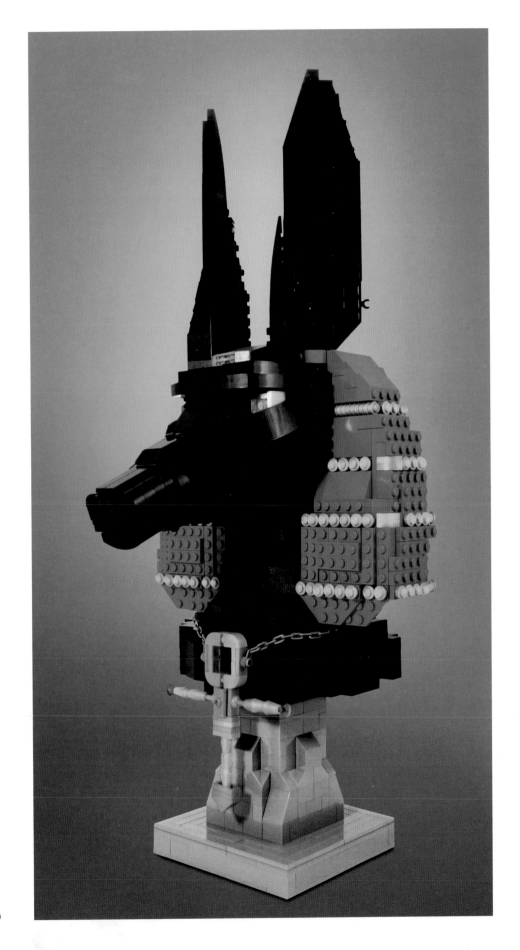

Tyler Halliwell
Anubis 2014 (~1500 pieces)

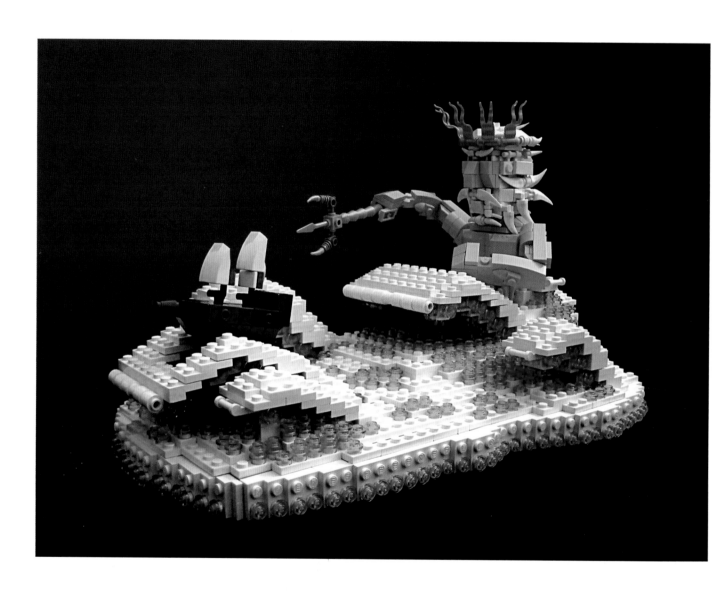

(above)
Tyler Clites
Poseidon Float 2011

(opposite)
Anton Fedin
Temple of Ennoc 2013 (~3000 pieces)

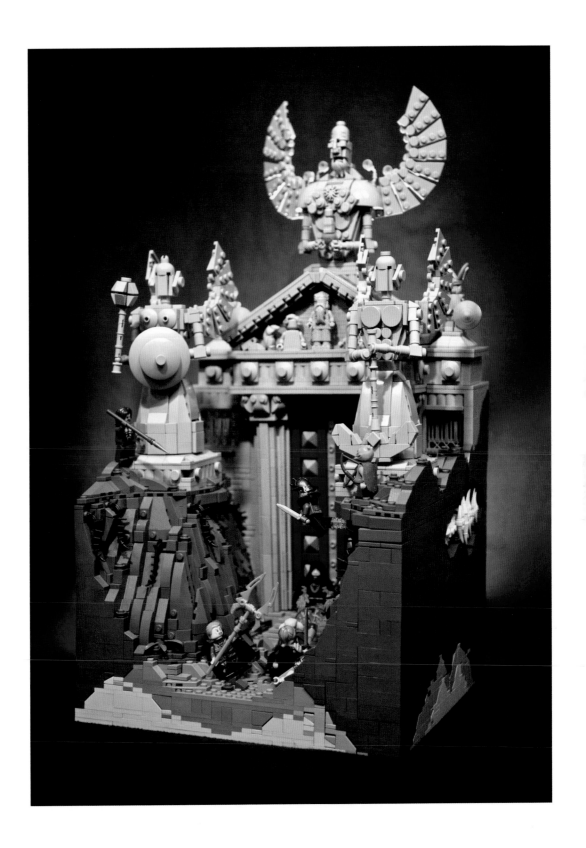

Otherworldly

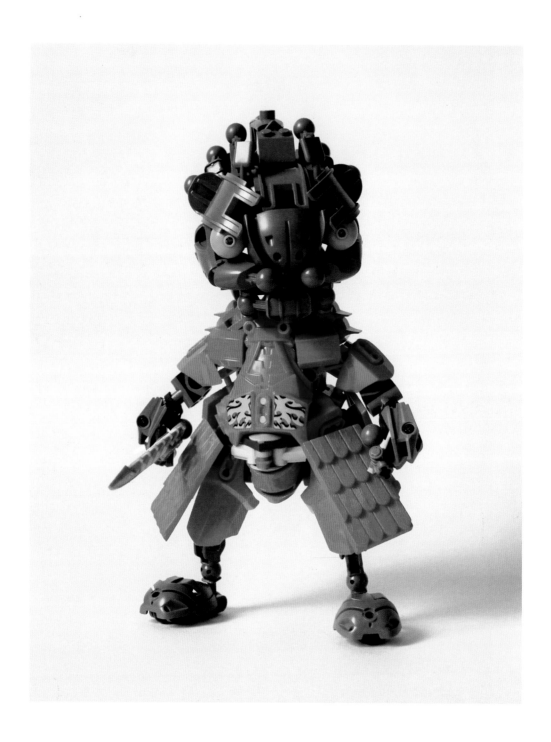

Vlad Lisin
Shinjen the Samurai 2013

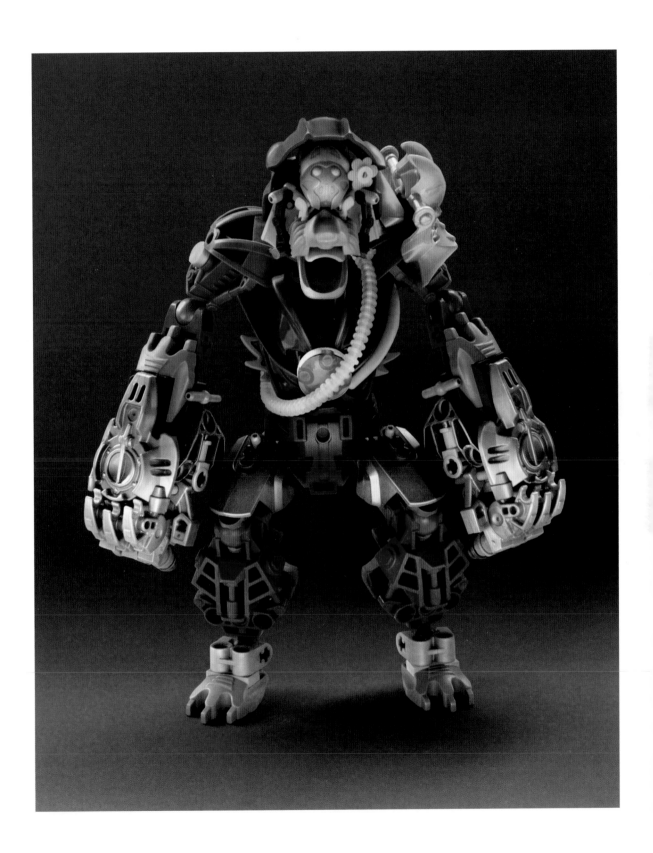

Vlad Lisin
G'Loona 2013

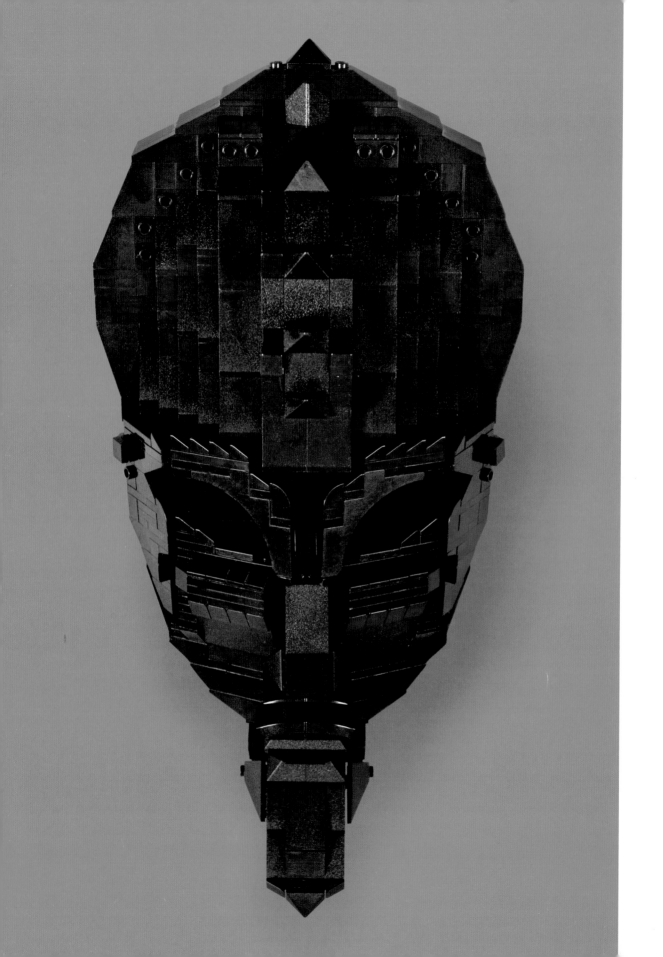

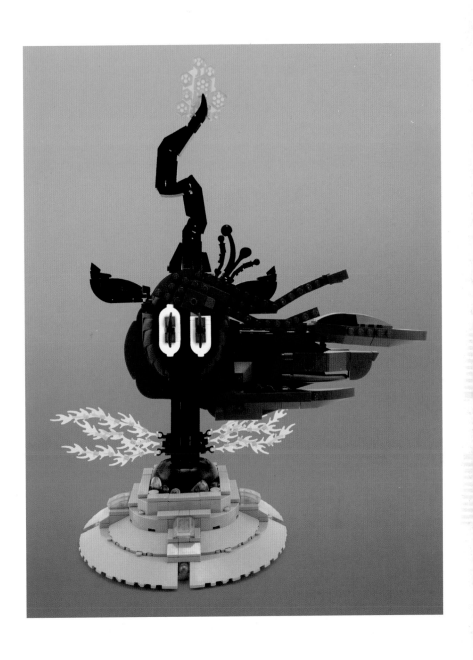

(opposite)
Ekow Nimako
Lady Ama 2013 (~900 pieces)

(above)
Aaron Van Cleave
Chrysalis, Queen of the Changelings 2014

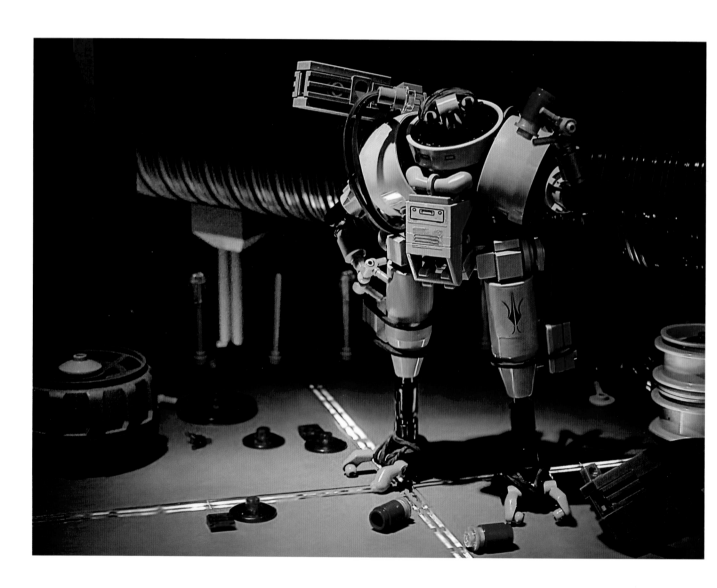

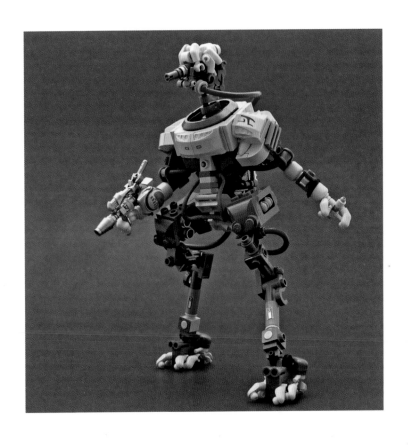

Tyler Clites

(opposite) Crime Scene 2010
(above) Organibot 2010

Patriot Axe

(top)
Blake Baer
detail from Fort McHenry 2010

(bottom)
Mike Nieves
Flag 2013 (~100 pieces)

(opposite)
Carl Merriam
Motorized Patriot 2014 (~600 pieces)

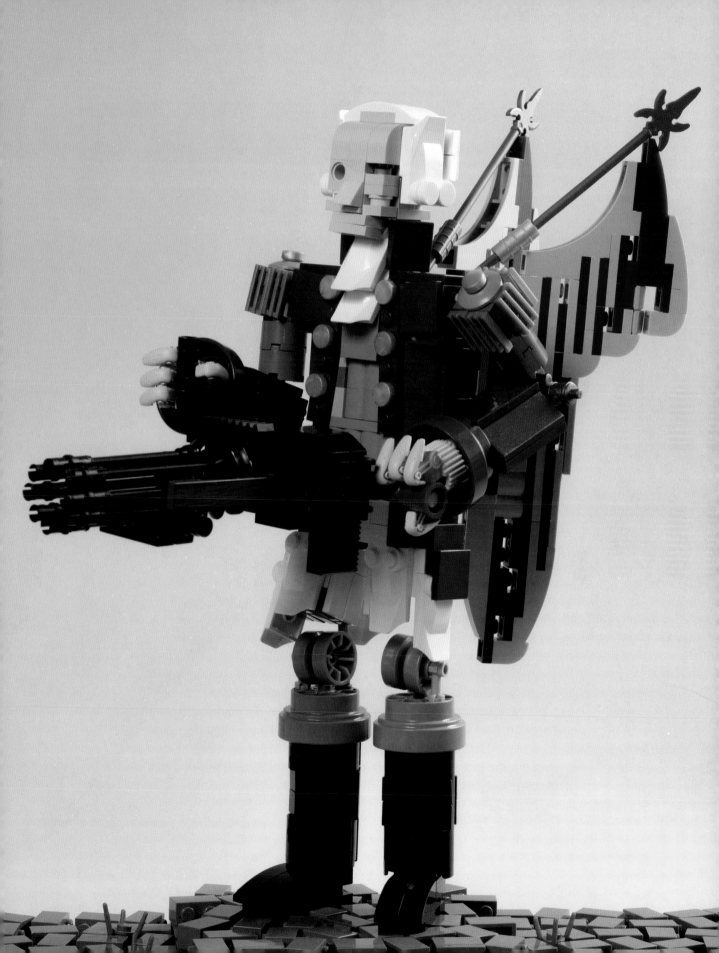

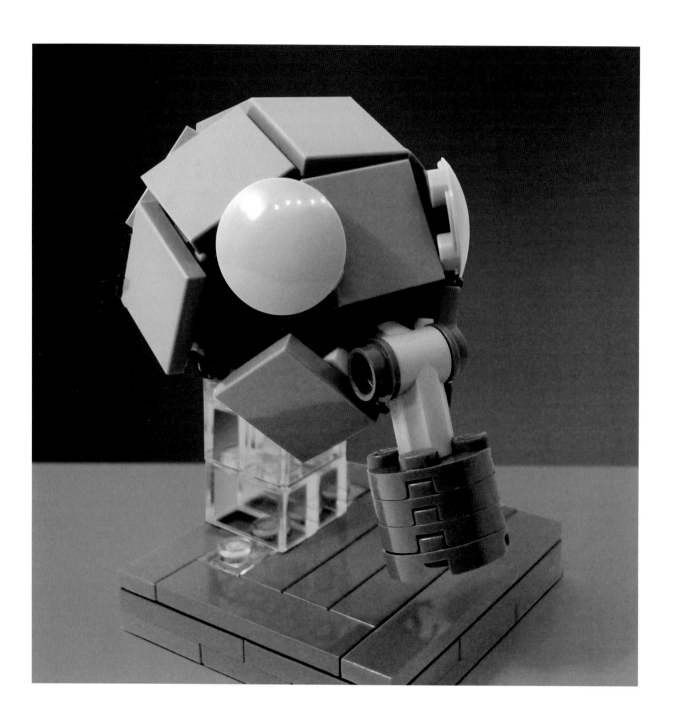

Eric Beitle
Gas Mask 2014 (~60 pieces)

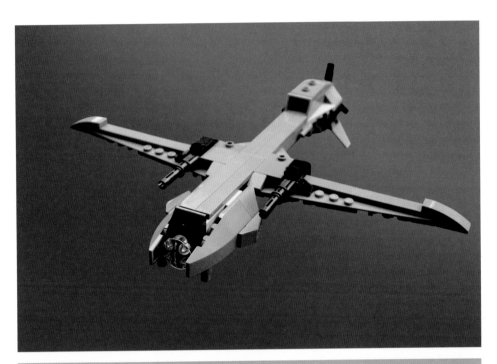

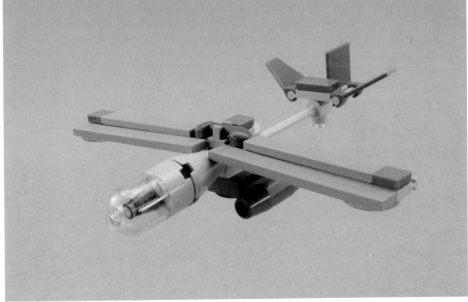

(top)
Almando Batangtaris
UAV Drone Fighter 2013

(bottom)
Brad Edmondson
Owl UAV 2009 (32 pieces)

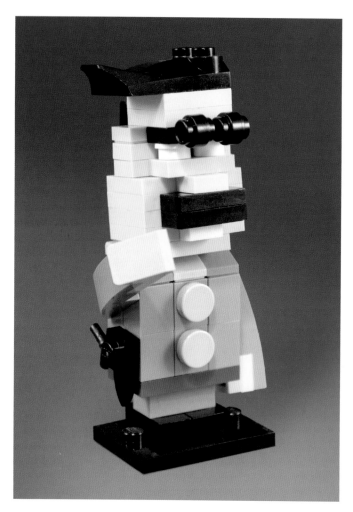

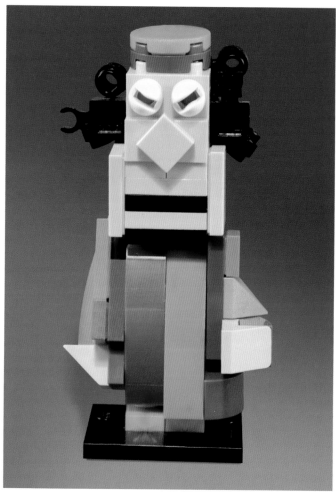

Rickard and Helen Stensby

(left) Saddam Hussein 2014 (61 pieces)
(right) Muammar Al-Gaddafi 2014 (62 pieces)
(opposite left) Fidel Castro 2014 (59 pieces)
(opposite right) Kim Jong Il 2014 (54 pieces)

272

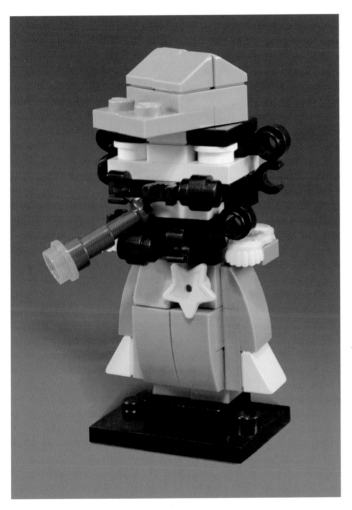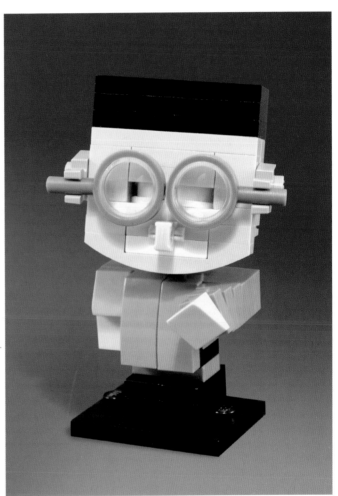

Wild Rides

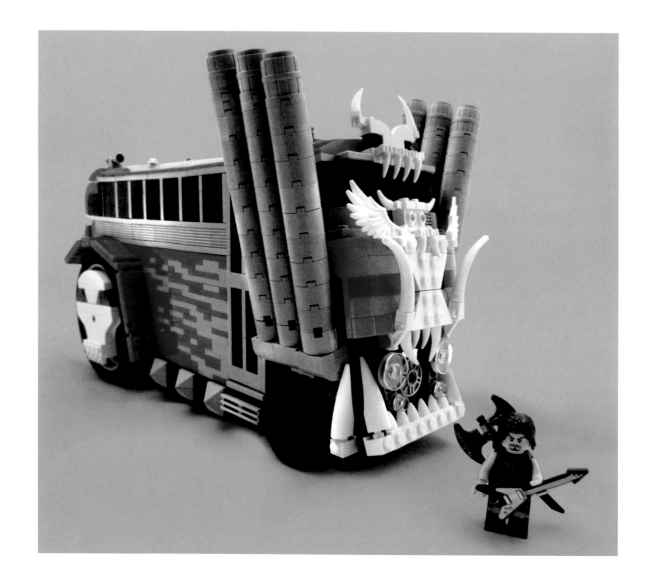

Lino Martins
Brütal Legend Tour Bus 2013 (~1100 pieces)

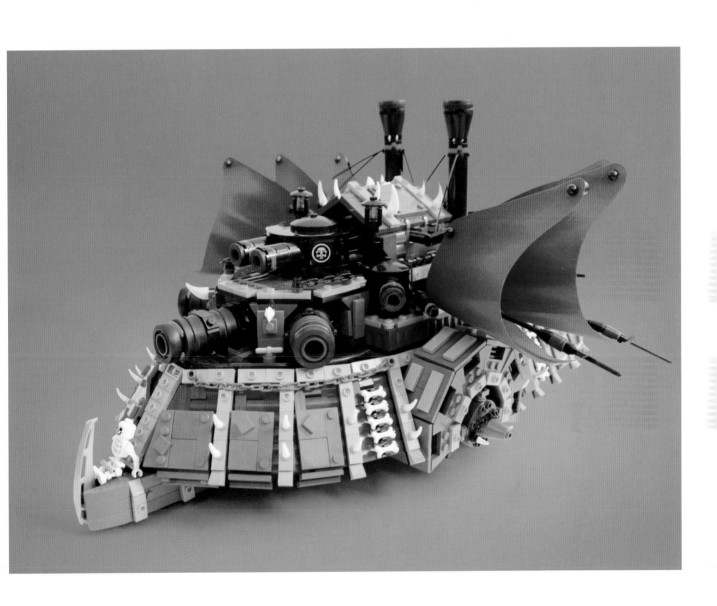

Jarek Książczyk
Orc Juggernaught (World of Warcraft) 2012 (~1500 pieces)

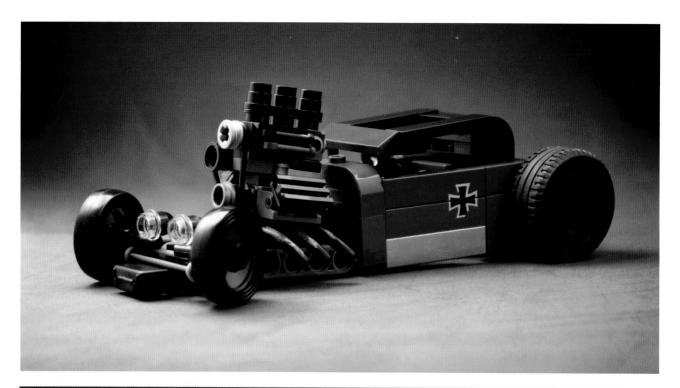

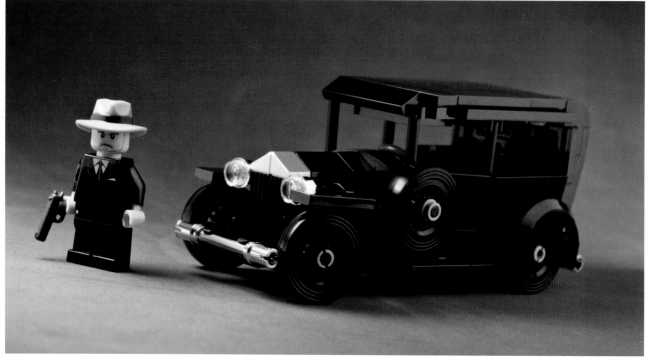

Călin Borş

(top) Roadkill – The Gypsy 2013
(bottom) Last Man Standing 2013

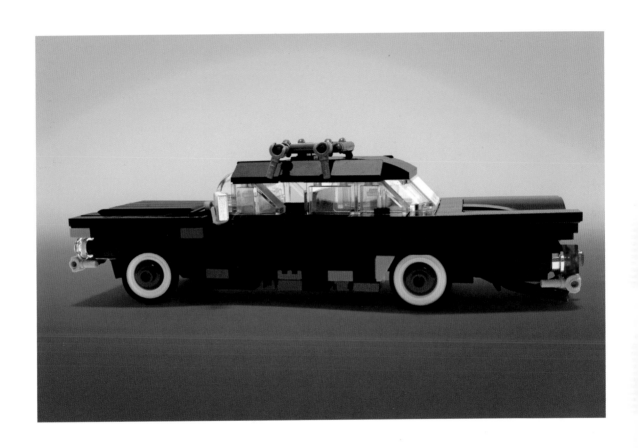

Adam
Winnebago 2013

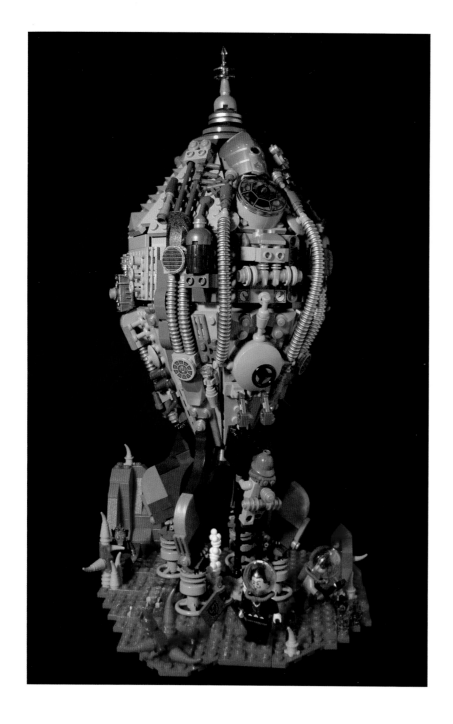

(above)
Sylvain Amacher
Steam Rocket 2010 (~1200 pieces)

(opposite top)
Jason Allemann
Lord Ship Amagosa 2013 (~1000 pieces)

(opposite bottom)
Kristóf Albert
Savage Rider 2014 (~300 pieces)

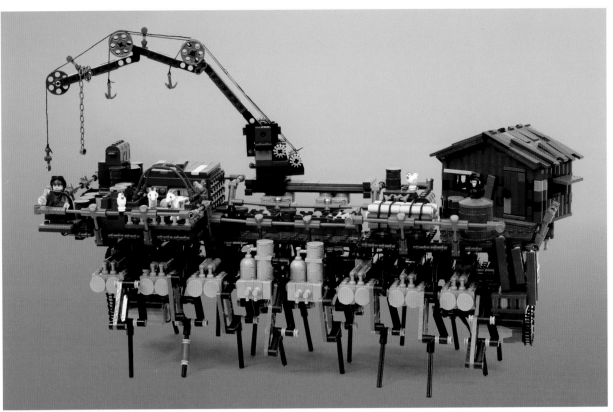

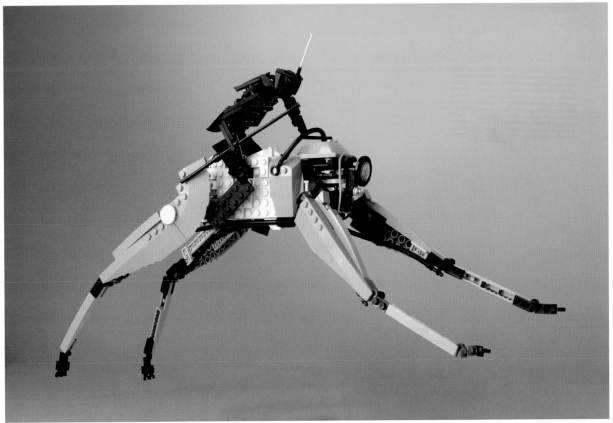

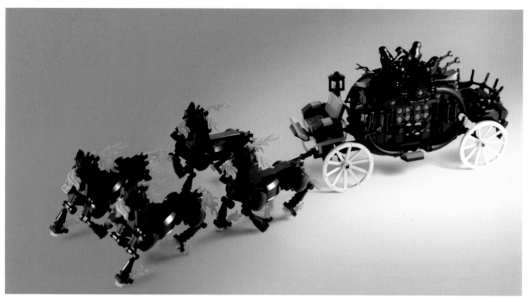

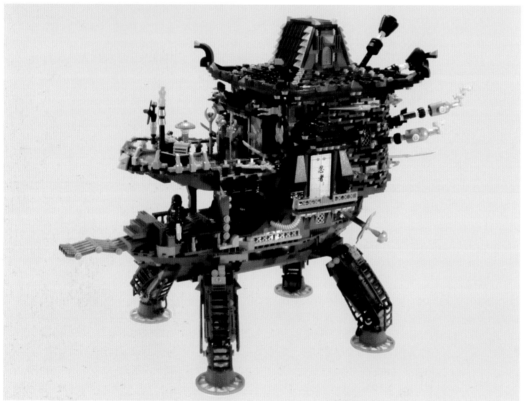

(top)
Ming-Wei Huang
Nightmare Carriage 2011 (621 pieces)

(bottom)
Jimmy Fortel
Steam Temple 2013

(opposite)
Hak Jin Kim
The Elephant 2013 (1004 pieces)

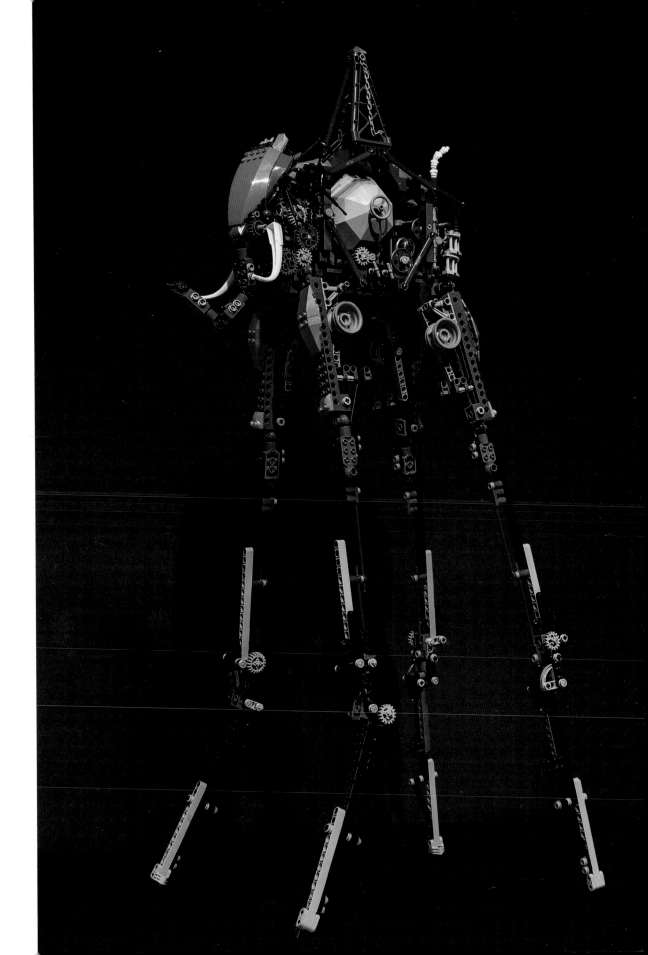

Mihai Marius Mihu

Why LEGO?

I've always been hooked on drawing. Drawing was my first true passion, and it was something that came naturally for me. I remember spending countless hours drawing from my imagination; I loved the experience of creating, the sense of achievement.

LEGO was something that I came upon much later. It wasn't until a few years ago that I bought my first LEGO set, but I was instantly captivated by the complexity, diversity of parts, and, of course, the process of building. There are many reasons why I like LEGO, but what I love most about it is that it merges perfectly with my other passion—drawing. For me, the process of building with LEGO is like drawing.

I love LEGO because I can create expressive and interesting works of art.

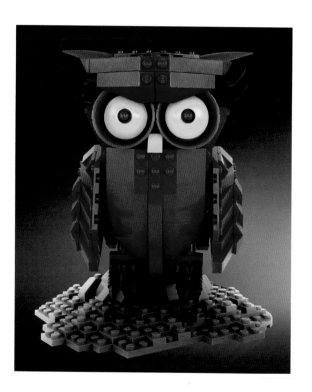

(left) The Wise Owl 2013 (~320 pieces)
(opposite) Maleficum 2013 (~470 pieces)

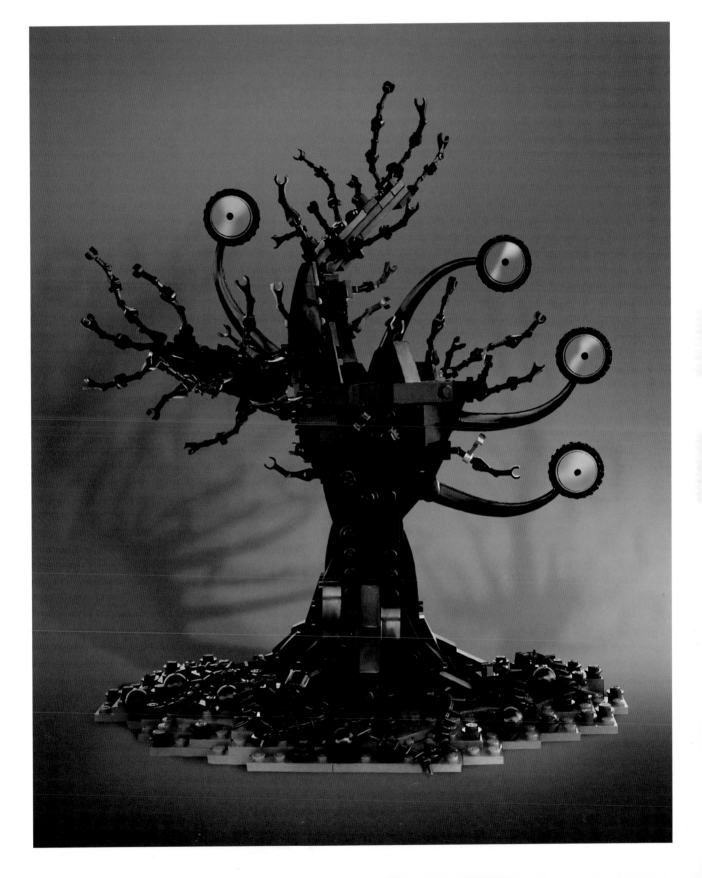

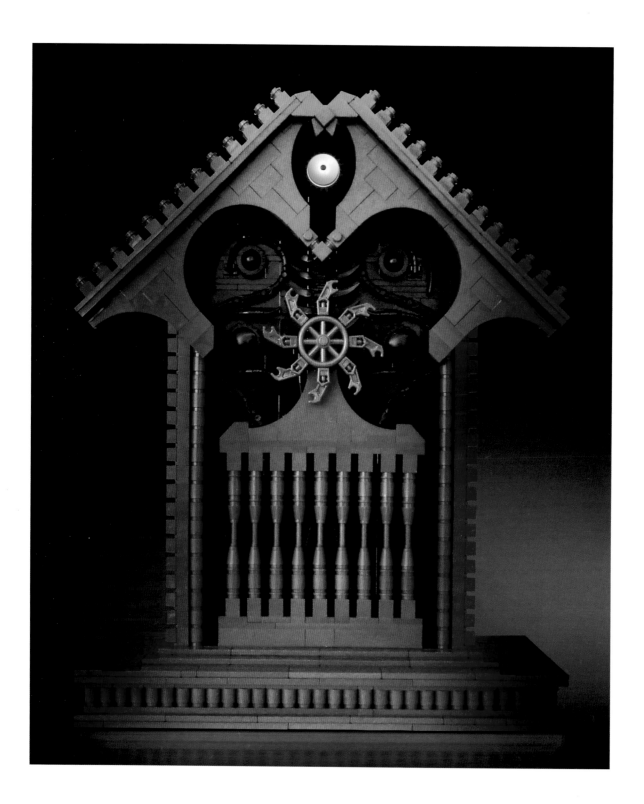

Worship Stelae 2013 (~1200 pieces)

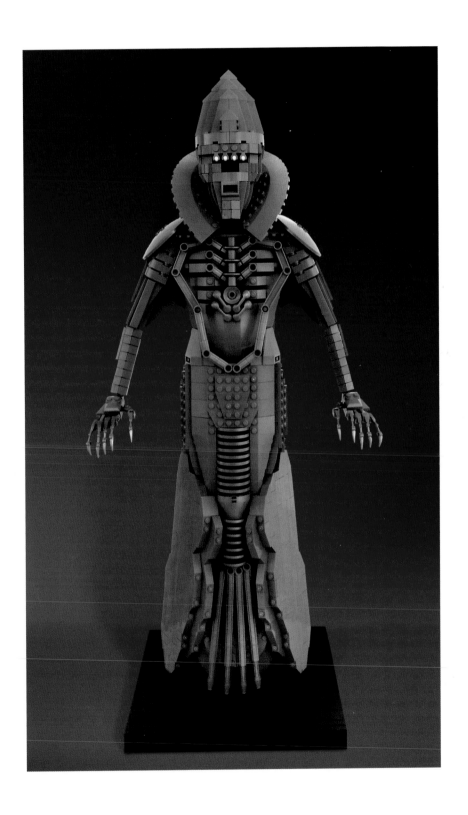

Pontumon 2014 (~900 pieces)

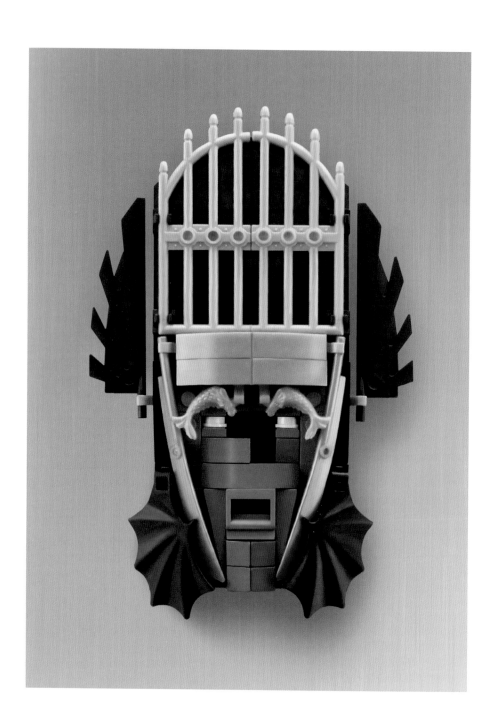

Demonic Amulet 2013 (~150 pieces)

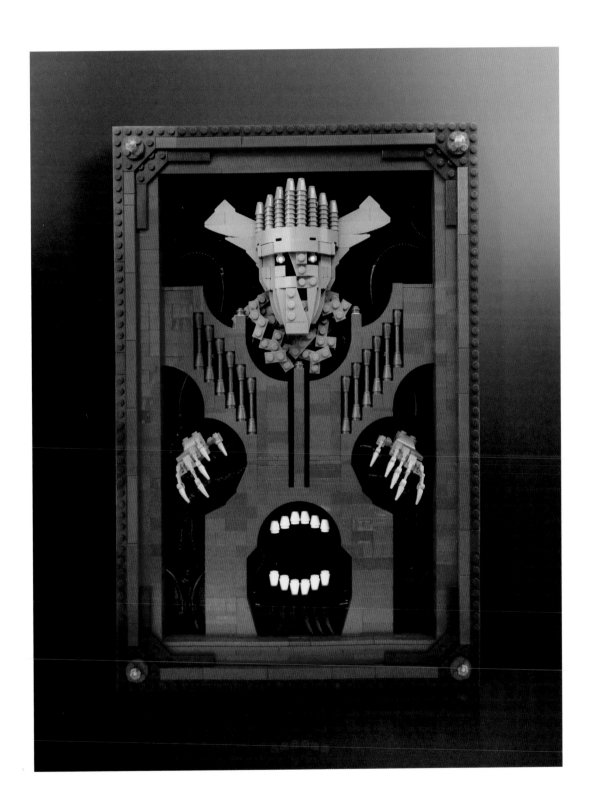

Demonic Book 2014 (~700 pieces)

The Birds

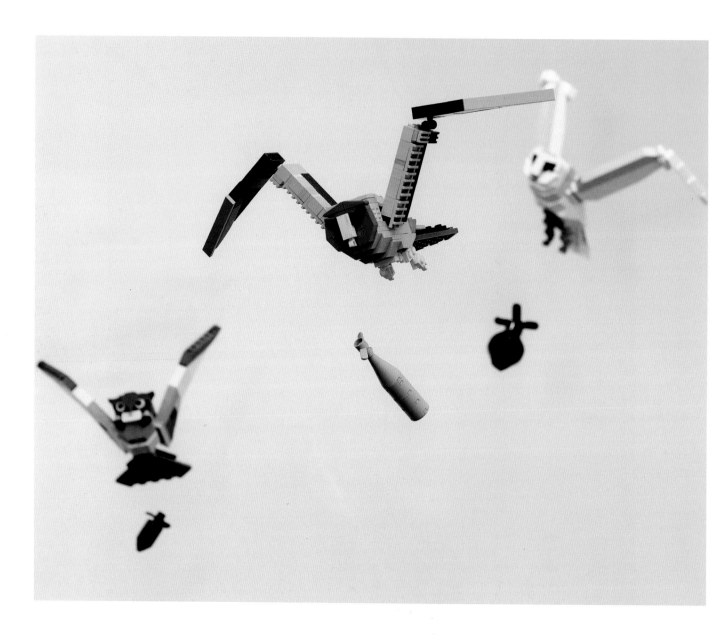

Ekow Nimako
(foreground) Black Banded Owl,
(right) Barn Owl,
(left) Northern Saw-Whet Owl
2012 (~720 pieces)

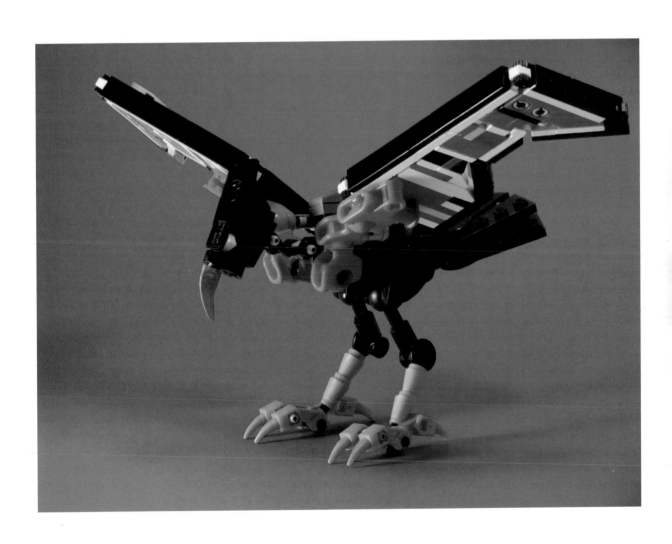

Mike Nieves
Laserbeak 2011 (~200 pieces)

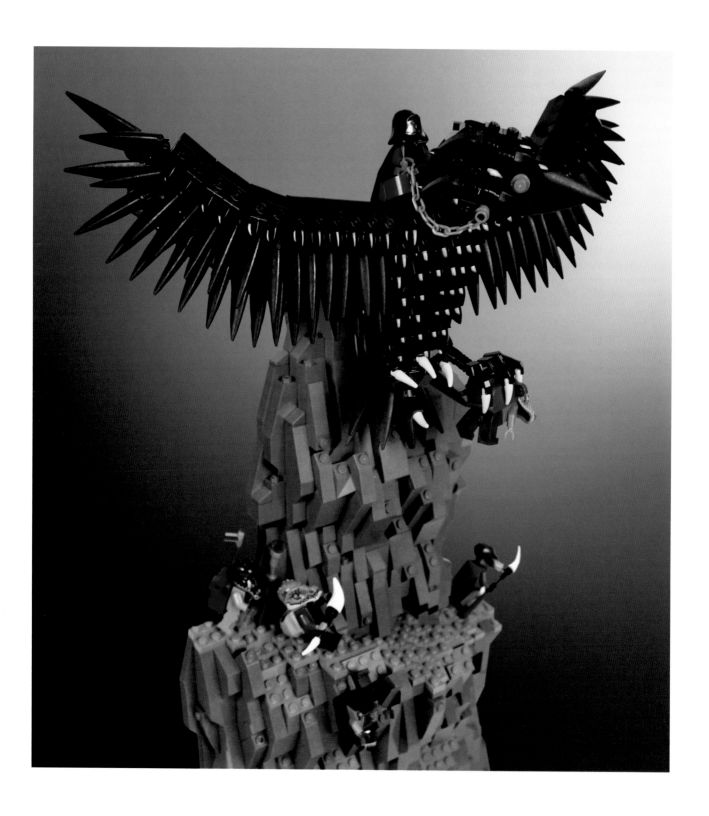

Andrew Simonson
The Spire's Toll 2013 (~4000 pieces)

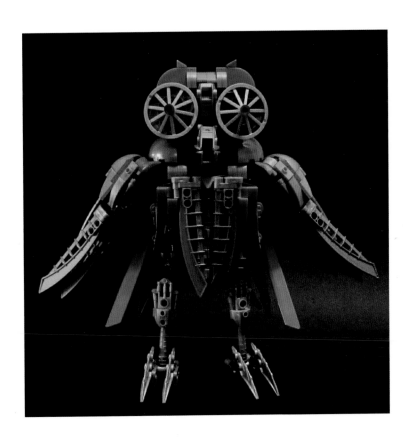

Andrew Lee
Bubo 2013

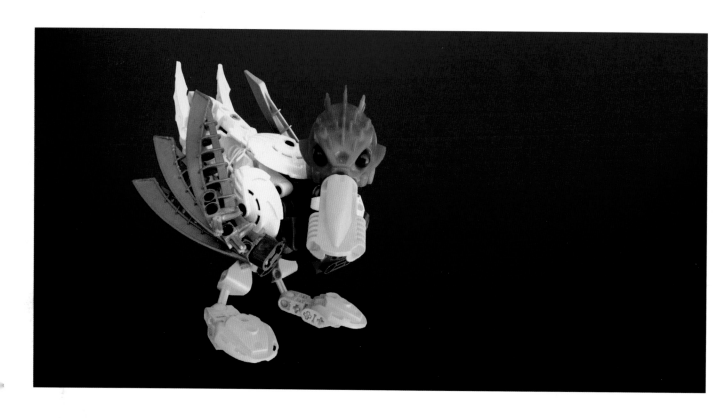

Michael Eerdekens
Angry Duck 2014 (115 pieces)

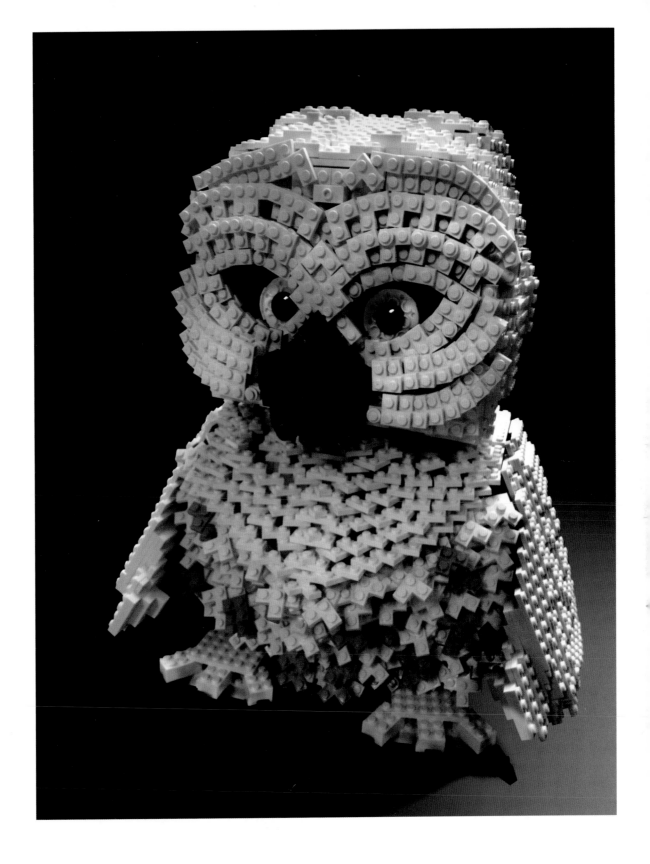

Alex Hui
Snow Owl 2013

Little Spooks by Matt Armstrong

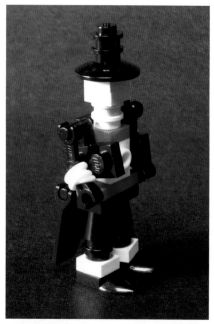

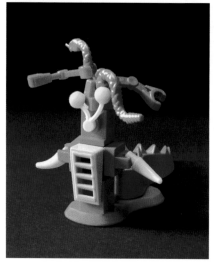

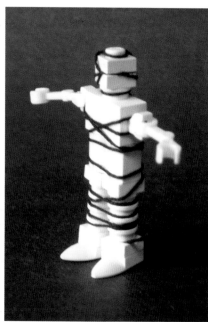

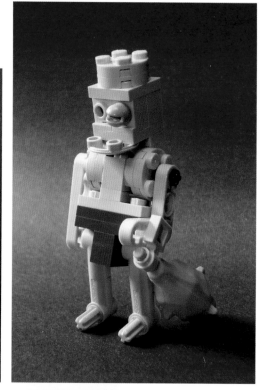

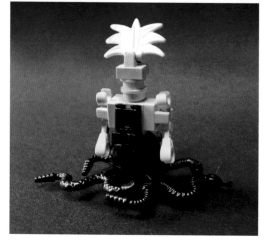

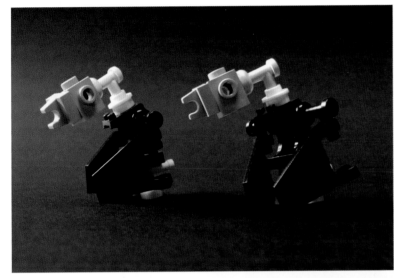

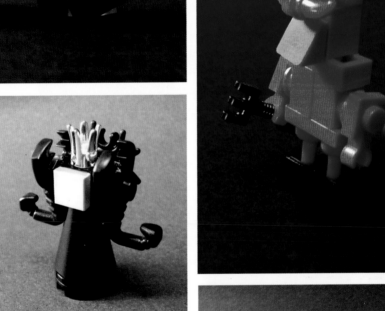

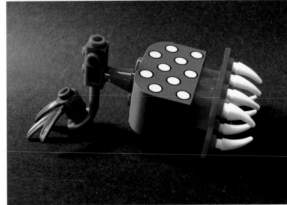

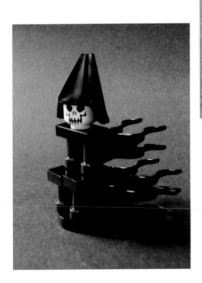

The Bewitching Hour

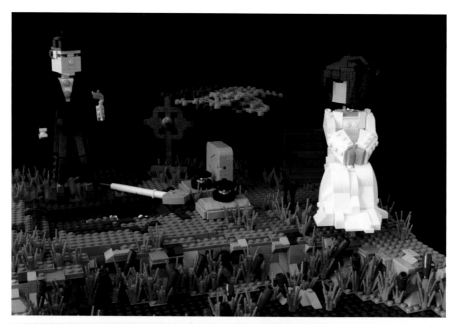

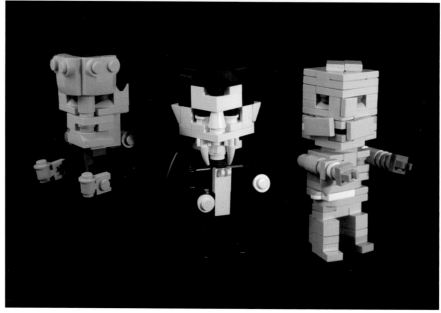

(bottom)
Lars Axelsson
CubeDudes – Classic Horror 2009 (~190 pieces)

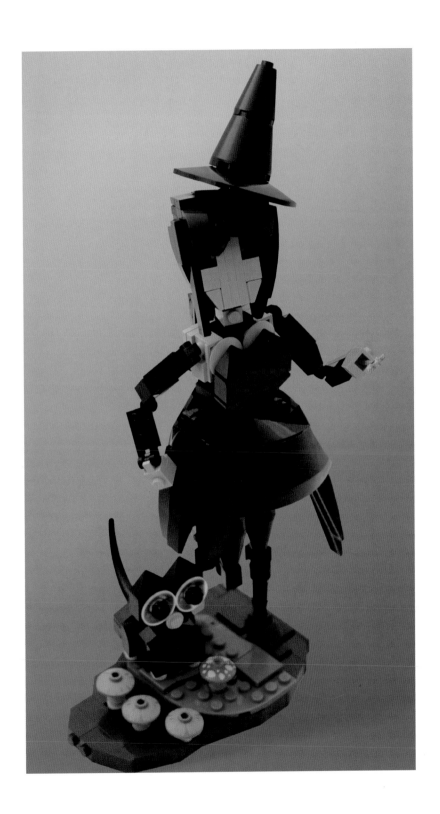

Evan Bordessa

(opposite top) Burning Bones 2012 (~1025 pieces)
(above) Isabella the Witch 2013 (~190 pieces)

Riot Girls

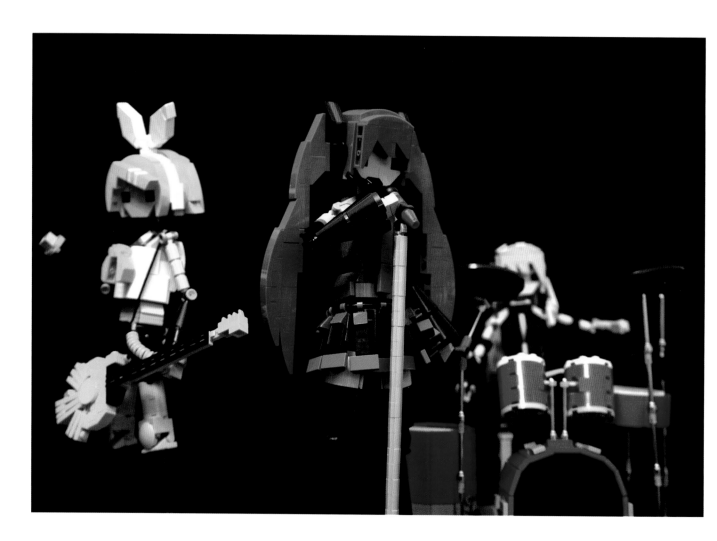

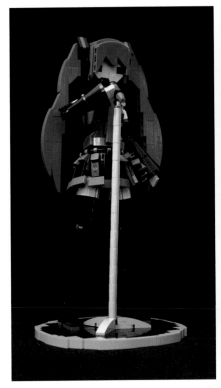
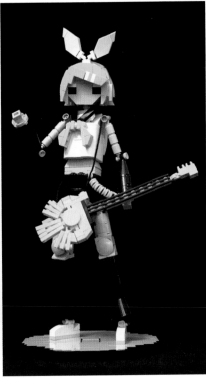
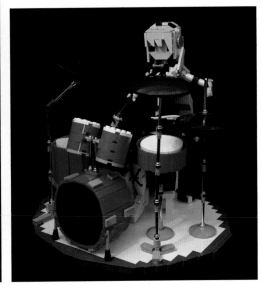

Mike Dung

(opposite) Vocaloid Band 2013 (~2400 pieces)
(left) Vocaloid – Hatsune Miku 2013 (~600 pieces)
(middle) Vocaloid – Kagamine Rin 2013 (~800 pieces)
(right) Vocaloid – Megurine Luka 2013 (~1000 pieces)

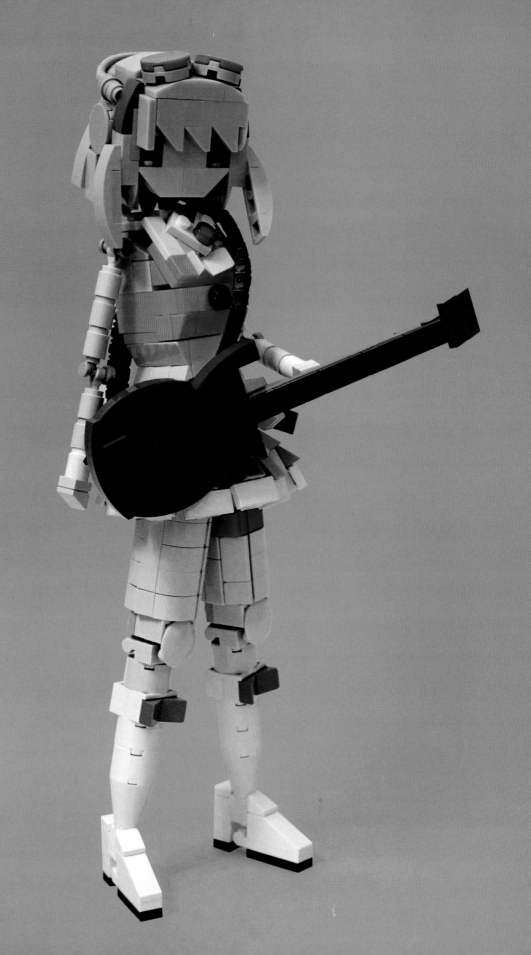

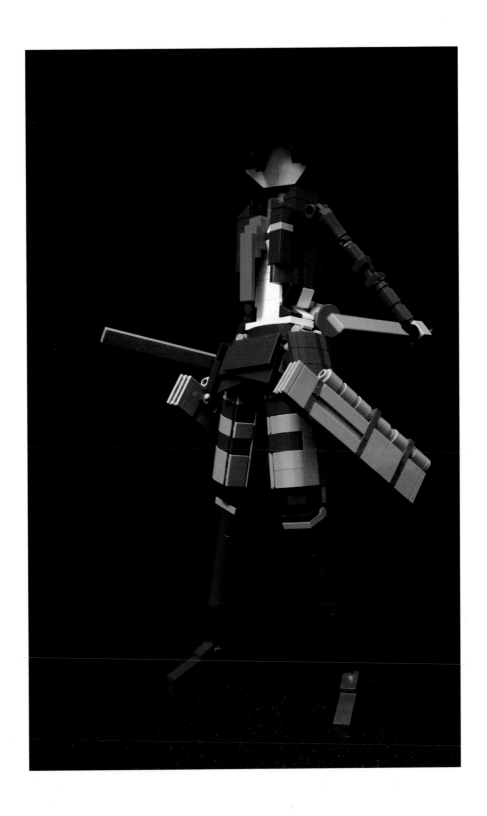

Mike Dung

(opposite) Vocaloid - Megpoid 2014 (~600 pieces)
(above) Mikasa Ackerman 2013

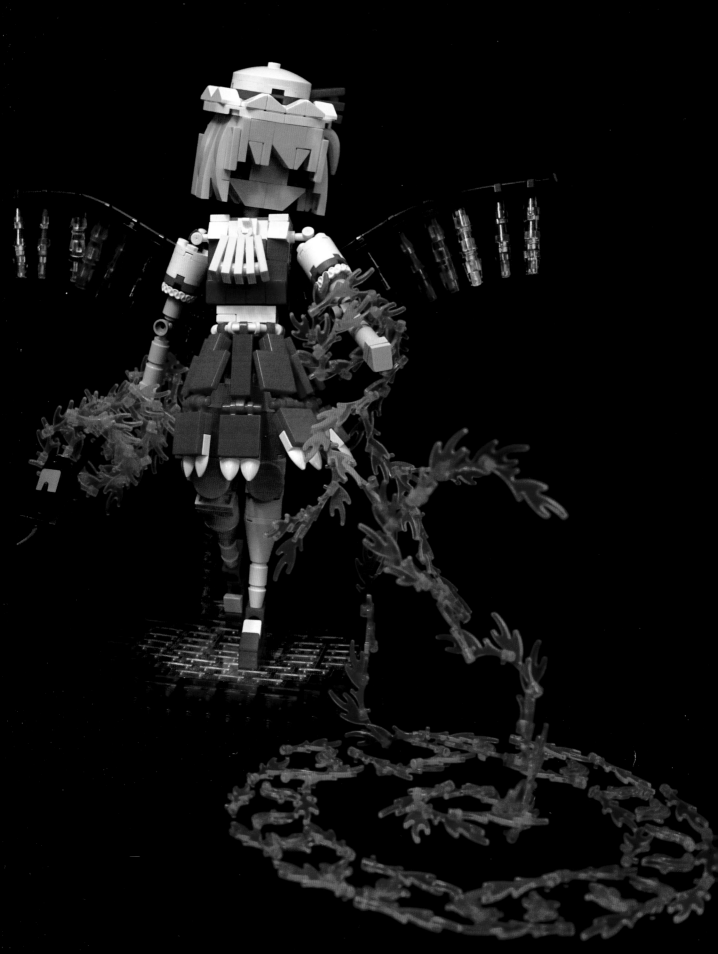

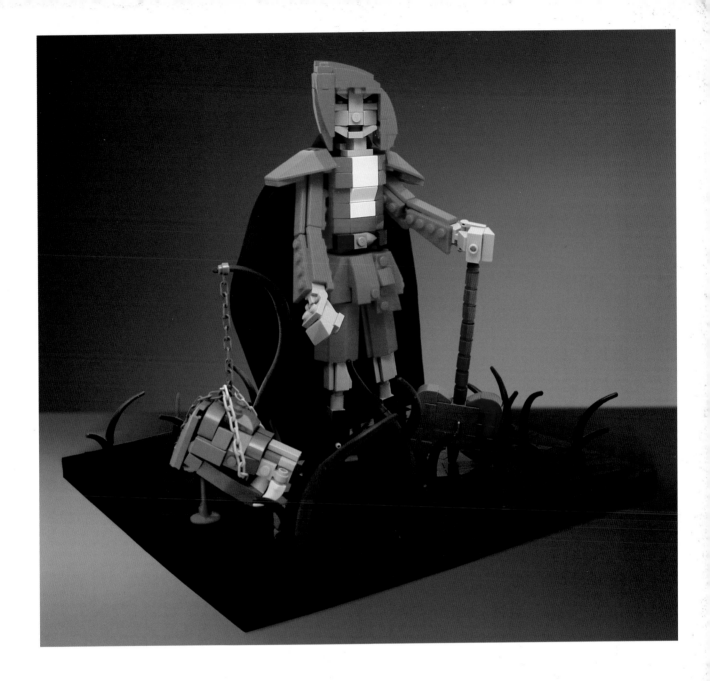

(opposite)
Mike Dung
Flandre Scarlet 2013

(above)
Evan Bordessa
Little Red 2012 (~400 pieces)

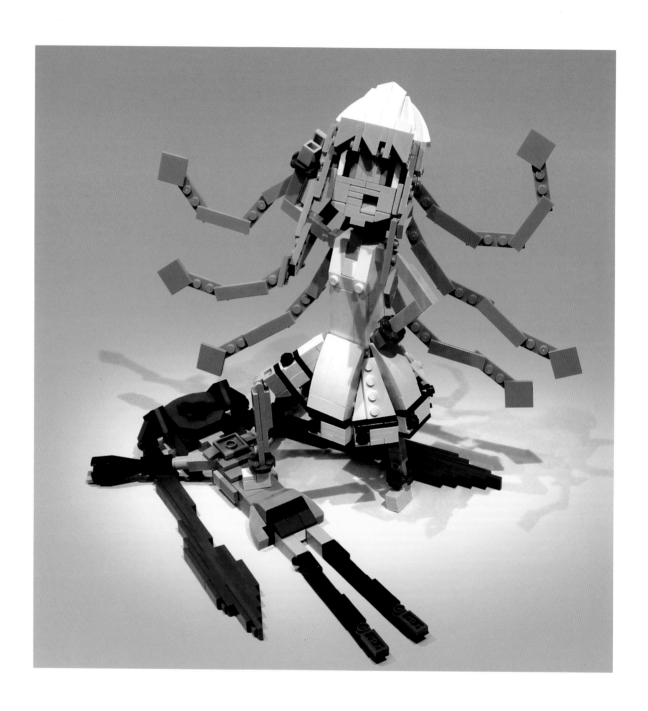

Iain Heath
Squid Girl Is Ink-redible! 2013

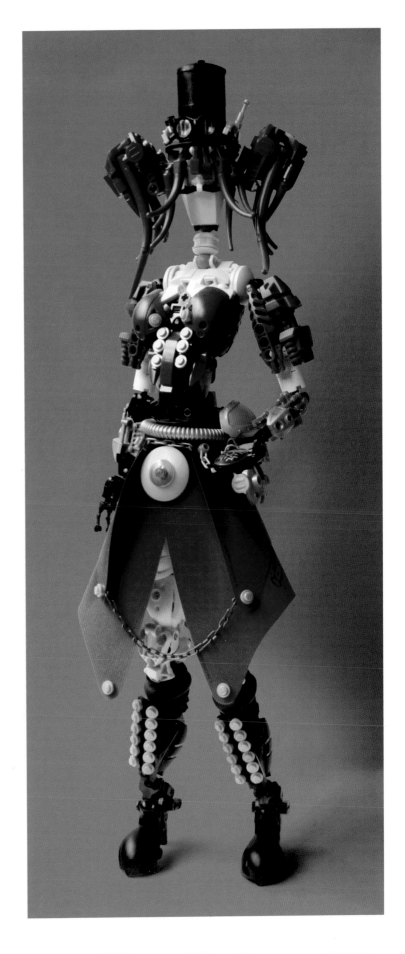

Eero Okkonen
Qwena 2013 (627 pieces)

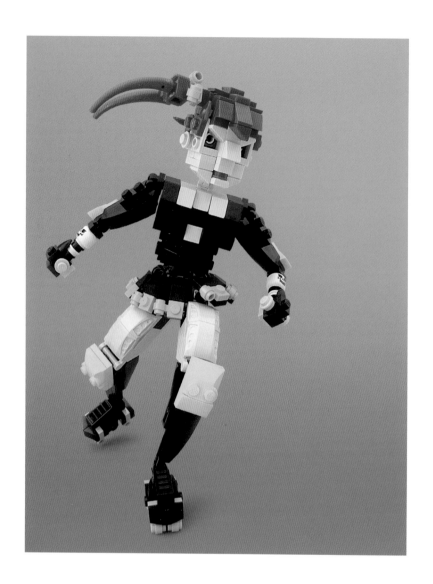

Tyler Clites
Odd Topsy 2012

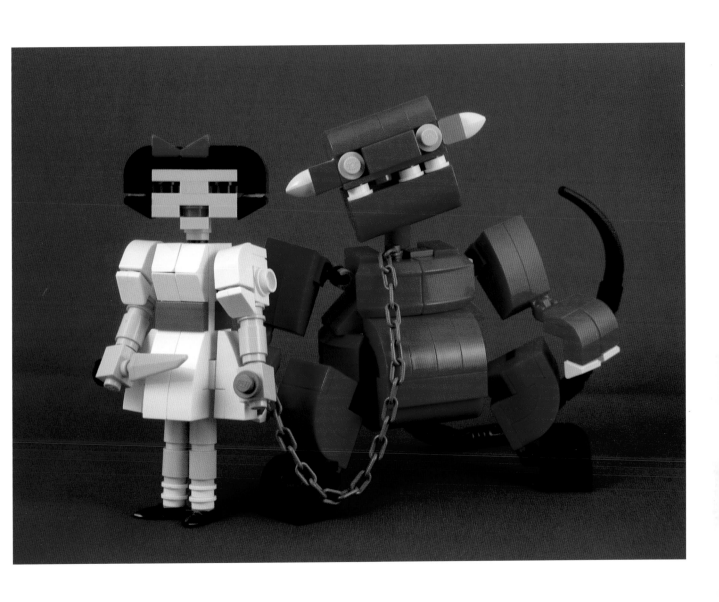

Aaron Anderson
Just a Girl and Her Demon 2011 (200+ pieces)

Bad Boys

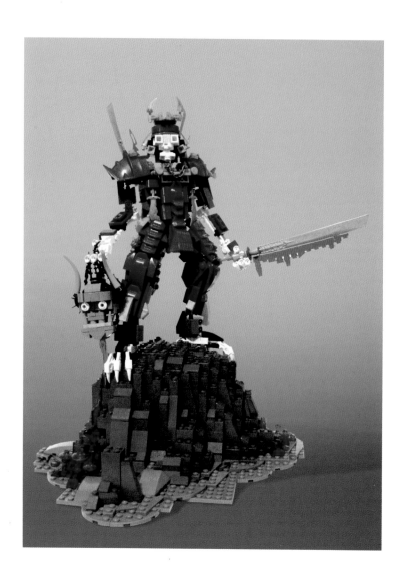

(above)
Andrew Lee
Yoshimitsu 2012 (~2000 pieces)

(opposite)
Dylan Mievis
Captain Redbeard 2014 (205 pieces)

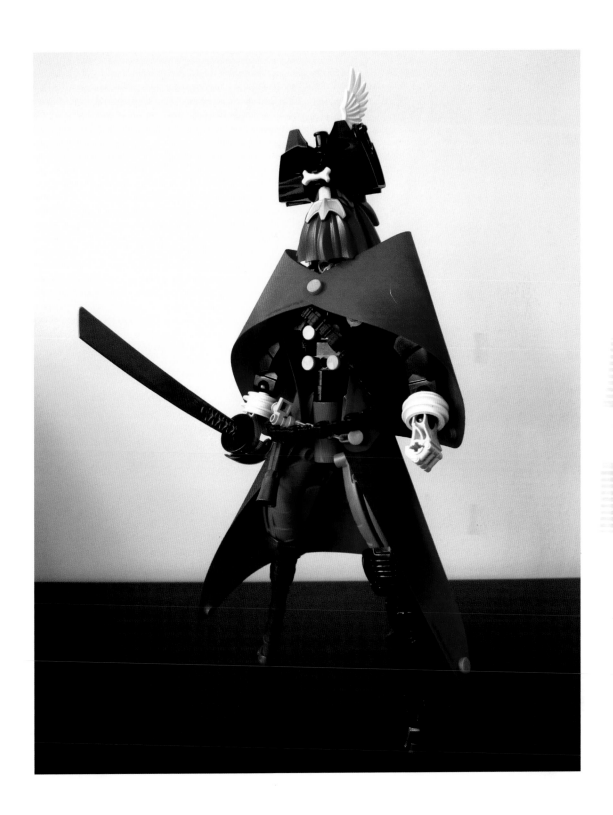

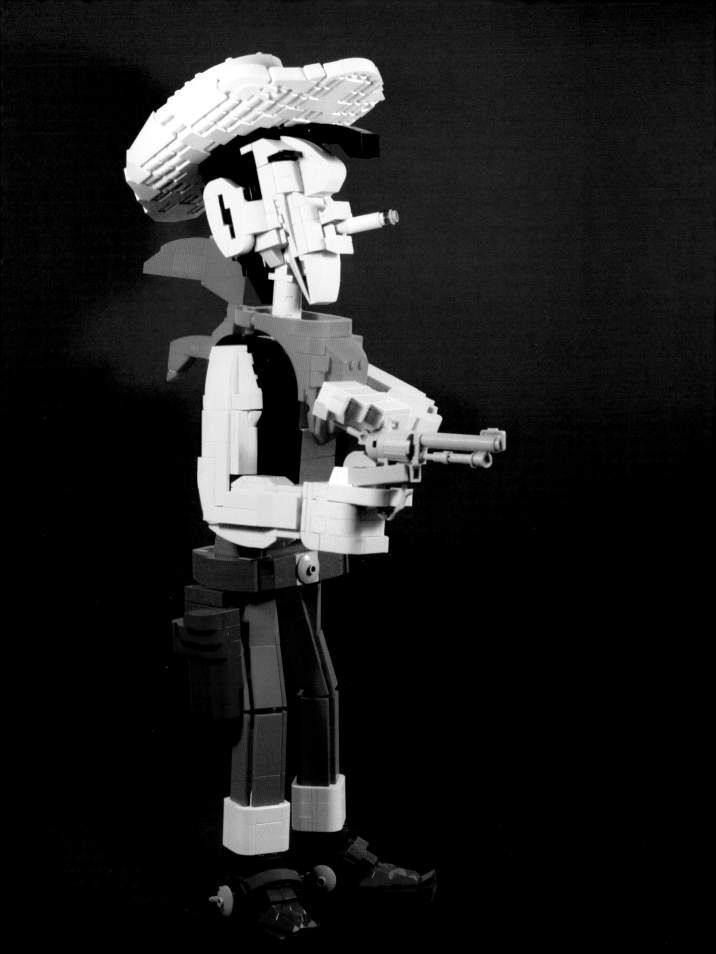

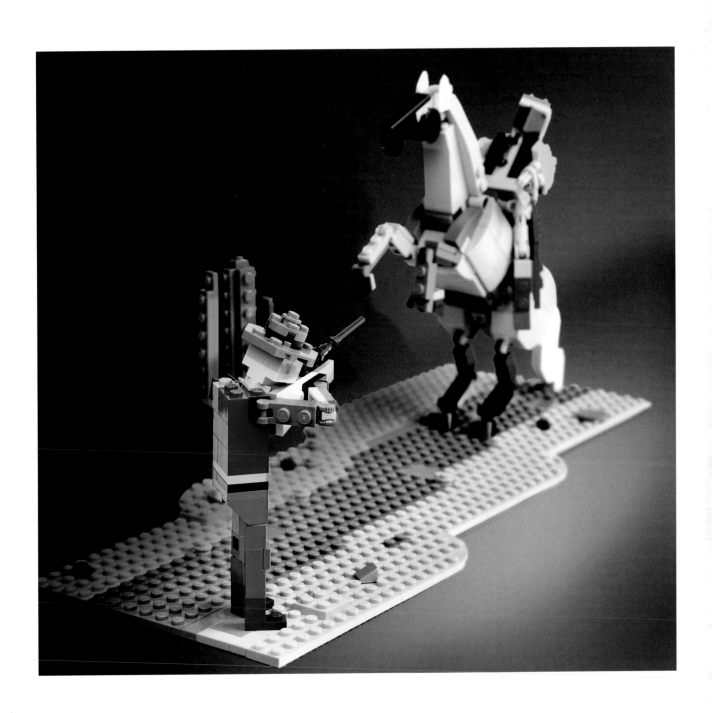

(opposite)
Jimmy Fortel
Lucky Luke 2013 (~1200 pieces)

(above)
Dmitriy Selivanov
Fateful Encounter 2013

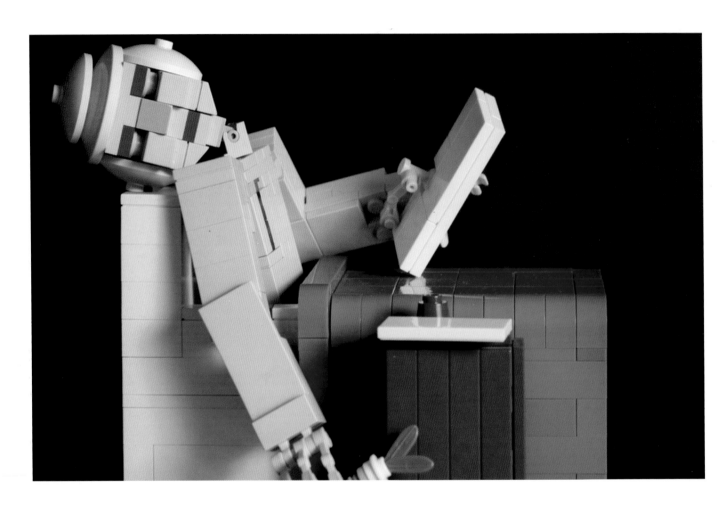

Sergio Rojas Téllez
Marat Assassiné 2013 (270 pieces)

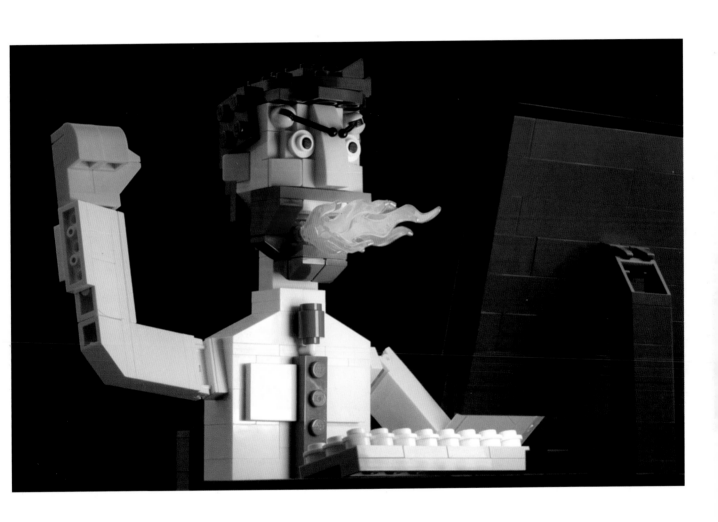

Chris McVeigh
Nerd Rage 2011

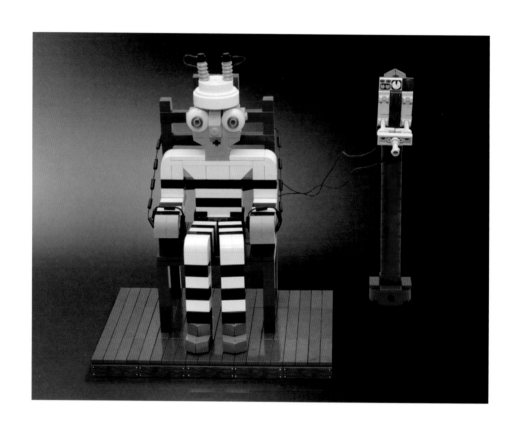

(above)
Gilcélio de Souza Chagas
Old Electric Chair 2013

(opposite)
Riccardo Zangelmi
Capitan Harlock 2014

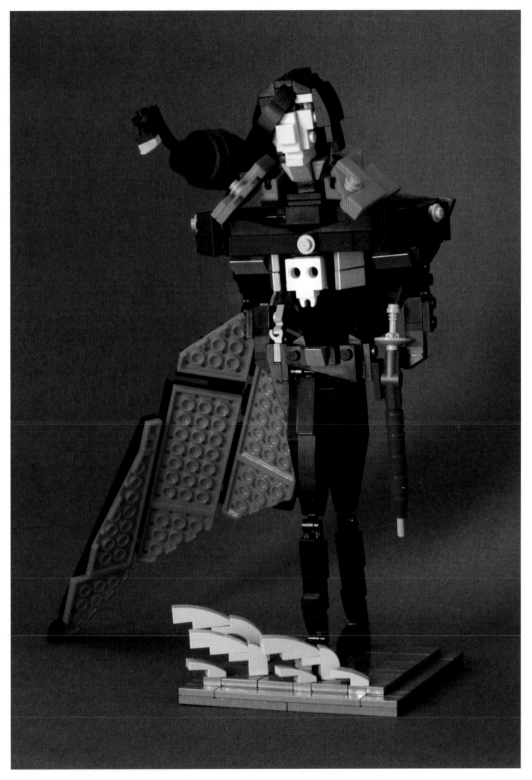

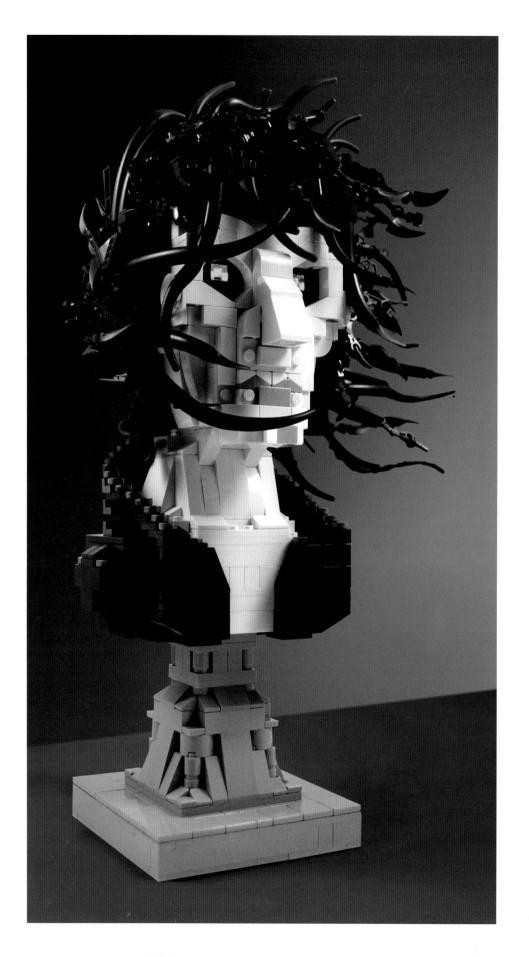

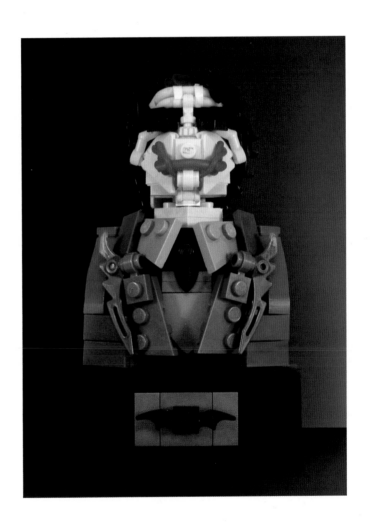

(opposite)
Tyler Halliwell
The Sandman 2014 (~1500 pieces)

(above)
Ian Spacek
The Joker 2014 (~150 pieces)

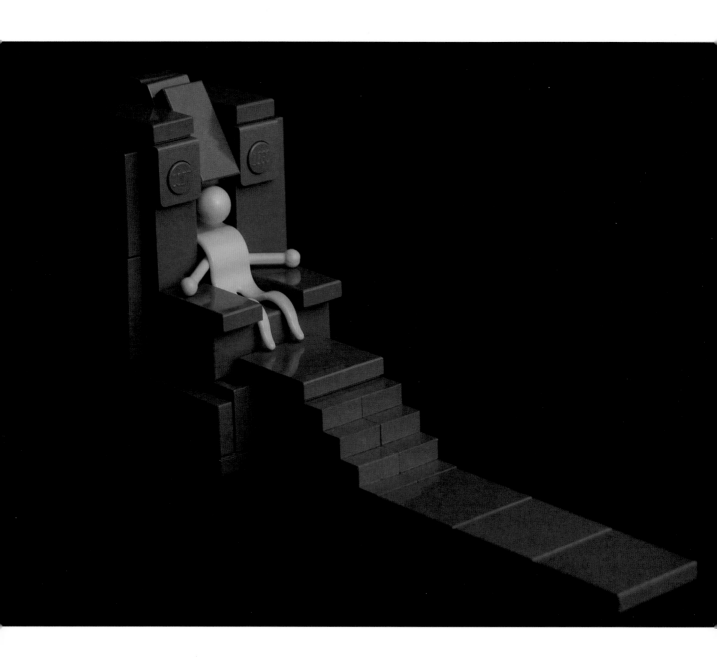

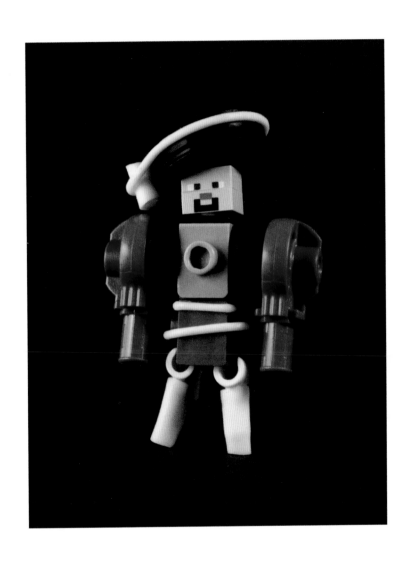

(opposite)
Brian Kescenovitz
The King in Yellow 2013 (50 pieces)

(above)
Bartosz Kacprzyk
Henry VIII 2013 (19 pieces)

Contributors

Unless otherwise stated, all photographs are copyright of the individual builders.

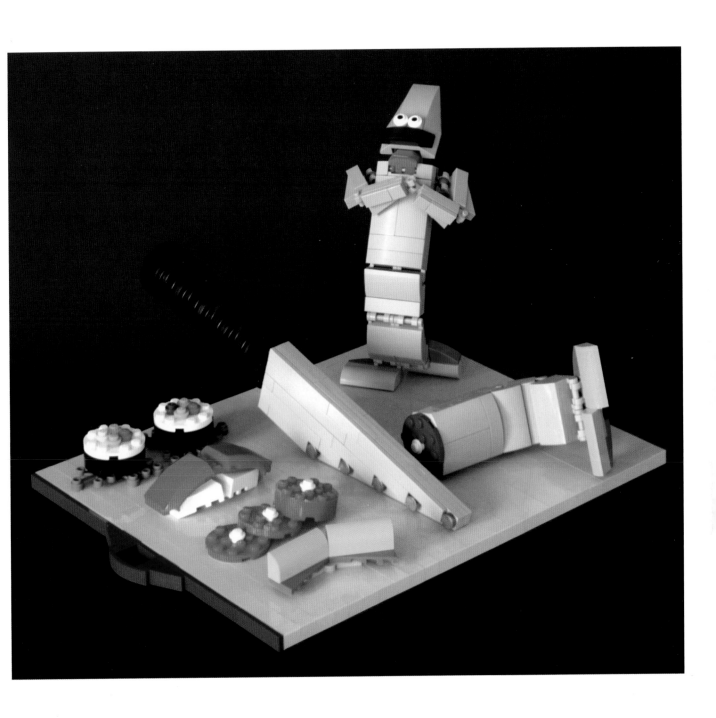

Riccardo Zangelmi
Sushi Affair 2014

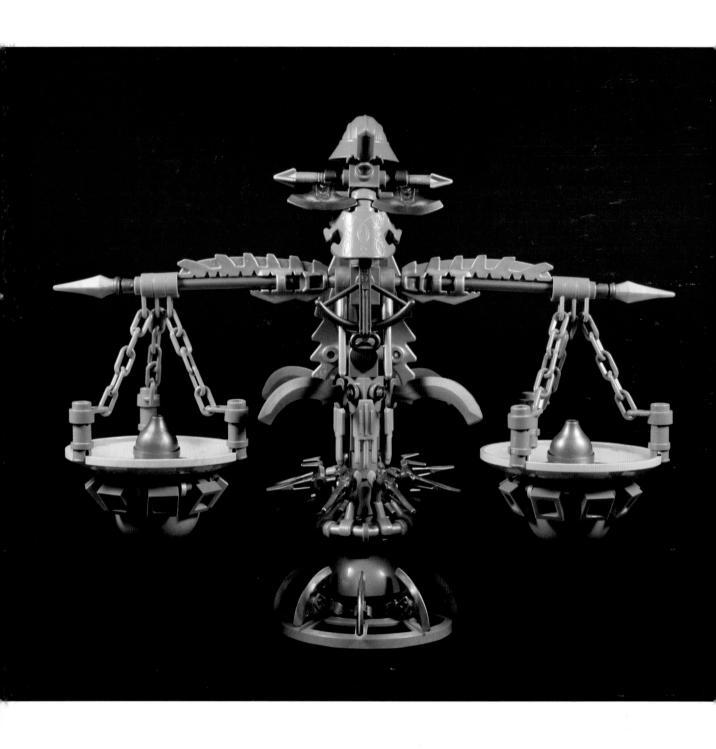

Jimmy Fortel
Game of Scale 2014 (~90 pieces)

Beautiful LEGO® 2: Dark. Copyright © 2015 Mike Doyle.

Printed in China
First printing

18 17 16 15 14 1 2 3 4 5 6 7 8 9

ISBN-10: 1-59327-586-2
ISBN-13: 978-1-59327-586-0

Publisher
William Pollock
Production Editor
Serena Yang
Jacket and Interior Design
Mike Doyle
Photo Retouching
Mike Doyle
Developmental Editor
Tyler Ortman
Proofreaders
Laurel Chun and Olivia Ngai

For information on distribution, translations, or bulk sales, please contact No Starch Press, Inc. directly:

No Starch Press, Inc.
245 8th Street, San Francisco, CA 94103
phone: 415.863.9900; info@nostarch.com
www.nostarch.com

Library of Congress Cataloging-in-Publication Data
A catalog record of this book is available from the Library of Congress.